5-29-86

JEWELRY

Jewelry is an effective hedge against inflation, as well as a memorable gift and a beautiful way to ornament your favorite outfit. This first encyclopedic guide to gems and metals includes:

- characteristics of over 50 gems and metals
- terminology of the trade
- procedures for determining the value, identification, and quality markings (i.e., cleavage, malleability, hardness)
- marketplace savvy to where and how to purchase jewelry
- steps for maximum care and protection in preserving value and beauty
- essential information on assessing jewelry and jewelry insurance
- special chapters on men's jewelry and costume jewelry
- valuable appendices and a glossary of jewelry terms

PREVIOUS BOOKS

Understanding Women's Liberation, A Complete Guide to the
Most Controversial Movement Sweeping America Today

The New Way to Become the Person You'd Like to Be, A
Complete Guide to Consciousness Raising

Furs

Vitamins and Your Health

This indespensable compendium for
the gift buyer as well as the jewelry
merchant will provide a rich lode of
facts and information.

Thousands of hints and tips give ad-
vice on all aspects of jewelry from the
history of the cultured pearl to obtain-
ing jewelry abroad and buying jewelry
wholesale. Complete, authoritative,
and up to date, this is the only guide
you'll ever need.

JEWELRY

EDYTHE CUDLIPP

E. P. DUTTON NEW YORK

For information contact: E.P. Dutton, 2 Park Avenue, New York, N.Y. 10016

Library of Congress Cataloging in Publication Data
Cudlipp, Edythe
Jewelry.
1. Jewelry. 2. Jewelry—Purchasing. I. Title.
TS729.C82 1980 739.27 79–17659
ISBN: 0-525-93122-8 *(cloth)*
ISBN: 0-525-93103-1 *(paper)*

Published simultaneously in Canada by Clarke, Irwin & Company Limited, Toronto
and Vancouver

Designed by Mary Beth Bosco

10 9 8 7 6 5 4 3 2 1

First Edition

My thanks to my friends for their help and support while I was writing this book, and especially to Gloria and Frank Jennings, Kathleen Smith and William Pustarfi, Iris Vinton, and Robert Trenour in New York; Helen and Robert Cain and Livia and Edward DeWath in San Francisco; Mary and Glen Hood in Washington, D.C.; and above all to Nicholas Carter in Sydney, Australia.

CONTENTS

PREFACE

You are looking at gems and are shown an evening emerald, at a price much lower than what you would expect to pay for an emerald of the same size. Would you buy and would you know what you are buying?

You are admiring a piece of gold jewelry and are told it is 14-karat gold. Do you know what marking to look for to make sure it is solid 14-karat gold and not rolled gold, gold electroplate, or gold wash? Do you, in fact, know what 14-karat and other terms mean?

You notice that stickpins are the latest fashion in jewelry and are being shown in both fine jewelry stores and costume jewelry departments of large stores. Do you know which you would buy and which might be the better buy, regardless of what you can afford?

You are cleaning an opal ring, a pair of diamond earrings, and a string of pearls? Do you know the best way to clean them and would you clean them together or separately? Also, how would you store them after cleaning?

You have inherited some jewelry. Included are a diamond ring and what looks like antique jewelry. You want to have the pieces appraised. Where would you take them and what is the difference among types of appraisals?

You insured your diamond engagement and wedding rings right

after you were married, and it is time to renew your policy. Is the original valuation still adequate or should you have the rings reappraised?

You want to buy a diamond ring. Would you look for a fine jewelry store where the tags are clearly marked to show price and quality, a store offering a sale on diamonds, a store where you might be able to bargain for a lower price, or even a mail-order offering of a packet of diamonds at a wholesale price? For that matter, do you know what the four Cs of diamonds are?

These are only a few of the questions about jewelry that are answered in this book.

*An evening emerald, for example, is not an emerald but any green stone of an emerald color.

*All karat-gold jewelry in the United States and some other countries has to be marked to show its quality, according to law. The term *karat* refers to the amount of gold used in proportion to another metal or metals.

*Another term for costume jewelry is fashion jewelry, and it can be the better buy for high-fashion designs that you may tire of or may go out of fashion in a year or two.

*Certain gems and types of jewelry require special care in cleaning and should not be stored together or in the same way, since they may become scratched or lose their luster or color.

*Only an expert in jewelry and gems can appraise jewelry, and appraisals can vary for legitimate reasons.

*Since both diamonds and gold have increased drastically in price over the past few years, jewelry should be reappraised at the time of an insurance policy's renewal to make sure the replacement value is up to date.

*In buying fine jewelry, there are few, if any, bargains: you get what you pay for. Clarity, color, cut, and carat size are the four Cs of diamonds, determining the quality and cost of any diamond.

How to buy jewelry, therefore, is only the beginning of what you need to know about jewelry. You also need to recognize value to realize that even gold and diamonds may not always be worth what you think they are. Actual value and sentimental value are two different things, and sentimental attachment can give a value to jewelry far beyond its monetary value since sentiment is one of the most important reasons for buying, giving, and wearing jewelry. Engagement and wedding rings, school and fraternal jewelry, birth-

stones and zodiacal jewelry, and religious medals are all jewelry with a value to you higher than what their actual or monetary value may be. For these reasons you should not think of jewelry as an investment, unless it is an investment in beauty. For these reasons, too, costume jewelry can be a better or more preferable buy than precious jewelry at times.

The phrase "fickle fashion" is all too true today for both men and women. A good example is blue jeans. Ordinary jeans are a staple for America's leisure-time wear. When top designers put their names on them, they become high fashion and a fad. Yet, how long does a fashion last? One year, two years? And how long will it take you to tire of the look? In short, you have to decide whether a designer's name on a pair of jeans makes them worth twice the price of ordinary jeans.

The same questions and qualification hold true for jewelry. An example of fashion or fad jewelry is stickpins. In 1979, they were seen and shown everywhere. A well-dressed woman "had to have" one or more. In karat gold, a stickpin could cost $20 or more, but you could get one for $5 or less in costume jewelry. Considering you may wear it only for a year or two before you tire of it or they go out of fashion, you might be better off buying costume jewelry. Then, there is the special outfit for which you want an equally special piece of jewelry that you may not be able to wear with anything else. Again, costume jewelry has a role to play. Yet, costume jewelry—like fine jewelry—covers a wide range of different qualities. You need to know what to look for in order to get the best buy. And you need to know how to care for it to keep it looking its best.

Care, in fact, is probably the most neglected area where jewelry, both fine *and* costume jewelry, is concerned. It extends far beyond the care you take in wearing it, to where you put it when you are not wearing it, how you put it away, and how you clean it. Not only should it be stored in a safe place but it should also be stored safely in such a way that one piece does not scratch or damage other jewelry.

The goals of this book, therefore, are to help you know how and where to buy jewelry, what the various kinds of metals and gems are, how to care for and protect jewelry, and how to appreciate its value. To do that, you have to know and recognize the pitfalls inherent in buying and owning items of adornment—and adornment is the actual purpose of jewelry—that have an intrinsic value.

Although many people have made a contribution to this book, I would particularly like to thank the following whose help was invaluable: Ralph Destino, president of Cartier's in North America; Morton Sarett, Jewelry Industry Council; Robert Crowningshield, vice president, Gemological Institute of America, New York; David Rosental, president, Kohinoor International, Ltd., of New York; The Gold Information Center; Kevin Tierney, Sotheby Parke Bernet, New York; Alfred L. Woodill, executive director, American Gem Society; Jules Schwimmer, Appraisers Association of America; Robert C. Nelson, R. C. Nelson and Sons, Inc., New York; Simone Gross, Retail Jewelers of America; The Silver Institute; Seymour Lipton, Permanent International Jewelry Exhibit; Fouad Khoury, Khoury Bros. Fine Jewelry, Arlington, Va.; Monet Jewelers, Inc.; Linda Jackson, Trifari Jewelry; Messrs Blairjohn, Kramer, and Pukel, U.S. Customs Service; and Robert A. Laurence, Casualty and Surety Division, Aetna Life and Casualty.

One further note: jewelry is an enormous subject. Books have been written on diamonds and only diamonds, on gold, on gems, on making jewelry, and so on. Thus, a book of this type can include only the most important information. For anyone interested in learning more about these highly specialized and technical fields, the following books are a start:

The Gem Kingdom, Paul Desautels, Ridge-Press-Random House, 1971.
Van Nostrand's Standard Catalog of Gems, John Sinkankas, Van Nostrand Reinhold, 1968.
Gems and Jewelry, Joel Arem, Ridge Press-Bantam Books, 1976.
Precious Stones, Max Bauer, Dover Publications, 1968, 2 volumes (originally published 1904).
Jade, Stone of Heaven, Richard Gump, Doubleday, 1962.
The Curious Lore of Precious Stones, George Frederick Kunz, Dover Publications, 1970 (originally published 1913).
Gold, Johann Willsberger, Doubleday, 1976.
The Book of Gold, Kenneth Blakemore, Stein & Day, 1971.
Antique Jewelry: A Practical and Passionate Guide, Rose Leiman Goldenberg, Crown, 1976.
The Beautiful Art of Enamelling, Ninette Dutton, ARC Books, 1968.
Creative Gold- and Silversmithing, Sharr Choate with Bonnie Cecil De May, Crown, 1970.

1.
KNOW THE METALS

Jewelry is metal. Although gems are also jewelry, the gems without the metal would be merely pretty baubles, because how would you wear the gems unless they were set in some way? The making of jewelry, therefore, depends on some kind of metal, whether the jewelry is a chain or necklace, a pin or brooch, a ring, earrings, or a bracelet.

Metals are divided into precious and base metals. The *precious* metals are gold, platinum, and silver. They are also called noble metals because they resist corrosion and oxidation, the process in which air and elements in the air eat away metals to form tarnish and rust. *Base* metals are all other metals, whose resistance to corrosion is less, such as copper, nickel, and iron.

Most metals used in jewelry are combinations of precious and base metals. Although the precious metals could be said to be diluted by the base metals, the reason they are combined may have less to do with making the precious metal less expensive than with the intrinsic qualities of the base as well as the precious metals. You need to know a little about what those qualities are in order to understand the metals themselves.

QUALITIES OF METALS

Malleability is the capability of a metal to be hammered or worked under pressure without crumbling. The most malleable metals, in order, are gold, silver, and copper. Gold is so soft or malleable, in fact, that early man could work it with the most primitive tools.

Ductility is the capability of a metal to be drawn into wire. A metal may be malleable without being ductile. For example, lead is malleable and can be hammered flat, but it is not ductile in that it cannot be drawn into wire. Gold, on the other hand, is both malleable and ductile.

Tensile strength is the capability of a metal to be worked without cracking.

Brittleness is the opposite of ductility. A metal is called brittle if it breaks easily or suddenly when being drawn into a wire.

Elasticity is the capability of a metal to return to its original form after it has been worked on.

Fusibility is the capability that permits one metal to be combined with another metal, both in the sense of being mixed together in a molten form and in the sense of two metals being bonded (fused) or welded together.

Malleability, ductility, tensile strength, and fusibility are desirable characteristics, since metals with these characteristics can be easily worked and will hold and retain their shapes after working and wearing. Metals that are brittle and elastic, with little fusibility, are undesirable for jewelry because they will break or lose their shapes and they cannot be used in combination with other metals. All precious metals are malleable, ductile, tensile, and fusible.

An *alloy* is a combination of two or more metals, in which the metals are combined in molten form, like mixing the ingredients of a cake. The reasons why a precious metal may be alloyed with a base metal will be explained under the individual metals, but the general reasons have to do with the above characteristics. A metal that is too malleable may be combined with another metal in order that the resulting metal will be harder and more durable, while retaining its own unique characteristics. On the other hand, a metal that is too hard may be alloyed with another metal to make it softer and easier to work, again while retaining its own unique characteristics.

A term that may be used with precious metals in connection

with alloys is *fine* or *fineness*. The fineness of a precious metal has to do with the amount of precious metal used in the alloy in proportion to the base metal. The more of the precious metal used, the finer the metal is.

Another term often used is *hallmark*. Hallmarks originated in England in about 1300. The purpose was to make sure that gold and silver articles actually contained the amount of gold and silver required by law. As a result, gold- and silversmiths took their articles to their guild or trade halls, such as the Worshipful Company of Goldsmiths in London, where the master assayed the article and stamped on it the mark of the hall—the hallmark—guaranteeing the article's content. Each guildhall in each city had its own hallmark. Other countries later followed suit.

Today, however, a hallmark is not necessarily a symbol indicating the content of the metal. The marking of metal content depends on the type of metal and the process, as well as the country of manufacture. In the United States, for example, a hallmark is simply the manufacturer's identification stamp on a piece of jewelry, rather than a mark of content.

These terms are basic in talking about metals. Each metal, nevertheless, has its own characteristics and its own terminology.

GOLD

When Columbus landed in the Western Hemisphere, his first question is supposed to have been, "Where is the gold?" From earliest times, gold has been the most desired metal and the symbol of wealth—and with good reason.

Gold is the color of the sun, and the ancients worshipped the sun. Since the gold was associated with kings and priests, too, gold was theirs to own and bestow.

Then, there is the rarity of gold. Imagine a cube that is 18 yards or 54 feet on all sides, weighing 100,000 tons. That relatively small cube represents the total amount of gold that has been mined in the six thousand years since written history began. It includes the gold bars in Fort Knox, the even larger number deep in the vaults of the Federal Reserve Bank of New York in Manhattan, the bars or ingots held by other banks around the world, the treasures in museums, the religious objects in countless churches, the inlays in millions of teeth, the jewelry owned by millions of people, the gold used in space and

computer and other industry technology, coins, secret hoards—in fact, all gold already mined, regardless of whether it is solid gold, in alloys, in wires, or in foil.

Yet, the rarity of gold is not the only thing that makes it unique.

*Gold is so ductile that 1 ounce can be drawn into a fine wire *50 miles long.*

*Gold is so malleable that 1 ounce can be hammered into a sheet so thin that it could cover *100 square feet.*

*Gold is so indestructible that jewelry buried in tombs 3,200 years *before* Christ and coins centuries old found in long-since rotted ships at the bottom of the ocean gleam like new. The treasures of Tutankhamen that amaze us today, for example, were as beautiful on their discovery in the 1920s as they were when they were placed in the boy king's tomb in 1358 B.C. Gold is not damaged by time or tarnish, by rust or corrosion, making it a truly noble metal. It can be used and reused, which is one reason there seems to be "so much" gold. No wonder it is called "the everlasting treasure."

HISTORY OF GOLD

Facts alone can't explain the mystique of gold, the desire for it that has helped shape mankind's destiny by leading to the rise and fall of empires, the discovery of new lands, and the opening up of vast countries. The world would be a lot poorer, both in wealth and story, without gold.

Although Helen of Troy's beauty was such that she was said to have the face that launched a thousand ships, it was Paris in legend who started the Trojan War. Asked to choose among three rival goddesses, he presented a golden apple to Aphrodite, who promised him the most beautiful woman in the world for his wife, instead of to Hera, who promised to make him king of Asia, or to Athena, who promised to make him victorious in battle. His reward was Helen, despite the fact she was married to another man. So, as a result of his choice, we have the *Iliad* and the *Odyssey*. Then, there was Jason and his quest for the golden fleece, which incidentally may actually have been sable, a fur as rare and as precious as gold in those times. Or how about King Midas, who was supposed to turn everything he touched into gold? Or Croesus, king of Lydia, whose greed for gold resulted in his overthrow, not to mention the expression "rich as Croesus"?

The Bible is rich in its allusions to gold. There are the fabled mines of King Solomon, from which the gold came to build the temple in Jerusalem and perhaps to pave the city with gold as well, as the New Testament says it was.

Fairy tales are a "gold mine," too. Jack climbed his beanstalk to search for the goose that laid the golden eggs, leading to another common expression and a moral about killing the goose. Rumpelstiltskin had his gold-spinning loom.

Then, there are the expressions we use every day that illustrate the emphasis we put on gold. All that glitters may not be gold, but no one could possibly ignore a golden opportunity. We all know what a heart of gold is and what good as gold means.

FINDING GOLD

Yet, for all the ease with which such terms fall from our "silver tongues," gold is not easy to find. Some gold may lie in the open and be relatively easy to find, but most is buried deep in the earth where it is hidden, difficult to find, and dangerous to mine. The metal was formed when the earth was very young in a manner that the alchemists of the Middle Ages would envy and sought to find in their experiments attempting to make gold from base metals.

According to scientific theory, the outer crust of the planet was thin and pockmarked with volcanoes out of which burst gases and molten liquids from the boiling cauldron of the interior. As the surface cooled, the molten liquids solidified into fissures in what became rocks and mountains. Some of the liquids became veins of gold. Others became silver and other metals, while still others became gems. Sometimes, they solidified near one another. Gold, one of the rarest metals, for example, is often found with or near quartz, the most common mineral. The ancient Egyptians noticed this neighborliness early, and when they saw quartz they looked for gold. Gold is also found with silver, and the famous Comstock mine in Nevada became a much bigger and richer source of silver than of gold. In addition, gold is found with a form of iron known as pyrites. Because iron pyrites are similar to gold in color and brightness, they are often mistaken for gold—hence the name "fool's gold."

All gold, nevertheless, was originally deposited deep within the earth. With the aging of the earth, however, gold from veins nearer the surface was eroded away from the rocks binding it. Streams and

rivers, in addition, cut their way through the rocks. Perhaps earth-quakes brought gold to the surface, too. At any rate, gold began to be visible even to the most unsophisticated eyes. The yellow glitter commanded—and commands—attention.

The loose gold, the gold found in rivers and streams or near their beds where it has been washed by erosion and weathering, is known as *alluvial gold,* gold deposited by running water. What caught the eye were gold nuggets, lumps and bits of gold that glittered in the sun and captured the gold rays. Almost all alluvial gold is found in small nuggets, some so tiny that they are more often called gold dust. The largest nugget ever recorded weighed 200 pounds and was found in Australia, where it was named the "Welcome Stranger."

Since this gold is usually found in or near water, water is used to find it, taking advantage of the fact that the gold is so much heavier for its size than the rocks, gravel, and sand with which it is found. The method is called panning. The Nubians and Egyptians "panned" with animal skins or cloth, which may also account for the "golden fleece" of legend. The method, nevertheless, is the same. Gravel and water are scooped into a pan. As the pan is shaken and the water poured off, the gold nuggets and dust settle to the bottom while the nonprecious minerals are washed away. In Colombia in South America, where gold is still mined using this principle, huge dredges have replaced hand panning. Another name for this kind of gold is placer gold, and panning is called placer mining. Sometimes mercury is used, since gold sticks to mercury. When the two metals are heated, the mercury vaporizes and leaves the gold behind.

The gold found deep in the earth is *native gold.* Because it is found with silver, quartz, and other minerals—minerals that have been washed or eroded away in alluvial gold—it is generally less pure than alluvial gold. As a result, the ore must be crushed, smelted, and refined to melt out the pure gold. In South Africa, the largest gold producer today, as much as three tons of ore must be processed to retrieve one ounce of gold.

SUMERIA AND EGYPT

The gold that first attracted the ancients, of course, was alluvial gold. They associated it with the gods, especially the sun god, be-cause of its color and brightness.

The Sumerians, a people who lived in the Middle East five

thousand years before Christ, were highly skilled goldsmiths and jewelers. Even then, they had learned how to stretch gold by hammering it for ornamental and other purposes. Their tombs reveal that gold was reserved for royalty, with silver and copper ornaments being worn by ladies-in-waiting and others.

The ancient Egyptians, who followed the Sumerians, became still more skilled at working with gold, as anyone who has seen the treasures of Tutankhamen knows. They developed techniques for engraving, embossing, etching, filigree, and enameling with metal and for engraving gems. They were so profligate with gold that sometimes royalty wore little else. One reason was that they were highly skilled in another way—at finding gold. Wherever they found quartz, they looked for gold and developed techniques, as well, for mining gold.

The mining of gold required another art, smelting, since mined gold is rarely pure. The rock and ore were crushed in a mill and then put in sieve-like vessels, which were put in an oven. A charcoal fire was kindled and kept going by blowpipes until the ore had reached the melting point of gold—1,063° Centigrade—at which time the molten gold flowed out of the holes in the vessel. In the meantime, silver (which has a lower melting point) had already been refined. As the Egyptians became more expert and extended the length of time of the firing, the gold became purer because more silver had been separated from the gold. Even so, the gold was probably not as pure as today's gold. It was most likely 22-karat, rather than 24-karat, gold.

The Egyptian thirst for gold was unslaked. Geologists went south and found gold in a place they called Nubia, naming it after the Egyptian word for gold, *nub*. Geologists were also sent to Arabia, Cyprus, and Iberia (Spain). They may even have circumnavigated Africa to search out gold in legendary Punt, which historians think may have been at the mouth of the Zambezi River in Southeast Africa. The result was that in the Copper Age (3900–2100 B.C.), Egypt is estimated to have had 80 percent of the world's yield of gold.

So much gold put the country on the gold standard. Gold rings of 7.15 or 15 grams became the standard of exchange, not that everyone could afford them any more than everyone today can afford to own much gold. Yet, "good as gold" still has tangible meaning in many sections of the world. In parts of the Middle East,

people invest in gold as people in other parts of the world put their money in stocks and bonds or real estate. Bracelets, earrings, necklaces, anklets, even nose rings are a girl's dowry in marriage. A father who cannot afford such jewelry may not be able to marry off his daughter. In India and other parts of Asia, gold jewelry is also the preferred form of bank account—and the purer, the better. Even though 22-karat gold, much less 24-karat, is soft enough that it may lose its shape with much wear, Indian women don't seem to mind. They like to have their jewelry remodeled every so often, and the cost of labor is cheap enough that they can afford it, unlike in other countries where the cost of redesigning and remodeling jewelry can be high enough to make a woman or man think twice about having it done.

The Egyptians, therefore, could be called pacesetters. At the same time, not all the Egyptian gold that glittered was real gold. Priests were not above exchanging gold idols for idols of copper colored with quicksilver and arsenic to give them a gold finish. The real idols were put to the priests' own uses, and the substitutes stood inspection—as long as no one scratched them with a fingernail to bare the copper beneath the gilt surface.

After 2000 B.C., the Egyptian "gold rush" began to lose its impetus. Perhaps the mines were exhausted. Perhaps the pharaohs and priests were too lavish in their use of gold. Perhaps there was too much hoarding, not counting what went into the tombs. Or perhaps Crete was too aggressive and took the gold and silver trade of the Mediterranean out of Egyptian hands.

THE ETRUSCANS

Although there was little "new" gold, gold continued to be used. It was traded, taken as spoils of war, and given as tribute. The Greeks in Athens' Golden Age (460–429 B.C.) were noted more for style and moderation than for flamboyancy, but the Etruscans surpassed even the Sumerians and Egyptians in the jewelers' art.

The Etruscans were the original occupants of Rome. For about six hundred years, from 800 B.C., until almost all traces were obliterated by the Romans, they were a major power. They were merchants and shipowners, exporting gold, tin, and copper to England, Ireland, Sweden, Greece, and Egypt, but their real mastery was in goldsmithing. A trademark, so to speak, was their use of gold

beads, so perfectly made and so unique that no one could imitate them for centuries. The beads were used both in jewelry and to decorate objects.

The lost art was rediscovered in the Renaissance by accident. A goldsmith's apprentice dropped a container of molten metal, for which he was beaten by his master. Later, he recalled that the metal, when it hit the floor and cooled, had formed drops or beads that had rolled away. The memory stimulated the apprentice to try the experiment with gold until he had perfected the method, making gold beads as lovely as the Etruscans'.

ROME

As far as the Romans were concerned, once they had control of Italy, they set out to conquer the world and corner the gold market. From the Egyptians of about 2000 B.C. to the Romans, no one had mined gold, but the Romans became even more proficient than the Egyptians, and Iberia was the gold mine of Europe. To pan for alluvial gold, the Romans built aqueducts, which also came in handy for their mining operations. Another source of gold was military conquest, with generals bringing back gold in all forms, displaying it in their triumphal processions, and sometimes causing wild fluctuations in the market. After the fall of Jerusalem, so much gold was taken that the price of gold in the East fell by 27 percent, according to a historian of the time. Gold was the Roman status symbol, with the wealthy wearing it lavishly, sometimes on all ten fingers. What was important was the amount of gold, the number of stones, and the weight rather than the artistry.

THE BYZANTINE EMPIRE AND THE MIDDLE AGES

With the fall of the Roman Empire and the coming of the Dark Ages, the knowledge of mining gold was lost again. What gold was already available was often melted and recast, not that the limitations imposed by the lack of more gold caused hardship, at least during the Byzantine Empire. The Byzantine emperors were lavish in their use of gold, especially for religious purposes. Gold, at one time the symbol of sun gods, became the symbol of the Holy Ghost and of Mary. At the same time, early Christians treasured the kingdom of heaven more highly than earthly possessions, and relics of the bone

and hair of saints became more valuable than golden and jeweled amulets.

By the time of the Middle Ages, there was little gold in Europe, mainly because there was little commerce or trade during the times of Holy Roman Emperors like Charlemagne and Otto I. The shortage led the alchemists to try to make gold from base metals. That situation changed as the Crusades offered an opportunity not only to serve God by the retaking of Jerusalem from the heathens but also to take their wealth.

Interestingly enough, the Prophet Mohammed, who founded the Moslem religion in the seventh century, had said men could own gold but wearing it was ostentatious and effeminate. That did not stop many a Moslem prince from owning and wearing a variety of precious gems, especially diamonds.

As the Crusades lost their hold on men's imagination, another vision arose: the discovery of America. Queen Isabella of Spain even sold or pawned her jewels, a common practice among royalty of the time to finance both domestic projects and war, to pay for Columbus's first voyage.

THE NEW WORLD

The treasure hunters were not far behind, as the Spanish conquistadores seized greedily on this new source of gold. Cortez landed at Vera Cruz in Mexico in 1519, conquering the country by 1521 with four hundred men. The lion's share of the booty was sent to Charles V of Spain. In an ironic twist of fate, French ships captured the Spanish treasure ships and sent the booty on to Francis I, who used it to finance his explorations in North America.

No matter how much gold the Spaniards found in Mexico, they wanted more and constantly sought for an El Dorado or legendary city of gold. As a result, twelve years after the taking of Mexico, Pizarro marched on Peru and the Inca Empire with 160 men, confiscated all the gold he could find, and used extortion to get even more. Taken prisoner by Pizarro, Atahualpa, the last emperor of the Incas, to buy his freedom, offered to have his cell filled with gold ornaments and jewelry above the height a man could reach. Although contemporary accounts of the size of the cell disagreed whether it was about 375 square feet or 595 square feet, all accounts agreed that the cell was filled to the stipulated height. Despite the

Inca's being declared free, Pizarro held him in protective custody and later had him killed.

Given even the smaller dimensions of the cell, the amount of gold must have been enormous. One estimate places it at 6 tons, so much that historians have doubted it and have researched the records of the Spanish crown, to whom one-fifth of all such treasures went. According to those records, since the crown received its full share of the gold, the amount must have been 6 tons. Yet, not a single one of those Inca ornaments survives today, because the gold was melted down to make it easier to ship to Spain. What ornaments have survived to this day are mostly from Colombia, where the search for El Dorado centered.

Even then, the Spaniards didn't get all the Incas' gold at first. More jewelry and ornaments were on the way when the Incas heard of their emperor's death and buried or hid it. Much of that gold was later found by the Spaniards, who were not above using torture to sate their appetites for gold. Was all of it found? No one knows, but legends and stories of the lost Inca treasure persist today.

The Spanish treasure ships had to weather storms and pirates to get back to Spain. Both hurricanes and pirates took their toll. English privateers, operating with the tacit approval of Queen Elizabeth I, were pirates with a polite name, and Sir Francis Drake's voyage around the world started out as a treasure hunt for Spanish gold. That treasure hunt still is not over, as hunters today use modern technology to locate the wrecks of treasure ships and stake their claim to the gold and precious gems.

While Spain was busy in Mexico and South America, the English, French, and Dutch turned to North America, where gold proved to be in short supply. Disappointed at first, they soon realized the value of the fur trade, which was a gold mine in itself for more than 350 years after the discovery of America.

THE U.S. GOLD RUSHES

In 1849, gold was neither a royal prerogative nor a privilege of nobility. The early treasure hunters had all been members of the nobility. In Russia, Czar Alexander I expanded the gold mining in the Urals in the 1820s. That search was later pressed into Siberia, but it was the wealthy—the nobility—who profited. The year 1849 saw all that change.

Gold had been found in the United States in 1799, when a twelve-year-old boy found a large, yellow-colored rock in a creek near Concord, North Carolina. He took it home, and his father used it as a doorstop for three years until curiosity made him take it to a jeweler. The farmer offered to sell it for $3.50, and the jeweler—who had recognized the gold—seized the opportunity of buying the 17-pound rock whose value was closer to $3,600. Later, gold was found in Georgia in 1827. Both strikes were substantial enough for the government to establish branches of the mint in North Carolina and in Georgia.

Then, on January 24, 1848, James Marshall, the foreman at the sawmill in the Sacramento Valley owned by John Augustus Sutter, found gold. Sutter tried to keep the news quiet, but it leaked out. Within a year, the gold rush was on. San Francisco was filled with entrepreneurs of all kinds. The price of a shovel rose from $1.00 to $10.00. The population of California was swelled by almost 500,000 people, who came from Europe, Australia, and other countries as well as the United States. At one time, there were 40,000 miners on Sutter's property alone.

In the first year, an estimated 575,000 ounces of gold worth $10 million were taken from the rivers of central California. Nine years later, by the time of the Nevada strike, that amount had reached 2.5 million ounces, or 820 tons.

The 1859 Nevada strike was made by two Irishmen near what became Virginia City. They sold their claim to Harry Comstock, who sank a mine. The Big Bonanza mine of the Comstock lode was the primary source of gold in the United States for the twenty years it held out, providing $130 million worth of gold and a massive $170 million of silver.

AUSTRALIA

In the meantime, one of the seven thousand Australians who had joined the forty-niners had gone home disappointed after having had his claim jumped. Edward Hargraeves did not give up his search for gold, and he did not remain disappointed for long. In 1851, he struck gold in New South Wales, and Melbourne and Sydney boomed, as had San Francisco, with a rush of prospectors from all over the world.

No other country has ever felt the impact of the discovery of

gold as much as Australia did. It was first settled in 1788 as a penal colony and remained one for sixty years. Gold changed that, tripling the population from 400,000 in 1851 to 1,200,000 in 1861, as more gold was discovered in Western Australia and Queensland. That 200-pound nugget was a "Welcome Stranger" in more ways than its size.

THE LAST GOLD STRIKES

The discovery of the world's gold was not over, however. The last half of the nineteenth century saw strike after strike. In 1876, another gold rush began in South Dakota, resulting in the discovery of the Homestake Mine that now extends some 200 miles and still yields about 300,000 ounces of gold a year.

During the same period, gold was found in South Africa. The original settlers were basically farmers who drove away the prospectors after the first find in 1850. More gold was found in 1870, resulting in the first gold rush in South Africa, with the second rush starting in 1886. What marked the South African rushes as being different from those in the United States and Australia was that from the initial discovery the exploitation was systematic, with English engineers constructing the mines and smelters. The gold, nevertheless, was the bone of contention between the Boer farmers of Dutch descent and the English, leading to the Boer War.

The last gold strike of the nineteenth century was in the Alaskan and Canadian Yukon in 1896. It was made by George Washington Cormack, the son of a forty-niner. Cormack had shipped as a dishwasher aboard a U.S. Navy ship to Alaska, where he jumped ship. He went to the Yukon, married the daughter of an Indian chief, and made a living by fishing for salmon on the Klondike River. Although occasional prospectors came to the neighborhood, no one had found gold. While fishing one day, however, Cormack met a prospector who told him there was gold. The forty-niner's son went his way, but he could not resist dipping a can in the water to scoop up the gravel. What he found was a gold nugget the size of his thumb, and the next day he filed a claim with two Indians. The gold rush was on. The Klondike was the richest source of alluvial gold of all time, and 60,000 men fought the freezing wind, the ice, and the snow in the hopes of striking it rich.

FOOTNOTES TO HISTORY

A footnote to the history of the gold rushes is what happened to some of the men who found the gold that changed the fate and face of nations. Sutter died in 1880 in a Washington, D.C. hotel room. Although the gold had been found on his land, he profited little and at the time of his death was struggling to survive on a government grant of less than $5.00 a week. Marshall, who discovered the gold, died within five years of Sutter and was buried in a pauper's grave. Hargraeves, in recognition of what he had done for Australia, received a grant of 10,000 pounds and a pension for life from the Australian government. Cormack took a fortune in gold from his claim and died a rich man.

As to the countries that the discoveries enriched, their status as gold producers has changed, too. The United States was once the world's primary producer. Today, South Africa is first, producing yearly more than 50 percent of the world's gold. The U.S.S.R. is second, although production can only be estimated because the figures are secret. Canada is third, producing about 3.75 percent, and the United States is fourth, producing a little more than 2.25 percent. Australia is now seventh, with Papua-New Guinea and Rhodesia producing more gold than it does.

Another footnote concerns why gold was found so late in North America, Australia, and South Africa. The reason usually given is that the native inhabitants had little interest in gold, unlike the Sumerians and the Egyptians, the Aztecs and the Incas. That explanation seems as good as any, since the gold was in the rivers and streams if anyone wanted to find it.

"SOLID GOLD"

The gold rush today is in buying gold, but to do that one has to know more about what gold is. It can have many meanings, depending on how the word is used and what terms are used to modify it.

The advantages of gold are what makes it a precious or noble metal. The disadvantage is that pure or solid gold is soft: the softness that makes it so malleable and ductile means that gold by itself is so soft that it is rarely used in jewelry. Pure gold isn't practical because the jewelry can easily lose its shape and become scratched. To make gold harder and more durable, not to mention more practical, an-

other metal is added to the gold to make an alloy. The other metal may be one of a variety of metals, or it may be a combination of metals. The proportion of gold used in proportion to the other metal or metals is what determines the fineness of the gold, and this fineness is measured in *karats.*

Karat measurement is historical, going back to the bazaars of the Middle East long before there were any standard weights and measures. At that time, various seeds were used as balances on scales in buying and selling gems and gold. The seeds of the carob tree, *qirat* in Arabic, were among the most popular because when the seeds were dried they had a constant weight. Most experts agree that *qirat* became *carat,* the unit of weight for gems. They disagree whether it also became *keration,* a Greek word that became *karat,* the unit of measurement for gold. At any rate, during the time of the Roman Emperor Constantine in the fourth century A.D., pure gold was composed of 24 *kerations.*

Today, pure gold is still 24 karats, although karats in general indicate proportion and not weight. The reason is that the weight of gold will depend on the metal with which it is alloyed, since some metals are heavier than others. For example, an alloy of gold and platinum will be heavier than an alloy of gold and copper because platinum is a heavier metal than copper.

The amount of gold in an alloy, then, determines what is called the *fineness* of the gold item of jewelry. Twenty-four-karat gold is gold that is 24 parts gold, or 100 percent gold, with each karat representing 1/24 part gold. Twenty-two-karat gold is 22 parts gold and 2 parts other metal; 18-karat gold, 18 parts gold and 6 parts other metal; 14-karat gold, 14 parts gold and 10 parts other metal; and 10-karat gold, 10 parts gold and 14 parts other metal. In marking gold, karat may be spelled out, or it may be abbreviated as K., Kt., or k.

When the above terminology is used, the gold may be called "karat gold," "fine gold," "real gold," or "solid gold," at least in the United States. What may be called by those terms can vary in other countries (see below). Before going into the differences in different countries, however, you need to know a little more about alloys. As was mentioned, there are more reasons for alloys than to "harden" the gold.

One reason, of course, is wearability. Remember, the finer the gold, the softer it is and the more easily it will lose its shape and even

wear thin. Thus, 24-karat gold is rarely used in jewelry, while 22-karat gold may be used but is too malleable for every-day, all-round wear. Eighteen-karat gold is far more wearable, while 14-karat gold is even more practical, especially for jewelry in which a smooth, hard surface is desirable—such as in rings. The harder surface would resist scratching and the shape would remain the same even with constant wear.

Another reason for alloys is color. Gold's natural color is yellow. In fact, it was the bright, sparkling-sun color of gold nuggets gleaming among common pebbles that originally caught primitive man's eye. So, how can there be pink, red, green, or white gold? The cause is the base metal used in the alloy, with the color depending on which metal or metals are used.

If copper *and* silver are used, the gold will retain its natural color. At the same time, the greater the number of karats, the more yellow the gold will be. For example, 22-karat gold will be yellower than 18-karat gold, and 18-karat gold will be yellower than 14-karat gold. If only silver is used (and sometimes small amounts of copper and zinc), the result is green gold. If only copper is used, the color will be pink or red. If copper, zinc, and nickel are used, the gold will be white. The use of other metals will create other colors. In all cases, the type of metal doesn't change the karat content—what counts is the proportion of gold used.

Although we take such colors for granted, someone had to invent them—and the invention wasn't always easy or successful. In the seventeenth and eighteenth centuries, for instance, alchemists, goldsmiths, and even apothecaries were trying to find a way to turn gold white. A German apothecary's assistant named Boettger was rumored to have succeeded at the beginning of the eighteenth century. At that time, many royal courts had their own goldsmiths, men who might become wealthy but who were also virtual prisoners, so valued was their artistry. When Frederick I of Prussia became interested in Boettger's work, the goldsmith fled. He was found by Augustus the Strong, ruler of Saxony and king of Poland, who decided to keep Boettger at his court, despite the reward offered by Frederick —and the threat of war to get him back.

Augustus was successful in keeping the poor apothecary's assistant locked up for fifteen years, but Boettger never gave away the secret, if he ever had it. Finally, though, he did reveal the secret he did have, that of making porcelain, what has been called "white

gold," and became the director of the famous Meissen porcelain factory in Dresden.

The color of the gold aside, the number of karats is probably the most important factor in buying gold jewelry. In this respect, you want to be careful where—in what country—you buy it, because markings, standards, and laws can vary from country to country. What is "solid gold" in the United States may not be solid gold in another country. By the same token, what is solid gold in another country may not be solid gold in the United States.

GOLD IN THE UNITED STATES

The Bureau of Standards of the Department of Commerce and the Federal Trade Commission are responsible for regulations and standards for precious metals. The regulations include what terminology can be used and how metals must be marked.

The term *solid gold* means the item must be solid as well as gold. It cannot be hollow. If the item is hollow, for example, it must be marked "14 karat gold—Hollow Center" or "14 karat gold tubing" or whatever description is appropriate. Such an item is fine gold, but it is not solid gold. The point is that solid gold has to be solid, and gold cannot be sold or advertised in such a way that consumers or prospective consumers could be deceived.

Abbreviations used in place of karat must also be clear. Both K. and Kt. may be used. In addition, the trademark or name of the manufacturer must be stamped or engraved on gold jewelry.

The standards for content are equally specific. The word "gold" alone can be used only for 24-karat gold. Other gold must show the number of karats, and fine gold can be called "fine gold" only if it is 10-karat gold and above. Items containing 9 karats and below of gold are considered to have too little gold to be of a quality to be fine gold.

The basic karatages are 10-, 14-, 18-, and 22-karat gold, aside from 24-karat gold, which is not used in jewelry. Twenty-two-karat gold is used only rarely for the most expensive jewelry. At one time, 12-karat and 15-karat gold were also used for jewelry, and you may find old pieces of this content, but today 12-karat is seldom used and 15-karat is never used. Twelve-karat gold may be seen more often, however, as the price of gold goes up. The most common and popular gold is 14-karat gold. In all cases, any item

described as gold and using gold in the description must be marked gold, preceded by the correct karat designation, with both the word "gold" and number of karats equally conspicuous, that is, of equal size. For example, "14 karat gold" is permissible, while "14 karat GOLD" is not because the word *gold* is more prominent than the number of karats.

Other descriptions of the gold, such as the percentage of gold to base metal, may be used but are supplementary. Percentages, expressed as decimals, in fact, are often used in other countries instead of karats to identify gold content. That is why you may see a marking other than the familiar karats on jewelry made in other countries, such as Italy and France, and sold in the United States.

GOLD IN OTHER COUNTRIES

Percentages of gold are related to karats in that 24-karat gold is 24 parts, or 100 percent gold. At the same time, you will never see 100 used, because 24-karat gold is considered to be only 99.99 or 99.96 percent pure. The extra refining to make gold 100 percent pure would make gold so expensive the price would be even more prohibitive than it already is.

The refining process is costly and time consuming. The ore is embedded in rock, and this rock must be crushed, treated, smelted, and otherwise treated in extensive processing to extract the gold and to separate it from such other minerals as silver, copper, and zinc with which it is often found. Even with the most modern refining technology, therefore, the purest gold is considered to be 99.99 percent gold. Gold traded in gold bars on the international money market may even be 99.6 percent pure.

When you consider that an average of 3 tons, or 6,000 pounds, of rock and ore may yield only 1 ounce of pure gold, you can understand why 99.9 percent or even 99.6 percent is more than acceptable as pure gold. There is the cost to consider, too.

Twenty-four-karat gold, nevertheless, is 24 parts gold, with the 24 parts being the "100" percent standard on which the other markings are based. These markings, which are commonly used in Europe and elsewhere in the world, are:

Karat Marking	Gold in Percent	Decimal Marking
24 K.	100.0%	.999
22 K.	91.6%	.916
18 K.	75.0%	.750
14 K.	58.5%	.585
10 K.	41.6%	.416

If the markings are different in different countries, so are the minimum standards. In Great Britain and the Commonwealth, 9-karat gold can be sold as fine gold. Karat, however, is spelled with a c, and the marking would be "9 C." or "9 ct." The standard may be even lower, with a few countries accepting 8-karat gold as fine gold.

On the other hand, other countries set minimum standards much higher. In France and Italy, only 18-karat or .750 gold and above can be sold as fine gold. Still other countries have no legal minimum standards at all.

In short, in buying gold on your travels, you want to be careful about what is called gold and be sure to see—and understand—the markings. What is called gold in Great Britain, for example, may not be gold in the United States. What is gold in the United States may not be gold in France or Italy.

You want to be wary for another reason. Not all countries, regardless of a minimum standard, are fussy about enforcing or insuring that the marking means what it says. Sellers may even mark the gold with any markings they choose, knowing that tourists will often snap up a "bargain." What you buy may not even be karat or real gold at all, but gold-plated. The only way you can tell is to test the gold with acid. Ten-karat gold and below will react to nitric acid, while gold above 10 karats reacts with *aqua regia,* a mixture of nitric and hydrochloric acids. No one, however, wants to carry corrosive acids around, and few jewelers would be amenable to your using them. Your best protection in buying jewelry anywhere, regardless of country, is to buy from reputable jewelers and avoid street sellers and hole-in-the-wall shops with bargain prices.

SILVER

If gold was the metal of royalty in historical times, silver did not go unnoticed and unappreciated. Granted, silver tarnishes and will corrode, but it is still a precious metal.

The ancients knew and valued silver as long ago as four thou-

sand years before Christ. For a time, according to historians, it was even more precious than gold. The Greeks used silver for jewelry and to make battle shields, while the Romans were among the first to use it for money. The Scottish highlanders were particularly fond of silver. During the times of the clan wars and the wars with England, no Scot went into battle without a silver ornament. The ornament was usually a brooch or pin, often set with stones or gems, and was used to fasten the plaid or shawl that was a part of their native dress. It was also a good luck charm, but if the Scot had the bad luck to be killed, the silver ornament was insurance that the warrior would have a decent burial, with the person burying the body expected to do so in exchange for the ornament.

Pure silver, like pure gold, is 99.99 percent or .999 silver. Like gold, too, it is too soft in itself to be worked unless it is alloyed with another metal, usually copper. Unlike gold, it does not require as much of a base metal to be worked. Again, unlike gold, silver standards are worldwide. In addition, in the United States, Great Britain and the Commonwealth, and other countries, both the quality of the silver and the hallmark (or trademark or name) of the manufacturer must appear on the item.

Fine silver is *sterling* silver. Sterling silver is 92.5 percent silver and 7.5 percent copper. Silver alloys, therefore, have a lower percentage of base metals and a higher percentage of silver than karat gold, making it more apt to be scratched or gouged than gold. It may be marked "sterling," "92.5 fine," or ".925."

The term "sterling" goes back to the fourteenth century and England's King John, who imported Germans to refine silver to a certain standard for use as coins. The Germans came from the east and were called "Easterlings." As a result, the money came to be called "easterling," which was later shortened to "esterling" and finally to "sterling." In fact, in 1300, King John ordered that all silver had to be of "esterling allay," thus establishing England's sterling standard for money.

The other kind of silver you may find in jewelry is coin silver. *Coin silver* is 90 percent silver and 10 percent other metal. It may be marked "coin," "coin silver," or "900."

Although these standards are universal, in some countries you may also find .800 silver. This is 800 parts pure silver and 200 parts other metal, or 80 percent silver.

The term "coin silver" comes from the fact that coin silver was

literally the silver used for coins. After King John established the sterling standard, all silver technically had to meet the same standard, but if silver were popular for decorative purposes, that meant there was less available for coins. During the Middle Ages, silver for ornamentation fell out of favor except in monasteries. The Renaissance brought a rebirth of the love for it, starting in Italy and France and spreading to England. The appetite was fed later on by the enormous discoveries in the New World, and the Old World could not get enough of the shining metal.

Even so, there was not enough to go around. During the seventeenth-century reign of Charles II in England, for example, silver was so popular that silversmiths resorted to melting down coins to meet the demand. As a result, the mint ran short of coinage despite all the pleas and efforts to get silver turned in to the mint instead of to the smiths. To prevent the use of coin silver, the amount of silver required for articles such as jewelry, candlesticks, silverware, and other decorative items was raised, while the amount in coins remained the same. Since all items had to be assayed for silver content before being sold, cheating could be detected—and the penalties for using the lesser quality were severe.

Coin silver regained popularity during the Victorian period, especially for elaborately initialed link bracelets. In the United States, Indian jewelry made much use of coins until 1890, when laws were passed making their use in jewelry illegal.

The disadvantage of silver jewelry, aside from being subject to scratching and gouging, is that it tarnishes unless it is worn regularly. As a result, some manufacturers in the United States coat or plate the silver with rhodium, an element of platinum. Rhodium plating does not affect the quality or standard, and it insures a bright, silvery finish that does not tarnish.

OTHER KINDS OF GOLD AND SILVER

Alloys are nothing new. Their quality marking or labeling could even be called a landmark in consumer protection, since the hallmark of the guild was assurance that customers received what they paid for. At that time, however, the concern was to keep the precious metals from being diluted too much, since an alloy involves combining metals in their molten form.

Combining two or three sheets or layers of metal, with a

layer of base metal under or between precious metals like a sandwich, is another matter. This sandwich analogy is the basis of what is called either *rolled* or *filled* gold and silver—and that process was discovered only a little more than two centuries ago by accident.

Thomas Bolsover was a silversmith in Sheffield township in England. While he was mending a crack in a silver knife, he placed a copper coin next to the blade to make the vise tighter. Then he applied heat to the knife to mend the crack, but as he did so the town crier passed by. Distracted by the latest news, he did not notice what he was doing until he looked back at the knife. The copper coin was bonded or fused to the blade. When he experimented with the ruined knife, he found that the silver and copper could be rolled and worked together much as silver alone could be. This discovery led to the making of the Sheffield silverplate that made his town famous the world over and also made silver available to a market that could never before afford it.

In 1817, the method was extended to gold, with karat gold being used with a base of other supporting metal for producing fine jewelry at more economical prices than for karat gold alone. Rolled or filled gold was popular in the nineteenth century, even among those who could afford fine gold, and jewelry of that era commands a good price today.

Electroplating is a different process altogether. In electroplating, an item of base metal is placed in a bath that contains precious metal and other additives. An electric current is passed through the solution, and the precious metal is deposited in a film on the base metal to the desired thickness. As with rolled or filled gold and silver, the method—which was discovered in 1840—was first used for silver and for silver flatware in particular.

In the United States, standards for these processes protect the consumer. Any item that is made of rolled or filled or electroplated gold or silver must have the process identified, as well as the precious metal content. Other countries are not always as fussy. An 18-karat gold-filled item can sometimes be marked simply 18-karat gold. Since filled gold can be difficult to recognize, even impossible without the use of acids, the best protection is to be careful and to buy only from reputable jewelers and stores.

The definitions and explanations of rolled and filled and electroplated gold and silver given below pertain only to the United States.

Again, they are set and monitored by the Bureau of Standards of the Department of Commerce and the Federal Trade Commission.

Silver-filled jewelry is jewelry in which a layer of silver is bonded to one or more layers of supporting base metal. The silver layer (or layers) must be at least 1/20 of the total metal weight. The item must be marked "silver filled." If it is sterling, the world "sterling" or ".925" must precede the words "silver filled" and neither phrase can be more prominent in size than the other.

Silver overlay is another term for silver-filled and means the same thing. The same regulations for weight and marking also hold true.

The standards for electroplating silver—*Silver Plate* or *Silver Electroplate*—vary, depending on the article. Federal Trade Commission regulations state, however, that the plating or coating must be of "substantial thickness." In any case, the words "sterling" and "coin" *cannot* be used on the jewelry, and it must be marked to indicate that it is plated or coated.

Gold-filled jewelry is probably much more common than silver-filled because of the difference in prices of the two metals. Gold-filled is synonymous with "rolled gold" and "gold overlay." The same restrictions and regulations hold true in the United States, whichever term is used.

The layer of karat gold must compose at least 1/20 of the total weight of the jewelry, and the quality of the gold must be indicated. The gold, in addition, must be at least 10-karat gold. Sample markings are "14 K. Gold Filled" or "14 K.G.F."; "14 K. Rolled Gold" or "14 K.R.G."; and "14 K. Gold Overlay." No part of the marking can be more prominent than any other part, which means figures and letters must be of equal size.

Gold Plate and *Gold Plated* do not mean the same when used in connection with gold as they do with silver. Both are a form of rolled gold, and *rolled gold plate*—which you may also see—is the more explicit term. If these words or their abbreviations (G.P. or R.G.P.) are used with the karat marking alone, the jewelry must have at least 1/20 of its total weight in that karatage of gold.

Not all gold-filled jewelry contains 1/20 karat gold. If less gold is used, however, the consumer is protected. In these cases, the karats must be shown *and* the weight of the gold in proportion to the total weight of the jewelry.

Confused? The terminology is confusing, and the following examples are offered to help clarify the situation. If you see "14 K. Gold Plate," 1/20 of the total weight of the jewelry is 14-karat gold. If you see "1/30 14 K. Gold Plate," the 14-karat gold is only 1/30 of the total weight of the jewelry. Remember, any of the abbreviations given above may also be used. The point to keep in mind is that the smaller the amount of gold, the thinner the layer of gold bonded to the base metal is and the sooner the gold will wear off and the base metal show through. In addition, the smaller the amount of gold, regardless of the number of karats, the cheaper the price will be. At the same time, what you are getting on top is genuine gold that looks like gold and will wear like gold, depending on the thickness.

Another point to keep in mind is how and how often you will be wearing the jewelry. Rolled gold or gold plate may be perfectly adequate for a fad or high-fashion piece of jewelry, such as a stickpin, that may be the height of fashion this year and passé next year. On the other hand, if you are buying jewelry for all-around wear, such as a ring or a necklace, you want as thick a layer of gold as possible and possibly solid gold. Thus, you want to balance wearability with price in deciding how to spend your jewelry dollar.

Gold may also be *electroplated,* in which case no karat marking can be used. The metal is basically a base metal with none of the distinctive characteristics of karat gold. If the jewelry is marked "Gold Electroplate," it means that the gold used is of at least 10-karat fineness and that the coating is the equivalent of 7 millionths of an inch thick. If the coating is thicker and equivalent to 100 millionths of an inch of at least 10-karat gold, the item can be marked "Heavy Gold Electroplate."

Any item that has less than the minimum standard of 7 millionths of an inch of at least 10-karat gold can be called only "Gold Flashed" or "Gold Washed." Terms that are considered misleading would be "genuine gold finish" or "gold-filled look." Before buying this kind of jewelry, one jeweler suggests that you rub the jewelry with your thumb. If the coating is too thin to wear, it will easily rub off—which is a good indication of just how much wear you will get out of the jewelry.

COST AND VALUE

You do not have to be an expert to know that karat gold is more expensive than the finest silver. On the other hand, the following

general price comparison by the Precious Metals Institute may be helpful as a guide of respective costs of types of gold and silver. The comparison is based on the premise that you are buying like products, such as rings or necklaces or earrings. Thus, a ring without gems would be most expensive in karat gold and least expensive in silver electroplate.

Karat Gold
Sterling Silver
Gold-Filled (about the same price as sterling)
Rolled Gold Plate (less than 1/20 by weight)
Silver-Filled (Sheffield)
Heavy Gold Electroplate
Gold Electroplate
Silver Electroplate (plate)

PLATINUM

Platinum is considered the noblest of metals, since it is the hardest metal and the most resistant to corrosion and it never oxidizes, much less tarnishes. It is the rarest of the precious metals, too, with 10 tons, 20,000 pounds, of ore rock required to yield 1 ounce of pure platinum.

Platinum is so hard, in fact, that it has been worked only in relatively recent times. Earlier gold- and silversmiths did not have the tools necessary to create the masterpieces in platinum that they could make in gold and silver. As a result, it was undervalued and not even recognized for the precious metal it is, although a few pre-Spanish Indian artifacts have been found in Colombia.

The Spanish conquistadores thought so little of the white grains of metal they found with gold deposits in Colombia that they threw the metal, which they called *platina* from the silver *(plata)* color, into the sea as they loaded their treasure galleons. It didn't take long, however, for platinum to arouse the interest of gold- and silversmiths and jewelry buyers in Europe and become appreciated for its beauty and quality. The history of platinum, then, extends back only about three hundred years and not the thousands of years of gold and silver.

Platinum is actually composed of six elements: platinum (Plat.), iridium (Irid.), palladium (Pall.), osmium (Osm.), rhodium (Rhod.), and ruthenium (Ruth.). These may be used in any combination in

jewelry, and the platinum jewelry in the United States must have quality markings to indicate which are used and the quantity.

The marking "Platinum" or "Plat." means that the item consists of 985 parts per 1,000 of platinum and its elements, with at least 935 parts being pure platinum and no more than 50 parts being the other elements. If the item is soldered, the total amount of platinum has to be in the proportion of 900 parts of platinum and 50 parts of the other elements of platinum.

If less than those amounts of platinum are used, you must be informed of that fact. Jewelry that contains between 500 and 935 parts per 1,000 of pure platinum (500 to 900 when solder is used), with the remainder being one or more of the other platinum elements, can be marked platinum only under certain circumstances. The following markings are indicative of what you should look for: if the amount of platinum is at least 750 parts per 1,000 and at least 50 parts of one of the other elements, such as rhodium, the marking would read "Rhod., Plat."; if the amount of platinum is between 500 and 750 parts pure platinum, the exact amounts of the other metals must be included, with the marking reading "600 Plat., 350 Pall." or "500 Plat., 200 Pall., 150 Ruth., 100 Rhod."

When less than 500 parts of pure platinum is used, the article cannot be marked platinum under any circumstances. It must be marked with the element that predominates, and that element must be spelled out and not abbreviated.

Platinum is almost always used in the finest jewelry. A wedding band may be platinum alone, but you will rarely find platinum used with any gems except diamonds, emeralds, rubies, and sapphires—the costliest gems.

OTHER METALS

Metals other than precious or noble metals are often used in less expensive jewelry. Copper, aluminum, and pewter (a combination of tin and other metals) are a few examples. With the exception of aluminum, most of these will tarnish or oxidize, especially when there is sulfur in the air. At the same time, you will find lovely, often inexpensive, jewelry made of these metals, especially in handicraft shops and shows.

No quality marking is required for these metals. Thus, you want to be careful in buying them unless the price is so reasonable and the

style so appealing to you that you feel the item is worth the money. You can recognize aluminum because of its extremely light weight. Pewter has a dull finish. Copper has a coppery finish, of course, but it can be electroplated, which means that you cannot tell whether it is pure copper. Copper jewelry may be lacquered much like silver to prevent tarnishing.

2.
KNOWING JEWELRY
AND JEWELRY
TERMINOLOGY

The first jewelry was probably made of shells, bright seeds, or soft stones that could be easily pierced and strung together. The harder gems and stones, pretty as they were, were more likely only toys or playthings until skills advanced and they could be used in jewelry.

Superstition was an influence in the evolution of jewelry, too. Ancient peoples had a strong belief in sympathetic magic as a means of understanding nature. Some experts think that the wearing of pieces of jewelry as talismans was more important than the idea of personal adornment. A hunter's necklace or bracelet of tiger's teeth or an adornment of feathers may have signified primarily his hopes for more game. They may also have been status symbols, with the more tiger's teeth or feathers indicating the greater the hunter the wearer was.

Jewelry certainly did confer status in later, although still ancient, times. Regardless of the civilization, jewelry was the prerogative of men more than of women. Although women wore jewelry, especially women of high rank, gems in particular were the province of men. Jewelry was a symbol of a man's wealth and position, a wealth and position that women—except for queens like Cleopatra—derived from fathers or husbands.

The type of jewelry was significant, too. From early times the circle has had a mystical and religious meaning that undoubtedly

carried over to rings. Rings were often practical, as well as decorative, with the stones or metal carved to make a seal that could be impressed in wax. Seals were an important means of authenticating a document, insuring it came from the person who was supposed to have sent it and was not a forgery. Today's signet, crest, school and class, and fraternal rings are descendants of the early seal rings.

Rings were exchanged to indicate trust—the circle of friendship. When Mary Stuart, Queen of Scots, sent a diamond ring to Elizabeth I of England as a token of friendship, the gift was reciprocated by a ring. Mary regarded her ring so highly that it was one of the few pieces of jewelry she took with her when she was forced to flee from Scotland for England. She returned the ring to Elizabeth as a token of their friendship along with a plea for help and asylum. That ring had no charm. After nineteen years of imprisonment, Mary was beheaded by Elizabeth.

Rings did not always have to be exchanged. In the Rome of the Caesars, a young woman was given an iron ring at the time the marriage contract was drawn up. This ring was changed for a gold one at the marriage ceremony, but it was worn only on that occasion and on later special occasions.

As far as the Christian world goes, the wedding ring for centuries served the dual purpose of being both engagement and wedding ring. Even today in Europe, it serves the same purposes, with the ring being worn on one hand during the engagement and switched to the other hand at the ceremony. Originally, the wedding ring was always worn on the third finger of the left hand because a vital vein or artery was supposed to run from that finger directly to the heart. After the Reformation, the custom changed a little, with some Protestants wearing the wedding ring on the left hand while engaged and on the right hand after marriage.

Royalty were the first to give what we would call engagement rings. The fifteenth century seems to be the first time that diamonds entered the picture. In 1477, the Archduke Maximilian gave a diamond to Mary of Burgundy as a token of their engagement.

Other superstitions have been associated with rings over the years. One was that a woman in childbirth must never remove her wedding ring because the ring prevented evil spirits from entering her body.

Among all the kinds of jewelry, however, necklaces have had the most magical properties. In some cases, they were designed as amulets or charms to insure good health and good luck or wealth to

the wearer. Such necklaces could be very simple, with a gem or carving carrying the burden of the charm. They could also be very elaborate, glittering with gold and gems. These necklaces were designed with the purpose of distracting the eyes of the viewer from the wearer's face and eyes—and thus protecting the wearer from the dangers of the mysterious Evil Eye.

Earrings have a mysticism, too. The next time you put on a pair of earrings, keep in mind the fact that earrings with clips and screwbacks that can be worn without piercing the ears are a twentieth-century invention.

From earliest times, ears had to be pierced to wear earrings. Why? Certainly, jewelers as expert as those from long before the ancient Egyptians through the famous goldsmiths like Benvenuto Cellini in the Renaissance and Fabergé in the nineteenth century could have designed earrings that could be worn without having to pierce the ears, had they wanted. Pierced ears were the custom, however—and one historian attributes the piercing to the desire to punish the ears for overhearing what they should not hear. The earrings, in turn, were all-too-human a consolation for the pain and suffering, not to mention the infections caused in those days before sterilization and antibiotics. The more decorative and expensive the earrings were, in other words, the greater was the consolation.

As jewelry became more and more elaborate, more demands were put on the maker's skill. The skill became a craft and an art. Because metals were involved, including the melting and forging of metals, the first artisans were smiths. And because the metal most highly prized in the craft was gold, the first jewelers were goldsmiths.

THE GOLDSMITHS

Again, legend is the source as to the price placed on the goldsmith's art. Hephaestus was the goldsmith to the gods of Olympus in Greek mythology. He was the son of Hera and Zeus, queen and king of the gods. According to Homer, he was born ugly and crippled in the legs, unlike the other gods, who were paragons of perfection. Hera, ashamed of him, threw him from Mount Olympus into the sea, where he was rescued by two nymphs. He lived with them for nine years, beguiling them with the beautiful jewelry he made and plotting revenge on Hera. The revenge was a golden throne, which he sent to Hera.

The entranced Hera sat on the throne and was immediately

bound by invisible bonds. When none of the other gods could free her, Dionysus, god of wine, finally managed to get Hephaestus drunk and bring him from his grotto in the sea to Mount Olympus, where he was convinced to free Hera. He then made golden jewelry for the gods and goddesses and such other objects as the golden arrows of the god of love and Apollo's golden chariot.

He later angered Zeus, who threw him from Olympus. Again, he was convinced to return because he was unsurpassed as a goldsmith. According to another story, it was this second fall from Olympus that broke his legs, Zeus's purpose being to make sure he would never again leave Mount Olympus.

The story of the goldsmith, crippled for whatever reason and unable to leave, is interesting. For one thing, kings in antiquity were not above crippling their goldsmiths to insure their working for them, and the mythology may have risen as justification for their cruelty.

The Middle Ages and Renaissance were kinder to goldsmiths, although kings were not above imprisoning or using prison as a threat to keep goldsmiths at their courts when money failed to do so. Goldsmiths, nevertheless, were highly esteemed, so much so that Czar Peter the Great (1672–1725) preferred to live with the court goldsmith when he visited Augustus the Strong, King of Saxony and Poland. The jewelry of the time, moreover, was actually sculpture, and goldsmithing was considered apprenticeship for painters and sculptors. Ghiberti, Botticelli, Verocchio, Donatello, and Mantegna in Italy and Durer the Elder in Germany began as goldsmiths, whose art was often rewarded with wealth and power.

The art of the time advanced from large brooches and belts or girdles, both often crudely set with an array of gems in gold or silver, to finely detailed work. Gold with rubies, emeralds, sapphires, diamonds, and baroque pearls, often combined with enamel, were worn—all at the same time. Bracelets, pins, pendants, and chains were popular, and the designs became more elaborate and rococo as time went on. But fashion inevitably changes. During the Victorian Age, dog collars, necklaces, tiaras, lavalieres, chatelaines, and a wealth of inexpensive jewelry were popular. In addition, gold-filled jewelry was being made and worn along with karat gold. Toward the end of the nineteenth century, there was also a revival of the Renaissance designs.

Today, gold is still the most popular metal, with almost everyone owning at least one piece of karat-gold jewelry. At the same time, plastic, wood, and imitation gems are worn and enjoyed. In addition,

most jewelry is now mass-produced in smaller or greater amounts, rather than being handcrafted a piece at a time—not that jewelry has become any less decorative or desirable or prized. The changes mean that all of us can now afford lovely jewelry. What was once the province of kings and the wealthy is available to anyone who can afford it.

The mass production and availability, nevertheless, have another ramification. So much jewelry makes the decision of what to buy a difficult one. To help you make that decision, you should know a little about how jewelry is made, what the finishes are, and the methods of working metal. You should also know a little about enamel, and you should be aware of the terms used to describe different kinds of jewelry.

HOW JEWELRY IS MADE

First, metals may be worked in several ways. The earliest method was probably simply to *hammer* the metal into the desired shape and thickness. Handmade jewelry today may still be hammered, shaped by hand, and perhaps polished.

Casting jewelry is more common. A mold is made of an original design, after which molten metal is poured into the mold and allowed to harden. Casting permits mass production of an original piece of jewelry.

Another method of casting, and one that is used today for about 60 percent of all karat-gold jewelry, is what is called *lost-wax casting.* The method was developed by the ancient Egyptians but was lost during the Dark Ages. Benvenuto Cellini, the Renaissance goldsmith, rediscovered the process, although after his death it was again lost for about four hundred years. Ironically, various primitive people (at least by Western standards) such as the Incas also probably used the process.

The method is basically this: a rubber mold is made of the model, with several wax copies being made from the mold. The copies are affixed to a rod-shaped base or "tree," which is then placed in plaster of paris. The solid mass of plaster of paris is allowed to harden and then is fired in an oven, during which time the wax melts and is "lost." What is left is the plaster mold containing the design of the item being duplicated. Molten metal is forced into the mold. After the metal has hardened, the mold is broken away, and

the copies are cut from the tree, ready to be finished and polished. The advantage of lost-wax casting is that there are no sharp edges, as there may be in regular casting, to be filed or polished away.

FINISHES

The finish on cast articles may be left shiny and glossy to achieve its own patina with wear. A *polished* finish brings out the warm glow of gold and the lustrous white sheen of platinum and silver. Other finishes give other effects. Florentine (see below) is the most popular finish, although not the only one. Most finishes are usually achieved by engraving, in which lines or designs are incised into the metal. The most common finishes are:

Florentine. Parallel lines are engraved in one direction and cross-hatched by other parallel lines at a 90-degree angle, with one series of lines being more lightly engraved than the other series. The result is a textured effect.

Diamond. This finish is similar to the Florentine, except that the parallel lines are farther apart and may be engraved with equal pressure.

Matte or Frosted. This is a soft, nonshiny finish. The article is sandblasted to achieve the effect. The finish may be left "as is." Gold articles may also be electroplated with pure gold to enhance the effect, in which case it may be called a "Roman gold finish."

METHODS OF WORKING METALS

Designs may be worked on a metal that are actually a design or "picture" rather than a finish. Several methods are used:

Engraving. The design or pattern is engraved in metal with a sharp implement that removes the metal. Etching is similar, except that an acid is used to remove the metal by eating it away in the desired pattern or design. The design or pattern is thus lower than the surface of the jewelry, in both engraving and etching.

Chasing. Chasing is done entirely by hand. The design may be raised above the surface of the item or indented below it. The metal is worked from the top, with the metal pushed aside to form the design, rather than being removed.

Embossing. Embossing is also called *repoussé.* The metal is worked from the back or inside to create a raised design.

Filigree. The metal is drawn into a fine wire that is twisted and soldered to form intricate patterns and designs.

Toledo. The metal is grooved, after which gold and silver are hammered into the grooves to form a design or pattern.

Damascene. Damascene is worked in the same way as Toledo. Traditionally, the metals used were iron and steel, but today you will find Damascene combining gold, silver, and even copper and bronze.

Niello. Niello is sometimes called Russian silver. It is silver with a blue-black inlay and is usually .625 silver. *Siam* silver is similar, except that the silver is blue-black and the pattern or figures are incised into the background. The Siam process is not as old as the · Russian silver form of niello.

Piqué. Piqué is usually used with tortoise shell and not metals. A design is cut in shallow channels into the shell, and the channels are filled with silver.

Vermeil. A design in karat gold is electroplated on sterling silver.

ENAMEL

Metal is the basis of enamel jewelry. Enamel has been used since ancient times with metals and especially with gold. Silver enameling is more difficult, although the early Greeks and Romans did make some silver enamelware.

Enamel is basically composed of a vitreous or glass-like compound, usually in combination with lead and sometimes other elements. It may be transparent or opaque, with various pigments being used to give it color. In jewelry, it is baked at high temperatures on or with metals, not only to set it but to fuse it to the metal.

Certain eras are particularly famous for enamel jewelry, particularly the Renaissance and the Art Nouveau periods. The Art Nouveau period, in fact, was a time when interest was high in all things having to do with the Renaissance. Fabergé, who had workshops in both Paris and Russia, was famous for his fine gold and enamel jewelry, artfully enlivened with gem flowers and birds. Today, such jewelry can have a worth far beyond its intrinsic value for collectors. The basic kinds of enamel are:

Champlevé. A design is etched or engraved in metal and filled in with enamel.

Cloisonné. This is a kind of mounted filigree and is the opposite of champlevé, in that the enamel is above the backing material. The wire is twisted to form a design, which is mounted on a metal backing. The wire "cells" forming the design are then filled with enamel.

Plique-à-Jour. A design is made of filigree, and enamel is used to fill the cells formed by the wire. Since the filigree is not backed by metal, the result is like stained glass rather than cloisonné.

Basse-Taille. A design is formed by embossing or repoussé, that is, the design is raised above the surface of the metal. The valleys formed are then filled with enamel, which is ground level with the repoussé after the enamel has been fired or baked.

Encrusté. Encrusté is made the same way as basse-taille, except that the enamel is left "rough" and not ground level with the design.

Limoges. This form of enamel may also be called *wet enamel.* A picture or portrait is painted on the wet enamel, which is then fired to set the picture. Before photography, Limoges was popular for lockets and commemorative jewelry.

2096695

SETTINGS AND MOUNTINGS

Stones may be set or mounted in metal in various styles. The two basic styles are open, or *à jour,* and closed.

In an *open setting,* the stone is set in prongs or claws. The prongs touch the stone in as few places as possible, and the entire stone is visible in all directions. A *belcher* setting is an open setting that is relatively flat, while a *Tiffany* setting is high, permitting the maximum amount of light to reflect and refract in the gem.

In a *closed setting,* there are no prongs. The stone is set in a cavity in the metal. The cavity is the same size and shape as the stone, and the rim is fashioned in such a way that it holds the stone tightly in the setting. The inside of the cavity may be totally enclosed or there may be a hole, permitting some light to pass through the stone. If the stone (or coin) is set flush with the setting, the mounting is called a *gypsy mounting.* Gypsy mountings are popular for men's rings.

Another type of mounting is called *pavé* or *en pavé.* Small

stones are set in prongs over a closed backing, giving a paved or studded effect.

TYPES OF JEWELRY

Other terms you may see or hear in buying jewelry and in looking at advertising are used generally to describe the jewelry. These terms are used with all kinds of jewelry, from jewelry of precious metals to costume jewelry and from jewelry of metal alone to jewelry of metal and gems or of beads.

The terms under "Settings and Mountings" pertain basically to rings, with the exception of pavé or en pavé, which may be used with some of the terms given below. These terms refer to other kinds of jewelry you may buy.

NECKLACES

The various types and lengths of necklaces are:

Adjustable Choker	A short necklace, about 14 inches long, that fits closely to the neck and has a "hook and tail" closing, that is, a hook at one end of the choker and a linked tail at the other end, making it adjustable.
Bib	A necklace with several strands of different lengths, the longest being about 18 inches long.
Clasped Choker	A short necklace, about 15 inches long, with a clasp closing that cannot be adjusted.
Collar	A flat necklace that fits close to the base of the neck. It is usually from 15 to 16 inches long.
Dog Collar	A short necklace, about 13½ to 14 inches long, with either a clasp or adjustable closing. It is worn high on the neck and may have several strands.
Graduated	A necklace of beads or pearls with the beads increasing from small beads at each end to a single large bead in the center.
Lariat	A necklace with open decorated ends that are looped or knotted, not clasped. It may

	also have a sliding ornament to hold it together.
Matinee	A necklace that is usually from 24 to 26 inches long.
Opera	A necklace that is usually from 28 to 30 inches long.
Princess	A necklace that is usually from 20 to 21 inches long.
Rope	A necklace which forms an endless circle from 30 to 60 inches long.
Sautoir	A medium-length necklace with a second chain from which an ornament is hung.
Uniform	A necklace in which the beads or pearls are all of the same size.

EARRINGS

The various types of earrings, regardless of the kind of back, come in any size.

Ball	A round sphere.
Bobby Drop	A short "drop" earring, in which the drop or bottom half swings.
Button	A round, flat earring.
Cabachon or Dome	A round sphere cut in half.
Cluster	An earring with three or more beads fastened to the back.
Gypsy Hoop	A round loop suspended from a motif that fastens on the lobe.
Two-Ball Rigid, also called Snowman	Two spheres or balls, one placed in a fixed position on top of the other.
Wedding Band	A hinged earring that resembles the traditional wedding band. If it is for pierced ears there will be no hinge but a post of some type.

BRACELETS

The most common types of bracelets are:

Bangle	A rigid circle with no opening, large enough to slip over the hand.

Charm	A link bracelet with decorative motifs hanging from it.
Cuff	A wide bracelet that fits the wrist, usually with a hinge and clasp.
Expansion	A bracelet with a stretch band of elastic or hinged links.
Flexible	A straight line of metal, usually with pearls or rhinestones or other gems linked together with a catch. It is flexible to the touch but is not an expansion bracelet.
Hinge Bangle	A bracelet that opens on a hinge to make it easier to get on the wrist.
Spiral	A bracelet made of a length of metal or beads on a wire that is circled like a spring.
Tab	A bracelet with a single motif hanging from it.
Watch Type	A bangle-type bracelet, fitted to the wrist with a clasp, that has a motif to be worn on the top of the arm like a watch.

PINS

A pin is basically a piece of metal or other material, with or without gems, with a back that can be pinned to clothing.

Brooch	Another name for a pin.
Chatelaine	Two pins connected by a chain or a single pin with chains looped and caught to the side.
Clip	Similar to a pin or brooch, except that it has a prong back instead of a pin.
Fob	A brooch with a motif from which a decorative ornament is suspended.
Stickpin	A straight pin with an ornament at one end, usually with a guard to protect the point.

3.
KNOW THE GEM TERMINOLOGY

Every gem has its own unique characteristics. Those characteristics may include color or lack of color. They may have to do with whether the gem is transparent, translucent, or opaque. They may also concern such factors as clarity or flawlessness.

These are only a few of the terms used to describe gems you should know. Other terms refer to hardness, size, weight, and cut. To understand how they pertain to each gem, you have to begin by understanding what the terms mean in general.

Some terms may be familiar. Other terms may be new and seem technical. Yet all are necessary to describe gems and to answer questions you have about various gems. They are also essential in buying gems. Often, names and terms are used all too casually, as if buying jewelry were a game, but buying jewelry is not a game—and mistakes can be costly. Thus, even though some of the terms at first may seem pertinent only to experts, they do have a bearing on what you should know. For example, if you are told that a gem is a "genuine cat's-eye," what do you think you are buying? Keep that question—and your answer—in mind while you read this chapter.

Some qualities of gems are intrinsic. They are what make one gem a diamond and another an emerald. They are, in fact, what make stones gems or precious stones and not ordinary stones or

minerals. In this sense, durability or hardness and color are intrinsic. So is clarity—how perfect or flawless a gem is. Incidentally, imperfection may not be a sign of poor quality, regardless of what laymen often think. Imperfections, surprisingly enough, may sometimes be desirable in certain gems because they account for the striking characteristics of those gems, such as opals and star sapphires.

The chemical properties or characteristics of gems are also intrinsic. They are important to the expert, for one thing, as an aid in determining whether a gem is genuine or a fraud. The average consumer probably has little knowledge of chemistry beyond its bare bones, if that. For example, you probably do not care that a diamond is pure carbon or that a sapphire is aluminum oxide. Thus, the chemistry of gems will be left to the experts and will be mentioned only insofar as it has any pertinency to the other intrinsic characteristics.

Weight is intrinsic in one sense. Although gems come in many sizes and weights, experts speak of the specific gravity of gems, meaning the ratio of the weight of a stone (regardless of size) to an equal amount of water. As with the chemistry of gems, however, specific gravity is important only to an expert as a test to make sure what gem a gem is, since every gem has its own specific gravity. The average person is neither an expert nor amateur gemologist nor mineralogist who will be able to identify a particular stone as being a diamond or a zircon. We count on the jeweler for that.

However, technology plays an important role in detecting the genuine from the fraudulent. Consider the case of two of the most famous gems in the British crown jewels.

The Black Prince's Ruby has belonged to the British crown since it was given to Edward, the Black Prince, son of Edward III, by Pedro the Cruel, who was placed on the throne of Spanish Castile by the Prince in 1367. Because rubies were supposed to protect their wearers from injury, the ruby was incorporated in the helmet worn by Henry V at the Battle of Agincourt in 1415. Eventually, it was mounted in the Imperial State Crown in a place of honor. The Black Prince's Ruby is a polished stone, irregular in shape, 2 inches across. Its size and brilliant color make it spectacular. Unfortunately, modern experts have found that it is not a ruby at all, but a red spinel, sometimes called a ballas ruby—a stone few people have heard of. Spinel, which is beautiful, is much less rare and less expensive than rubies. As a result, it has been overshadowed by the gems it resembles.

Another famous "ruby" in the British crown jewels is the gem called the Timur Ruby or Tribute of the World, named for Tamerlane (Timur the Lame), who conquered India in 1398. Among his booty was a cartload of jewels that contained an enormous ruby of more than 350 carats. Engraved on its back were the names of all the people who had owned it. A subsequent owner was the Emperor Shah Jehan of India, builder of the Taj Mahal. The Timur Ruby finally found its way to the British East India Company, which gave it to Queen Victoria in 1851. The gem was mounted in a necklace and thus joined the rest of the crown jewels. Experts have since found that the Tribute of the World, like the Black Prince's Ruby, is a spinel.

The intrinsic qualities are what make both gems spinels and not rubies. But it took modern gemology to find that out.

Other qualities or characteristics are not intrinsic. They may be important to a knowledge of gems and to you individually, yet they have little bearing on the nature of gems. Beauty and rarity, for example, are not intrinsic. Beauty, all too often, is in the eye of the beholder, and rarity is no criterion except of cost.

Cut is not intrinsic, either. The way a gem is cut is hardly a characteristic of gems in general or of specific gems. Gems, after all, haven't always been cut, and some gems are still polished and never cut.

Size, including weight as a determinant of size, is also not intrinsic. Gems come in all sizes. The only size with which a consumer is concerned is the size or weight of the stone that he or she is buying.

For all of these reasons, cut and size will be considered separately.

INTRINSIC CHARACTERISTICS

Which is more important in a gem—color, clarity, or hardness? Experts may disagree, both with reason and for their own reasons, but the hardness of a gem should be given more importance than it usually is for very practical reasons. In making other expensive purchases, like furs or a car, you want to know how the fur or the car "will wear" and what care it needs to prolong its life. You are entitled to the same information about gems—and that is where hardness comes in.

Gems, even diamonds, may not always be "forever," despite what advertising says. You can spoil or even ruin any gem by not

knowing its limitations. That is where hardness is important. "Hard as stone" is a handy phrase, but not all stones are hard as stone, much less hard as a diamond. Hardness is relative, with some stones being harder than others. What hardness means to you personally is that it determines the care you should take with gems—in wearing them, in storing them, and in cleaning them.

<div align="center">HARDNESS</div>

Hardness can be defined in terms of how easily one gem scratches another kind of gem and how easily other gems scratch it. It is the index of a gem's resistance to scratching and abrasion, therefore. This means that the harder the stone, the less easily it will be scratched and the longer it will retain its original beauty and luster. By the same token, the softer the stone, the more easily it will become scratched, with the abrasions detracting from its original beauty and luster.

The resistance to scratching and abrasion is one reason that *hardness* is used together or interchangeably with *durability*. The harder the stone, the more durable it is, while the softer the stone, the less durable it is. Hardness is actually a more precise term, however, since durability can be misleading. For example, diamonds are considered to be—and are—the hardest gems. At the same time, the hardness is of such a nature that a diamond can chip when hit or struck by a door or an edge at the right place or angle. If it is struck by a hammer hard enough, moreover, it may and probably will shatter.

A diamond is *hard.* It is also *brittle* or *fragile* or *frangible,* synonyms sometimes used to describe this characteristic, which is related to *cleavage.*

Some gems may simply be fragile and easily chipped or broken, but not in a particular pattern. In other gems, such as diamonds, the fragility results in cleavage. Cleavage means that a gem has specific planes along which it will split, chip, or break. These planes can be likened to the grain in wood. A log of fireplace wood will split most easily when it is split with the grain. In the same way, a gem splits or cleaves most easily along its planes. Gem cutters use cleavage and cleavage planes to cut gems. Knowing that a certain gem is fragile or has high cleavage, therefore, will alert you to be more careful with that gem.

Toughness in gems is not a synonym for hardness. A tough gem is strong or firm in texture and not brittle. Jade (see Chapter 4) is nowhere near as hard as diamonds. In comparison, nevertheless, it is one of the toughest—if not the toughest—stones known. Two diamonds struck together with force would be apt to shatter one another: the same force used with two pieces of jade would *not* damage either piece. In short, diamonds are harder than jade and will scratch jade, but jade is tougher than diamonds because it is not brittle and has no cleavage.

All hardness means, then, is that a hard gem will generally scratch less than a softer gem. Since it can also be more brittle, regardless of how hard a gem is, you should still use a little common sense in the "wear and tear" you give it.

Despite this qualification, hardness is an intrinsic and desirable characteristic in gems. So is cleavage. Both qualities are tied in with determining whether and how a gem can be cut and polished. Softer gems may be polished, but they cannot be cut to the brilliance of the harder gems. A softer gem will not retain the highly polished surfaces and edges on the sides of the faces or facets of the cut to reflect light in the way a diamond does.

Mohs Scale of Hardness

Gems vary widely in hardness. The most commonly used measurement of hardness is a system developed by a nineteenth-century Viennese mineralogist, Friedrich Mohs, and called the Mohs scale after him. The scale is based on a range of 1 through 10, using a selected mineral to typify or stand for all other minerals of the same hardness. The number 1 indicates the softest mineral and 10 the hardest.

The purpose of the scale is to use hardness as a test for identifying minerals. If one stone scratches another, the first is the harder stone and must be a mineral above the other mineral on the scale. If neither stone is scratched, they are of equal hardness and in the same range on the scale. Thus, each mineral on the scale will scratch all minerals lower than it on the scale; that same mineral will be scratched by all minerals higher than it on the scale; and it will not be scratched by another mineral of equal hardness because the two minerals have the same number or degree of hardness on the scale. An even more precise definition for hardness of gems,

therefore, is scratchability—how easy or difficult it is for a gem to be scratched.

The Mohs scale may seem esoteric since few people want to identify stones. In addition, you would not want to experiment with your jewelry and run the risk of ruining the stones. Still, the Mohs scale is pertinent to understanding gems and may sometimes be used in talking or writing about gems—and it does have practical aspects in its interpretation.

One point to keep in mind in looking at the list below is that the minerals listed are test or sample minerals. They stand for all minerals of that hardness. Another point is that the disparity between the numbers is not equal. Diamonds are so much harder than other minerals that the disparity between diamonds and the next hardest mineral is far greater than between that mineral (corundum) and the lowest one on the scale. Still a third point is that stones can fall between the different numbers. For example, if a stone scratches a gem of one number on the scale just as easily as it is scratched by the next highest number, it lies between those numbers, perhaps at 8½.

A fourth point is that Mohs was a mineralogist and interested in the hardness of all minerals, not only gems. For that reason, the scale contains some minerals that are not used as gems. In addition, because the scientific names are used, even the names of some of the minerals used as gems may be unfamiliar. Thus, examples of gems familiar to consumers are given in parentheses after the species name, when applicable.

MOHS SCALE
1. Talc
2. Gypsum
3. Calcite
4. Fluorite
5. Apatite (one kind of cat's-eye is apatite)
6. Feldspar (moonstone is the most familiar feldspar)
7. Quartz (examples are amethyst, bloodstone, tigereye, agate, and other forms of quartz)
8. Topaz
9. Corundum (rubies and sapphires are corundum)
10. Diamond

Reading this table and the explanation preceding it, you note that diamonds will scratch all other minerals. A sapphire, on the other hand, will be scratched by a diamond but will scratch all minerals below it on the scale, and so on.

Scratchability can be defined in another way that may be more meaningful. For example, the hardness of a fingernail is about 2½. That means you can scratch talc (1)—it would be like scratching soap—and gypsum (2) with your own fingernail. You would need a knife, however, to scratch calcite. The knife would also scratch fluorite (4), apatite (5), and feldspar (6), but with increasing difficulty. Although a knife will not scratch quartz (7) and minerals higher on the scale, those minerals will strike a spark with certain types of steel.

The ability of one mineral to scratch another brings up the story that you can tell a genuine diamond by its ability to scratch or cut glass. That is true enough. Yet, as a test of diamonds it is closer to myth than fact. The fact is that other minerals will also scratch glass. Glass has the same approximate hardness as apatite (5). Thus, not only will diamonds scratch glass but all minerals with the hardness of feldspar, quartz, topaz, and corundum will also scratch glass. Granted, the harder the mineral, the easier it will be to do that.

Regardless of the desirability of hardness, however, it would be an oversimplification to say that hardness alone makes one gem more desirable than another gem. True enough, diamonds as well as rubies and sapphires are the hardest gems and are desirable and expensive. Yet, not all gems below 7 on the scale are all that much less desirable and less expensive.

Jade, the "toughest" gem, is between 6½ and 7 on the scale, depending on the type of jade. It is very desirable and is expensive. Opals are another example. While they have only the hardness of feldspar (6) and are fragile without the toughness of jade, opals can be very expensive and rare, as is the case with Australian black opals. Next are pearls, which rank between calcite and fluorite at 3½ on the scale. Their relative softness does not affect their beauty nor the demand for them. Thus, the Mohs scale is not a scale of absolute desirability.

Still, the scale serves several purposes as far as the consumer is concerned, which is why the hardness of the various gems will be given in the next chapter. It points out:

*Care should be taken in wearing gems, especially the softer ones.

*Jewelry with gems of one kind should be stored separately from jewels of another kind to avoid the gems' scratching one another.

*Care should be taken in cleaning gems below the hardness of 7. The lower on the scale a gem falls, the more easily it may be scratched by a rough or dirty cloth, powdered hand soap, and even dust that may contain minute quantities of grit or quartz.

CLARITY

Another important characteristic of gems is clarity. *Clarity* refers to the presence or absence of flaws called *inclusions.* Inclusions are the result of imperfections caused when the gem was created or crystallized by nature. The term inclusion comes from the fact that they are inside the stone, not on the surface. Inclusions, imperfections, and flaws are synonymous, therefore.

Inclusions can be of several types. They may be tiny bubbles, specks of uncrystallized minerals or material, hairline cracks, and other flaws that interfere with the passage of light in a stone. They may be large enough to be seen with the naked eye or so small that a jeweler's loupe, a type of single-lens microscope, or even a high-powered microscope is needed to spot them.

Inclusions can and do occur in any kind of stone. Diamonds, the most popular gem, will serve as a good illustration of the effect of inclusions on certain gems. Since inclusions interfere with the effect of light on a gem, diamonds with inclusions that can be seen by the naked eye have little or no value as gems. The larger and the greater the number of inclusions, the less light can pass through the gem, making it appear dull. Yet, very few diamonds (or other gems) are totally flawless, that is, completely without minute inclusions. Many more diamonds have minute inclusions, so minute that they do not interfere with the beauty or clarity of the diamonds.

The question for the consumer is this: "How great a magnification is needed to determine whether a diamond is flawless enough to have good clarity?" In the United States, the Federal Trade Commission has, with the help of the industry, established a standard. *A diamond can be considered to be—and is called—"flawless" when it shows no inclusions at 10-power magnification (magnified to 10 times its actual size).* In other words, the diamond may still have inclusions or flaws but they are so small that a stronger lens or

magnification is necessary for them to be seen and they do not interfere with the passage of light.

A flawless diamond, therefore, is one in which no imperfections or inclusions can be seen under a 10-power lens. Such a diamond has *top clarity*. Other terms are sometimes used, the most common of which are given in Appendix II. Still other terms may be used in other countries: "eye perfect," for example, means that no inclusions can be seen with the naked eye. Since they may be able to be seen under a 10-power lens, such a diamond would not be considered flawless or of top clarity in the United States. In fact, in the United States, the use of the term "perfect" is forbidden by the Federal Trade Commission because of the rarity of perfect diamonds that are totally without inclusions. You should be wary whenever you hear that term or see it used.

Inclusions, nevertheless, are not always bad. Some gems—such as opals, tigereyes, and cat's-eyes, and star gems—depend on inclusions for their intrinsic characteristics.

*In opals, the inclusions are grouped in such a way that the color flashes and shifts, giving off an iridescent play of colors. This iridescence, due to inclusions, is called *opalescence* after the play of light and colors in this particular gem. Another gem with opalescence is moonstone.

*Cat's-eye is actually a term for an effect of inclusions and light, rather than the name of a specific gem nowadays. In such a gem, numerous fibrous inclusions reflect the light, making the stone appear to have a satiny surface and giving the stone a silky sheen. This sheen is called chatoyancy, from the French word *chatoyer,* meaning to shine like a cat's-eye. In addition, needle-like inclusions are lined up in such a way as to reflect the light in a single line, similar in effect to the slit in a cat's eye and actually accounting for the name *cat's-eye*.

The term was once used only for cat's-eye chrysoberyl, also called "Oriental cat's-eye," but today it is often used for any of a variety of gems in which a cat's-eye effect occurs, such as tourmaline and quartz. Both tourmaline and quartz are more common and can be much less expensive than the rarer chrysoberyl. In addition, they are both 7 on the Mohs scale, while chrysoberyl is 8½ and much harder. The term *cat's-eye,* therefore, is a good term to beware. It is less the name of a gem than it is the technical name for the visual effect of a certain type of inclusion. Cat's-eye chrysoberyl is always

expensive and can be *very* expensive. So, price is one indication of what you are buying. In any case, in buying cat's-eyes, be sure to know what the gem is, in order to get the best gem for the money.

Tigereyes are related to cat's-eyes. Both have the same chatoyancy, but the visual effect is different. Tigereyes have alternating bands of yellow and brown, not a single slit. They belong to the quartz family and are relatively common and inexpensive.

*Star rubies and star sapphires have inclusions that create a silky sheen and a specific effect. Whereas in cat's-eyes, the needle-like inclusions occur in only one direction, in star gems the inclusions form three intersecting lines for a star effect. The star effect is called *asterism* and may occur in other gems as well.

Inclusions, therefore, may even be a reason for a gem's desirability. The fact that opalescence, chatoyancy, and asterism are inclusions, nevertheless, means that these gems are polished to show off their uniqueness rather than cut in facets or faces in the way diamonds and non-star rubies and sapphires are cut to show off their brilliance. First of all, cutting star and cat's-eye gems like diamonds might be impossible because the inclusions would cause the gems to shatter. Second, even if it were possible, such cutting would ruin the effect of the chatoyancy. Thus, inclusions affect the cutting of gems.

COLOR

A third intrinsic characteristic is *color.* Color is caused by impurities in the crystallization of the gem. Certain minerals or elements in combination create colors, the way an artist uses different paint colors to create new colors. A diamond, for example, can be pure carbon. This diamond would be colorless. If other elements were present at the crystallization, the color might be yellow or pink or any other color in the spectrum, including black, depending on those elements.

Thus, color refers not to the particular colors in which a particular gem may come, since many gems come in a variety of colors. What is meant is color in the broadest sense, as a general definition of what distinguishing characteristics of color are in talking about gems.

Three of the most important terms are hue, tint, and intensity. *Hue* means the actual color, such as red, blue, green, etc. *Tint* has

to do with how light or dark the color or hue is. *Intensity* means how vivid or dull the color and tint are.

Certain gems have been valued and prized down through the ages simply because of their hue, tint, and intensity. Emeralds (green hue), rubies (red hue), and sapphires (blue hue) that are dark in tint and high in intensity have always been valuable, accounting for their traditional distinction with the diamond as precious stones.

Color is partially related to the effects of gems on light and light on gems. All some gems have to offer is color: they are *opaque,* that is, solid and impervious to light. The color may be beautiful, but there is no play of light or "fire," as there is in other gems, and no satiny sheen, as there is in chatoyant gems. Opaque gems such as turquoise, lapis lazuli, and jade are lovely and desirable in their own way. Yet the loveliness could be called one-dimensional.

Other gems are *translucent.* Light passes through them with less difficulty than it does with opaque gems. Translucent gems, rather than being a solid mass, are composed of minute crystals in compact masses, with the structure of the crystals determining how much light is transmitted through the stone. Chatoyant, star, and opalescent gems are translucent, as is amber. They could be called two-dimensional.

Transparent gems, in contrast, transmit as much light as possible into or through the stone. Theirs is a multidimensional loveliness that accounts for the reason why some gems, like diamonds, are so highly prized.

Transparency, regardless of color (rubies and sapphires are also transparent), has certain characteristics of its own. One accounts for that fire and is known as *fire* as well as *dispersion.* A gem, no matter how transparent, is a solid mass. As a result, light passing through it is bent or refracted. Since each color—and even "white" light is composed of all colors in the spectrum—is refracted differently according to its own intensity, the result of light falling on a gem is a play of colors or fire. The light, in other words, is dispersed into its colors. Inclusions affect dispersion, since they distort light and may even prevent dispersion to a lesser or greater degree, depending on the size and number of the inclusions.

Different gems disperse light differently. Diamonds are particularly noted for their fire. They have a high dispersion characteristic. On the other hand, quartz has low dispersion characteristics. As a result, no rock crystal (a form of quartz often used to substitute for

diamonds) will ever have the fire of a diamond with top clarity.

Two other terms are also sometimes used and may be confused with fire. One is *brilliance*. When you look into a diamond, for instance, you see internal reflections of white light from deep inside it as well as external reflections from the highly polished hard surface. Brilliance refers to these internal reflections. Again, the fewer and tinier the inclusions, the more brilliant the stone will be. The other term is *scintillation*. Diamonds and other gems are cut with a multitude of faces or facets (see "Facet Cuts" below). Scintillation is the twinkling or flashing caused by light striking the facets as you move your eyes or as the source of light is moved.

Some gems exhibit another characteristic in light. These gems act as a filter, screening out various colors of light. A white diamond appears white because all light passes through. When only a certain color in light is transmitted, the gem will appear to be that color. Sometimes, two colors appear, depending on the direction of the light and the way the gem is turned. Such gems are said to be *dichroic,* showing two colors. More rarely, three colors can be seen, making the gem *trichroic,* showing three colors. The phenomenon of different colors appearing in the same gem is also known as *pleochroism,* meaning the ability to show several colors.

Gems exhibiting trichroism are quite rare. An example is tanzanite. It gets its name from Tanzania in East Africa, the only place it is found. Discovered relatively recently, it is actually a form of zoisite, a mineral seldom used in jewelry. Tanzanite is a clear, transparent blue gem at one angle, an amethyst purple at another, and a pale salmon-brown at the third angle.

The characteristics of the effects of light on gems are innate. A gem is either transparent or it is not. At the same time, the effects of light can often be enhanced—and that is where other features, such as cutting, come in.

GEM CUTS

Gem cutting is a relatively modern art, and today it is highly scientific and technical. What made early jewelry, such as King Tut's, spectacular was the gold. Thus, the original jewelers were goldsmiths and not gem cutters, and the goldsmith's art was paramount to the making of jewelry.

CABOCHON CUT

The *cabochon* cut is the oldest known, dating back to the crude beads found in the earliest archaeological sites. In fact, for centuries before Christ in the Middle East and Asia and for centuries afterwards in Europe, "cut" gems were merely modifications or refinements of those beads.

The roughly shaped beads were first ground and smoothly polished into round and oval-shaped domes. They then were cut in half, creating the cabochon: a flat-bottomed round or oval cut. The name itself comes from an old French word meaning head or knob. Until the seventeenth century, the cabochon was used for almost all gems. Modern cabochons, however, are cut and ground or polished to show certain gems off to their best advantage.

Some types of gems are always cut in cabochons. For that reason, you want to consider the gem as well as the cut, and you should know what to look for.

Opaque and translucent gems are most often cut in cabochons. In translucent gems the type of inclusions often dictates the height of the cut. It may be a high dome or one of medium or low height. Regardless of height, the top of all cabochons should be symmetrically curved. One side should not be higher than the other, and there should be no flat spots. The surface should be smoothly polished, without any pits that indicate improper or careless polishing and that detract from the value of the stone.

Star and "eye" gems are cut fairly thick for the strongest effect of the star and the eye. The top should be high, and the curvature at the top should be almost sharp in order to catch the light. The star or eye should be centered, since an off-center star or eye decreases the value of the gem. If the gem is big enough, an off-center star gem may be able to be recut to center the star. In buying such a gem, be careful to hold it under an electric light or in sunlight and move it from side to side to make sure the star or eye is where it should be. A lopsided star or eye is a poor buy. In addition, a star gem may also be sometimes cut and polished at the top, with the bottom half not cut off and left rough and unpolished. Regardless of what you may be told, the bottom half adds nothing to the effect and will only add to the weight.

In other gems, where the pattern of inclusions is irregular, their beauty depends on the flashes of light that are caught and reflected

by the irregularity of the pattern. These gems include moonstones and opals, and they are cut flat in comparison to the star and eye gems. Black opals, in particular, are cut almost flat, not only to show off the lights but also because the stone occurs in thin seams as a rule.

Aside from these special gems, the thickness of the cut can depend on other factors. One is the toughness of the stone. Jade, for example, is one of the toughest gems and is often cut thin as a result. Other gems, such as malachite, are much less tough and must be cut thicker.

Another factor is size. A large cabochon may be cut thinner or, if cut high, may be hollow, since it would otherwise be uncomfortably heavy to wear.

Although cabochons are usually round or oval, you may find other shapes. They may also be square, heart-shaped, rectangular, in the shape of a tear, or any other form appropriate to the size and original shape of the stone.

The precision with which stars and cat's-eyes have to be cut to center the optical effect means that they must be cut, ground, and polished by hand. So must fragile stones, like precious opal and moonstones, which may shatter under rough handling. Other stones can benefit from mass-production methods. Jade, for instance, is extremely tough and difficult to cut and polish, making it a problem to remove possible pitting. It may actually benefit from the mass-production method used for irregularly shaped stones and used to polish some cabochons.

The method is known as *tumbling,* and the irregularly shaped gems are called *tumbled* or *baroque* gems. The irregularly shaped stones—and stones cut in squares, circles, or other shapes—are placed in barrels with various abrasives and liquids and are literally tumbled for days or weeks. Once they have been shaped by this tumbling, they are put in another barrel and tumbled with polishing agents to smooth them.

The gems used in inexpensive jewelry are generally tumbled. Otherwise, the cost of hand labor would make the jewelry much more expensive. Baroque gems, in fact, have a charm of their own, with their irregularity contributing to the effect of the jewelry.

While the cabochon cut is ideal for translucent and opaque gems where the play of light on the rounded surface is enough, transparent gems are another matter. Here, the more surfaces there

are to let in light, the greater is the dispersion of light and the fire of the gem, as well as the brilliance and scintillation.

Starting in the fifteenth century and earlier in India, transparent gems began to be cut with faces or facets to enhance the effects of light. Although the method was introduced to Europe in Venice, Amsterdam soon became the center for this kind of gem cutting, which was common by the seventeenth century. Today, the centers of gem cutting are spread around the world. Antwerp, the Tel Aviv area in Israel, and New York City are among the top diamond-cutting centers.

The cut developed in India was relatively simple, employing eight facets and a flat top or table and bottom. More facets were gradually added, increasing the brilliancy and fire of the stone. The Dutch Rose, for example, used 24 facets. Other forms followed, until faceted diamonds and other gems were common and the vogue.

The way and shape in which a diamond or any other gem is cut can depend basically on its rough shape, color, clarity, and size. The most popular cut today is the brilliant cut, especially for diamonds, and this cut will be used to illustrate what you should know about the cut of faceted stones.

According to tradition, Cardinal Mazarin, a seventeenth-century French statesman, originated the brilliant cut to try to revive the Parisian diamond-cutting industry. To publicize the cut, he had 12 of the diamonds in the French crown cut in this style. These diamonds, known as the 12 Mazarins, disappeared during the French Revolution, and only a few were recovered later.

Looked at from the side, a round *brilliant cut* diamond resembles a kind of squat ice cream cone (see Diagram 1). The top third or ice cream part is the *crown,* with the flat facet at the very top known as the *table.* Slanting outward from the table are small facets known as *star facets.* The facets below them that meet the edge of the cone or girdle in a point are *bezel facets.* The bezel is the slanting edge above the cone, and above the girdle where the setting, pronged or otherwise, grips the stone. The rest of the facets are known as the upper girdle facets.

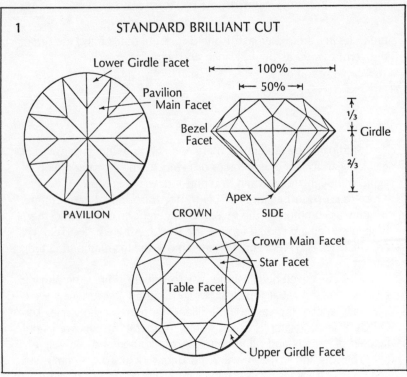

1 STANDARD BRILLIANT CUT

Lower Girdle Facet

Pavilion Main Facet

Bezel Facet

Apex

100%

50%

1/3

Girdle

2/3

PAVILION CROWN SIDE

Crown Main Facet

Star Facet

Table Facet

Upper Girdle Facet

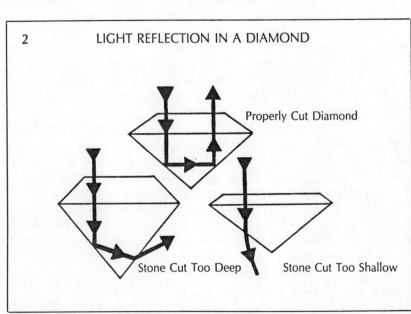

2 LIGHT REFLECTION IN A DIAMOND

Properly Cut Diamond

Stone Cut Too Deep Stone Cut Too Shallow

The *girdle* is the edge where the crown meets the cone and is the part where the gem is set into the setting. The cone, or bottom two-thirds of the stone, is the *pavilion* or *culasse*. The lower girdle facets match the upper girdle facets, while the pavilion facets meet the points of the bezel facets. The point, or very bottom, of the cone is the *culet* or *apex*.

All the proportions have to be very exact. When they are, the cut is called an *ideal cut.* What does this mean?

First of all, such a cut means that the diamond has the maximum brilliance, scintillation, and fire, with the facets reflecting and bouncing back the light. (See Diagram 2.) If the pavilion is too squat or shallow, the gem may look larger but light will leak out the bottom, causing the diamond to lose fire and appear watered down. If the pavilion is cut too deep, the light will leak out the sides, with the diamond appearing black in the center. The black dead or dead-looking center is called a "fisheye."

One further note: Ideal cut is a technical name for a properly and perfectly cut diamond, but it is also a trade name for a "brand" of diamonds carried by many stores. That does not mean that only that brand is ideal cut: any diamond can be ideal cut. If the words are capitalized—Ideal Cut—it is a brand or trademark and not the cut that is being advertised.

The typical brilliant cut has 58 facets. Round is the most popular shape, although the same cut may be adapted to other shapes—all of which have 58 facets. (See Diagram 3.) The *oval* shape is an elongated round brilliant cut. A *marquise* cut is an oval with pointed ends. The *pear* shape is an oval that is round at one end and pointed at the other, while the *heart* shape is basically a pear shape with a notch in the round end.

Two other adaptations involve the number of facets. The *step brilliant* cut has 20 more facets, 12 in the crown and 8 in the pavilion. The result is a greater sparkle because of the added facets. The English brilliant cut, on the other hand, has only 30 facets and, thus, has less sparkle.

The second basic cut is the *emerald* or *step* cut, and it derives from the old Indian cut. (See Diagram 4.) This cut is much more common for colored stones than for diamonds. The flat table facet accounts for as much as 50 percent of the top surface of the eight-sided rectangle. The culet is flat, rather than pointed, and the rest of

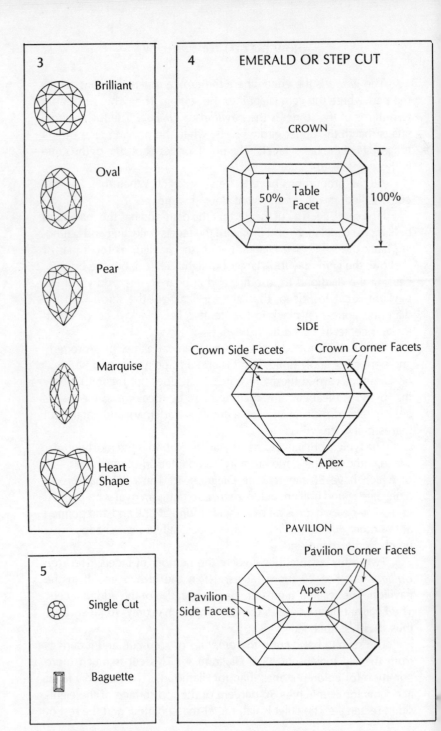

3

Brilliant

Oval

Pear

Marquise

Heart Shape

5

Single Cut

Baguette

4 EMERALD OR STEP CUT

CROWN

50% Table Facet 100%

SIDE

Crown Side Facets Crown Corner Facets

Apex

PAVILION

Pavilion Corner Facets

Apex

Pavilion Side Facets

the 58 facets are parallel to the table and culet, not at angles as in the brilliant cut. (See diagram.)

The emerald or step cut has its own adaptations, too. It may be square, hexagonal, triangular, five-sided, etc. The distinguishing characteristics are the parallel facets and the flat culet that matches the basic shape.

A simpler adaptation is the *baguette*. (See Diagram 5.) A baguette is a small gem, usually a diamond and usually used to set off other gems or to frame them. It is rectangular, or rectangular and tapered at one end, with only four corners and four or eight facets parallel to the table and eight pavilion facets.

Another term often used is *pavé*. It refers to a style of jewelry, not a cut. A pavé ring, for example, is a ring set with a number of small gems, generally brilliant cut, in a cluster. The brilliant cut, in this case, may involve only 17 or 18 facets because the gems are so small that there may be more than 200 of them to the carat. Such diamonds are called single- or eight-cut diamonds. (See Diagram 5.)

OTHER CUTTING

Gems may also be cut in other ways that have nothing to do with their shape or the number of facets. A better term in this instance is *engraved,* because a design is formed by carving it into a gem or a shell.

Intaglio means that the carver engraves the gem, as for a signet or seal ring. In other words, the carving is *below* the surface of the gem. The objective of the ring originally was to let the owner stamp his seal into wax to close a letter or to authenticate a document, giving the intaglio a useful purpose. Scarabs, miniature carved beetles made by the ancient Egyptians and often found in the pyramid tombs, were also often engraved with symbolic intaglios. Although almost any gem can be used for intaglio, the most common gems used are the opaque gems. Diamonds, nevertheless, have been engraved, despite their hardness and fragility that make engraving extremely difficult.

One carved diamond was the Shah, given to Czar Nicholas of Russia in 1829 by a Persian prince. Because of its irregular shape, the diamond was recut and the inscriptions of the names of three Persian kings who had owned the gem were lost. Another diamond, the Akbar Shah, was named after its first owner, the Great Mogul, Akbar,

and Arabic inscriptions were engraved on two faces by Akbar's successor. Although it, too, was later recut, the recutting left the inscriptions intact.

Cameo is the opposite of intaglio. In a cameo, the figure or inscription is raised in low relief. The art of intaglio is older than cameo carving, but cameo carving is also an ancient skill. Known to the Persians, the Egyptians, the Greeks, and the Romans, it was developed to high art in medieval Italy.

A cameo may be a stone or a shell. Especially suitable is material that occurs in bands or layers, with the result that the figure is one color and the background another color. Stone cameos are generally onyx or sardonyx, while shell cameos use certain mollusks, such as helmet shells. Shell cameos, despite the relative softness of the shell, can be finely and exquisitely detailed. Naples, today, is the center of cameo carving, both for the best cameos and those that are quickly and inexpensively turned out for tourists. The latter are generally small and have a minimum of detail, while the best cameos are larger—although rarely larger than 3 inches in diameter—and are of much better workmanship.

SIZE AND WEIGHT

Weight is the basic measurement used to determine the size of gems, and the basic weight used is the *carat* (ct.). The origin of the word is intriguing (see Chapter 1). Briefly, it may come from either the Arabic word for carob, *qirat,* a tree whose pods or seeds were used as a weight by ancient lapidaries in the bazaars, or from a Greek word, *keration,* which is related to *qirat.* Thus, carat and karat are probably related. In any case, karat is used for gold and carat for gems—except in England, where both are spelled carat, with a *c.*

Regardless of the origin of the word, however, the fact is that in ancient times many different kinds of seeds were used as balances on scales. As a result, there was no standard weight, with a carat being a different weight in different countries. In 1907, a standard weight was finally proposed by the International Committee on Weights and Measures. It was adopted by the United States in 1903 and by other countries by 1930. Today, 1 *carat* is universally one-fifth of a gram, or 200 milligrams. Since an ounce has 28.3 grams, 1 carat is also about .007 ounce.

A carat is divided into *points,* with 100 points equaling 1 carat.

The weight of a diamond or other gem, therefore, would be given as 2.36 points, for example, meaning that it weighs 2 carats plus 36 points.

Carats are a much more accurate measurement of gem size than any other measurement. Since gems can be cut to so many different shapes, a linear measurement could have little meaning. Although diameter can be used to measure a round brilliant-cut diamond, where would diameter be measured on a pear- or tear-shaped gem? Millimeters (mm.), nevertheless, are sometimes used with both faceted and cabochon gems. A millimeter is about .04 inch. In such cases, carat weight should also be given: for example, a 1-carat brilliant-cut diamond, 6.5 mm. in diameter.

Diameter is the most common measurement of size for cultured pearls, with the millimeter being used. Weight, though, may sometimes be used, including the carat, but two other terms are far more common. The weight of cultured pearls is measured in Japanese *mommes,* with 1 momme equaling 18.75 carats, or about 3.75 grams. The number of pearls in a momme varies, depending on the size of the pearls. The larger the pearl, the more it weighs and the fewer pearls there are in a momme. It would take 90 pearls, each 3 mm. in diameter, to make 1 momme, but only 3 pearls, 9 mm. in diameter. Natural pearls are weighed by *pearl grains,* with 4 grains equaling 1 carat. There are 75 grains to the momme. The weight of unstrung pearls, which tourists may buy in Japan, is more often given in mommes and grains than in millimeters.

OTHER TERMS

Other terms that are helpful in buying jewelry with gems are those used in connection with gem substitutes. Although the substitution can sometimes be easily seen by the naked eye, it can be so good that sophisticated laboratory examination is necessary to detect it. In short, you can not always trust your eyes, and anyone who tries to show that a gem is genuine by holding it up to a light or a window is to be suspected.

Substitutes are nothing new. The earliest substitutes were glass, and the ancient Egyptians, Greeks, and Romans were not above using "glass gems" in jewelry. Less precious gems have also been used to substitute for more precious gems. Other substitutes nowa-

days are man-made in the laboratory, thanks to advances in chemistry and physics.

Synthetic gems are man-made. They are identical in chemistry and crystal structure to the natural gems they represent. In some cases, synthetic gems are so "real" that they even have the same kind of inclusions as the genuine gems. The first synthetic gems were rubies, which were synthesized in the 1880s and were sometimes called "Geneva rubies." In 1904, August Verneuil introduced the Verneuil furnace, permitting mass production of synthetic gems. The crystals created are called *boules.* Today, several other techniques and methods using the latest scientific knowledge make possible the synthesizing of gems so closely identical to natural gems that even dealers may be fooled. Synthetic gems may also be called *simulated* or *created.*

Imitation gems can be made of any material as long as that material imitates or closely resembles the natural gem, at least to the casual observer. As noted above, glass was the first material exploited to imitate gems. Today, plastic may also be used.

Assembled or *composite* stones are part natural or genuine stone and part some other material. There are two kinds.

*A *doublet* has a genuine crown cemented or affixed to an artificial bottom. For example, the top may be ruby and the bottom red glass; or the crown may be colorless beryl, which is the same species of mineral as emerald, and the bottom green glass, giving the appearance of an emerald. Opal doublets are assembled for another reason than to substitute for a real gem. Precious opal is not a common gem and it often occurs in thin seams. If the layer of precious opal with the necessary opalescence is too thin, the thin layer may be cemented to a backing material to make it usable. Assembled or composite stones can easily be detected under magnification because the joint or joining will show—as long as the stone is unmounted. When it is mounted, the mounting hides the joint.

*A *triplet* has three layers. For example, the bottom and top may be clear beryl, with the beryl layers cemented to a middle layer of green glass, thus giving the appearance of an emerald. Opal triplets consist of a top layer of quartz, a middle layer of opal, and a backing layer, with the quartz giving strength to the fragile opal and protecting it.

A *reconstructed* stone is a stone in which genuine fragments of a gem have been heated at high enough temperatures to form a solid

mass that could then be cut. So far, the only gem that has been successfully reconstructed this way is the ruby, although amber can be created through the same process.

Altered stones are genuine. They are natural stones that have been treated in some way to change the color to a more desirable one. Altered stones, like glass imitations, are nothing new. The Paul, the First Diamond in the Russian crown jewels, was famous for its spectacular red color. Only in recent years has it been found that the diamond is actually a pale pink, with the red color caused by a red foil backing.

Today, diamonds may still be altered in similar ways, such as a blue coating on the pavilion to give them a better color. Jade can be stained or dyed, and serpentine—which resembles jade—can be stained, too, to look like jade. Opals may be coated black on the back to give the appearance of valuable black opals, while opal doublets may be glued together with black cement for the same effect. Turquoise can be soaked in wax or impregnated with wax to improve the color. Other stones can also be altered in these and other ways to improve the color. One indication of an altered stone is a price that seems too cheap for a genuine gem of that color.

The color of stones can be altered in other ways that may take an expert to detect. Some stones can be *heated* to improve the color. Unattractive brown-colored zircons can be changed to colorless or blue stones by heating, making them more valuable.

Irradiation by gamma rays is another way to change color. Off-color diamonds, when irradiated, become desirable brown, yellow, and green colors that can command a higher price as "fancies." In the United States, irradiated stones must be marked "irradiated" according to Federal Trade Commission regulations, to distinguish them from higher-priced natural stones. Irradiated stones are more popular in Europe, where colored stones have always been more in demand than in the United States, where colored stones are susceptible to the whims of fashion.

The results of both heating and irradiation, nevertheless, can be very desirable—as long as you know what you are getting. This is especially true of heated stones, which can sometimes fade or change color.

Gem substitutes, therefore, can be a problem and will be treated more specifically in the next chapter under the particular gems. Being careful where you buy and from whom you buy is the best way to

avoid being cheated. Few reliable jewelers would knowingly sell a substitute gem as a genuine one; if they did so unknowingly and the substitute was detected, they would make good on it for the sake of their reputation.

Keep in mind that if modern technology can create substitutes, it can also detect them. Trained gemologists, such as those at the Gemological Institute of America, are as up to date as the people making the substitutes. These experts can resolve doubts about gems.

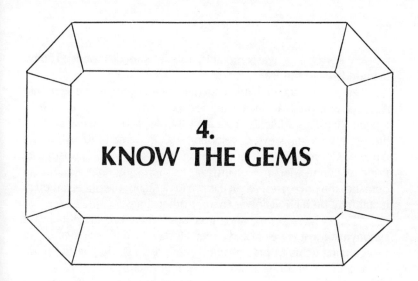

4.
KNOW THE GEMS

What is a precious gem?

Some gems are more expensive than others, sometimes depending on rarity and other times on demand or fashion. A good emerald easily costs more than a diamond, while a turquoise costs far less, because emeralds are rarer than diamonds and diamonds are rarer than most turquoise.

Yet, if rarity were the only gauge of a precious gem, the Australian black opal would be among the most precious, if not the most precious, gems. Although diamonds are found in many countries, black opals are found only in Australia. As late as the middle of 1978, almost no black opals had been found for years. They were extremely rare—and still are, despite the major find in September, 1978, which resulted in an "opal rush" of miners and gem merchants. Among a reputed $500,000 worth of opals dug by a single miner was one gem estimated to be worth a record $90,000.

As far as fashion and demand go, they can be capricious. In ancient India and in Roman times, diamonds were the most desirable gem. During the Middle Ages in Europe, the most highly esteemed gems were the colored stones. According to goldsmith Benvenuto Cellini, rubies, sapphires, and diamonds—in that order—were the most precious stones in sixteenth-century Italy. During that same

time in Portugal, it was emeralds, rubies, and diamonds. Today, diamonds head the list.

Fashion, in fact, can inflate the cost of any gem. In the Victorian Age, jet was popular, especially for mourning jewelry because of Queen Victoria's addiction to it after the death of Prince Albert. At the same time, cat's-eye chrysoberyl was in demand following the Duke of Connaught's gift of an engagement ring with that stone to Princess Louise Margaret of Prussia. In short, any time a gem is in demand, the price rises; when it is not in demand, the price, although it still may be high, is lower than at other times.

"Expensive," "rare," and "precious," therefore, are not always synonyms. Most jewelers and experts today, in fact, veer away from categorizing gems as precious and semiprecious, despite the traditional and general distinction of diamonds, emeralds, rubies, sapphires, and some opals as being precious and all other stones semiprecious. As Morton R. Sarrett, president of the Jewelry Industry Council, says, "The rising prices of jewelry and the demand for stones of all kinds mean that all gems are precious today, even though some may be more precious than others."

For these reasons, in buying gems you should know more about them than their rarity and cost. You should also know:

1. What the choice of gems is. You have more gems to choose from than you may realize. A good many are relatively unknown, despite their beauty, and are inexpensive in comparison to the better-known gems.

2. What to look for in a particular gem. Some gems come in different colors, and one color may be preferable to another. Again, color may be more important than clarity.

3. What you can expect from a particular gem. For example, will it scratch or fracture easily? Might it even fade or change color with time?

4. What the substitutes are. Substitutes can sometimes be passed off as genuine stones, but you do not always have to be an expert to tell which is which. Sometimes, too, substitutes that are genuine stones can be beautiful in their own right, as long as you know you are buying the substitute. An alphabetic listing of substitutes and what they actually are is given in Appendix I for easy reference.

The list of gems below covers these points. In addition, the hardness of each gem on the Mohs scale is given to indicate general

care. Remember, the Mohs scale runs from 1 to 10, with 10 being the hardest mineral or gem. As a rule, the softer the gem, the more care it needs. Where special care is necessary, that fact will be noted and the care given in Chapter 9. Although experts do not always agree on all points, the information represents as accurate a consensus of opinions on the subject as possible. The purpose of this book is not to be a text on gems but to be a guide to help you through the difficulties encountered in buying gems and, it is hoped, help you avoid some of the pitfalls.

Before considering specific gems, however, there is another side. That is the mystique of gems that goes back to mythology and legend, with certain gems supposed to have supernatural powers.

THE LORE OF GEMS

Blue gems have historically been associated with the eyes, to cure and protect them, and with good luck. The belief associating them with the eyes is so widespread as to be universal, even among people in whom blue eyes would be so much a rarity as to be unique, such as the American Indians and the peoples of the Middle East and the Mediterranean. The stone might be sapphire, lapis lazuli, or turquoise, but what was precious was the color—the color of the sky and the heavens, which had nothing to do with the color of the eyes. Even so, the eyes looked upward to the sky and those heavens where the gods dwelt, and that association gave blue stones an added significance religiously, with special powers to counteract the powers of evil and darkness or night.

In the same way, other colors had other powers. Red stones were associated with blood. The ruby, spinel, garnet, and bloodstone, among other red stones, were supposed to stop hemorrhages and relieve inflammatory diseases. Yellow stones were associated with the liver and with jaundice, while clear or transparent stones had the power of rendering the wearer invisible. Purple stones, particularly the amethyst, had other powers—to prevent drunkenness, probably because the color resembled that of certain wines. At any rate, the name "amethyst" comes from a Greek word meaning "not to be intoxicated."

These are only a few of the qualities attributed to some gems. In some instances, gems were supposed to have sex genders. An

early Greek writer, Theophrastus, spoke of dark hues of a particular gem as being male while lighter hues were female.

Then, there were the carved or engraved gems, of which seals are only one example. Carving or engraving certain symbols on a gem was often believed to enhance the power of the gem. The Egyptian scarab, for example, signified immortality. The scarab is actually a beetle that lays its eggs in dung and rolls the clump until it becomes round and hardened. Since the eggs, as well as the immature or pupal stage of the beetle, are hidden by the dung, the beetle appears to come fully grown from the dung. As a result, the round ball represented the world to the Egyptians, with the beetle seeming to represent reincarnation and immortality. The scarab carving, therefore, was more important than the gem itself, and many gems were used, regardless of whether the scarab was worn as a ring, pendant, bracelet, or other jewelry.

Another symbol found in cultures as different as the American Indian and the ancient Persian, with slight variations, is the swastika. Despite its association with Hitler in the twentieth century, the symbol is an old one and the name comes from a Sanskrit word having to do with one's welfare or good luck. It has been explained as representing the four cardinal points of the compass (east, west, north, and south); lightning, fire, or water; or even the human form. In later years, attempts have been made to relate it to the cross. Whatever the original symbolism and however it was used before Adolf Hitler, it was always engraved as a good luck charm.

Carvings could also be made of the heads or figures of animals. A lion carved on a garnet would preserve the health and wealth of the wearer. A ram on a sapphire exalted the wearer with dignities and honor. Quartz carved with the figure of a man with one hand upraised was said to be powerful against lawsuits.

Today, some of these beliefs may seem amusing. At the same time, they are still with us in the shapes and forms of jewelry, not to mention the gems themselves. Birthstones, for example, are supposed to confer special gifts on the persons wearing them who are born in the particular month for which they stand.

The idea of wearing your own birthstone is relatively recent, dating back only to eighteenth-century Poland. The idea of a gem for every month is far older. It is tied in with the number 12: the 12 months of the year, the 12 signs of the zodiac, the 12 apostles of

Christ, and originally to the 12 tribes of Israel and the breastplate of the high priest Aaron.

In Exodus, one of the oldest books of the Bible, God gives instructions for the making of the breastplate. On it, in four rows of three stones, are to be set different gems on which are carved the names of the tribes of Israel. Although the gems differ depending on the translation, what is striking is that the gems are 12 different colors. They were most likely either red jasper or carnelian, topaz or peridot, garnet, emerald, sapphire, diamond, amber or brown agate, gray and white banded agate, beryl, amethyst, onyx, and green jasper. The colors may have been more important than the gems. Those were war-like times, and the colors could well have represented battle flags, "colors" in another sense, under which the tribes rallied in times of war and for which they looked when separated from the rest of the troops in battle.

In the Book of Revelation in the New Testament, the number 12 and the same or similar stones are used for the foundation stones of Jerusalem. These stones are sometimes called the apostolic stones, because each stone was later associated with an apostle.

Since the number 12 was also the number of signs in the zodiac and of months of the year, the next step was to assign certain gems to certain times of year. The idea of a particular stone being particularly powerful during a given period of time, therefore, has ancient roots. The original idea, in fact, seems to have been that the gems were worn as charms or talismans in turn, with the gem changing with the month or sign of the zodiac. Although a first-century Roman writer and Saint Jerome in the fifth century suggested that wearing the gem of the month in which one was born was enough, the suggestion did not gain popularity until the eighteenth century. Even then, the order and the types of gems varied from country to country and from one time to another. There was so much variation, moreover, that in 1912 the National Association of Jewelers in the United States finally drew up a list which received the association's approval and is the one followed today.

Appendix IV lists the birthstones along with the significance of each stone. In case the gem for your particular month does not please you, you might want to consider wearing the gem for your sign of the zodiac. Since these gems have not been established as the birthstones have, the list in the appendix is from a seventeenth-century source that has been accepted by at least some experts.

Remember, in both cases, if you cannot afford the original gem, substitutes are available in most cases, and these are given under the individual gems below.

GEMS

AGATE

See Quartz

ALEXANDRITE

See Chrysoberyl

AMBER

Amber is the fossilized resin of ancient or extinct trees, an organic material rather than a mineral, as most gems are. Its hardness is between 2 and 2½ on the Mohs scale. It is so soft that it can be easily cut with a knife and so light that it will float on sea water, which is heavier than fresh water. Although it is usually yellowish, reddish, or brownish in color, it may be blue, green, white, or black. Antique genuine amber is a collector's item.

Amber is found along seashores, especially in the Baltic, and is mined. Sicilian amber is distinctively dark red or orange; Rumanian amber, brownish yellow; and Chinese amber from Burma, dark brown to brownish yellow.

Amber is generally cut into cabochons and is rarely faceted, because of its softness. It is better for jewelry other than rings, since rings are more easily scratched.

Amber has been used and prized for personal adornment since ancient times. In Greece, it was called *electron,* from which the word *electric* comes, since it becomes charged when rubbed on cloth and can pick up bits of paper and other light objects. The Baltic islands where it was found were known as the *Electrides* by the Greeks and as the *insulae glessaridae,* or Amber Islands, by the Romans.

Amber Substitutes. The electrification of amber is a good test for it. Opaque amber, in particular, is easily imitated in plastic—

sometimes called "ambre antique"—as well as glass. Copal, another resinous material, is not amber and is so much softer that it can be scratched by a fingernail. Another substitute is amberoid or ambroid, which is reconstructed or pressed amber. That is, bits of amber and sometimes copal are pressed together under heat and pressure to form a single block. Amberoid has the same properties as genuine amber and can be detected only under a microscope. A difference is that natural amber darkens with age, while pressed amber tends to turn white.

Care. Special care is needed. See Chapter 9.

AMETHYST

See Quartz

APATITE

Apatite has a hardness of 5 on the Mohs scale and comes in a variety of colors that resemble those of more precious stones, such as tourmaline, emerald, and beryl. Cat's-eye apatite can have distinctively lovely eyes. Although the stone is relatively soft, it can be cut into faceted gems. A pale yellow apatite, sometimes called asparagus stone, is found in the European Tyrol.

AQUAMARINE

See Beryl

AVENTURINE

See Quartz

BERYL

Beryl is the name of a species of gem that comes in a variety of colors and is known more familiarly by other names, according to those colors. All beryl is 8 on the Mohs scale, with low cleavage properties, making it durable. The value of beryl increases with its rarity.

Emeralds, green beryl, are the rarest and most valuable beryl.

Aquamarines, the next most valuable beryl, are blue or blue-green. Rose pink beryl is known as morganite named after the banker J. P. Morgan, who was a gem collector. Golden yellow beryl is known as golden beryl or heliodor, while colorless beryl is called goshenite. Although the latter three colors are not well known, they make beautiful and durable gems.

Aquamarines. Aquamarine is beryl that is a sky-blue, greenish blue, or bluish green, shading from intense to pale colors. The best colors are the intense shades, like the sea water from which it gets its name. The color also accounts for the legend that the gem is supposed to be invisible when placed in the sea. Deep sapphire-blue aquamarine is rare in nature, but greenish and some yellow-brown beryl turn blue when heat-treated. Heat-treating changes the color permanently, and there is no way to prove the color is not natural.

Aquamarines, unlike emeralds, are often free of inclusions—so often, in fact, that it is taken for granted that an aquamarine is flawless. The most expensive gems are a deep blue with no tint of green, and the best aquamarines come from Brazil. The lighter shades, however, can be very attractive and a good buy.

Aquamarine has been valued since long before the Egyptians. Because of its association with water, it was considered to be good luck for sailors or those traveling on water. Other superstitions linked it to good luck and everlasting youth. In addition, wearing an aquamarine was supposed to protect the wearer from poison.

Aquamarine Substitutes. There are no synthetic aquamarines on the market. Altered stones are more common, such as the heat-treated deep blue aquamarine. Unlike heat-treated stones in which the color change is permanent, irradiated stones of the same deep blue color will bleach to yellow or tan in sunlight and heat and eventually turn colorless.

Oriental aquamarine is beryl of the distinctive blue-green color of sapphires. Blue topaz, synthetic blue spinel, and even glass can be cut to resemble aquamarines.

Emeralds. Only intensely deep green beryl is known as emerald. Color, therefore, is the first consideration, followed by lack of flaws or inclusions, and size. An entirely flawless emerald is rare. Emeralds tend to have numerous and typical inclusions, and large emeralds may also have cracks and be cloudy. Such emeralds require care in mounting and in wearing. Although they may be cabochoned and

even engraved, the most popular cut is the emerald or step cut. Almost all emeralds come from Colombia, where a mine at Muzo has been a source of emeralds for more than 350 years. Emeralds have been found in the eastern United States, particularly in North Carolina.

One of the largest, most beautiful emeralds in the world is the Hooker Emerald. The clear, deep green gem surrounded by diamonds is supposed to have adorned a Turkish sultan's belt buckle at one time. It is now on display at the Smithsonian Institution in Washington, D.C.

Emeralds have always been admired and revered. The Greeks, for example, dedicated the gem to Venus, the goddess of love, despite the fact that its subtle changes of color were thought to prove how inconstant love is. Others who worshipped the emerald were the ancient Peruvians, who were supposed to have one the size of an ostrich egg. When Pizarro conquered Peru, he found a vast treasure of emeralds that he sent to Spain. Cortez also confiscated emeralds in Mexico, although the emeralds probably came from Colombia originally.

Wearing emeralds and gazing into them was supposed to cure eye troubles. They were thought to enable people to foretell the future, to be an antidote for enchantments, to make people honest and more intelligent, and to be a cure for certain fevers and illness when they were ground into a powder and drunk with wine. Interestingly enough, the fire from an emerald was supposed to kill a snake. Yet Cleopatra, who owned an emerald mine, died from a snake bite. Emerald beads and scarabs have been found in Egyptian tombs and can be seen in many museums.

Emerald Substitutes. Any qualifying word other than *true* or *genuine* used with an emerald should be a warning. Oriental emeralds, for example, are green corundum (sapphire). Evening or morning emeralds are also stones other than genuine emerald, as are cape and lithium emeralds.

Emeralds have been synthesized in the laboratory since 1912. They are manufactured in the United States, Germany, and France as well as other countries. These synthetics may even have inclusions and can be detected only through examination with a microscope. Sometimes, they are so good that additional gemological testing is required. They may be called *created, simulated,* or *synthetic* emeralds.

Soudé emeralds are doublets of clear, colorless quartz that have been glued together with green cement to give a green color.

Heliodor, Goshenite, and Morganite. Although these gems are not well known, they can be spectacular. They can also be quite large in comparison to emeralds and aquamarines. These gems and a pale green beryl (called green beryl) are relatively common and can be inexpensive since there isn't much demand for them, making them good buys. As with aquamarine, they are durable and require minimum care.

BLOODSTONE

See Quartz

CAMEO

A cameo is not a gem itself. It is a form of carving or engraving a stone or other material in a raised low relief. (See Chapter 3.)

If the cameo is stone, such as layered jasper, it has the same qualities as that stone. If it is shell, as Italian cameos are, it has the same qualities as shell. The larger the cameo and the greater the detail, the more desirable and expensive it is.

Shell cameos are reasonably tough, despite being soft. Although they tend to scratch, with reasonable care they are durable. They are *not* durable, however, in the sense that gemstones are. Cameos tend to disintegrate over a long period of time, but cameos several hundred years old are found in museums. Thus, a cameo from "Roman times," when cameos were popular, is an impossibility. Such shell cameos have to be fake.

CARNELIAN

See Quartz

CAT'S-EYE

See Apatite, Chrysoberyl, Quartz, and Tourmaline

CHALCEDONY

See Quartz

CHRYSOBERYL

Chrysoberyl, which is 8½ on the Mohs scale, is very hard, ranking third after diamond and corundum in hardness. It has no distinct cleavage and is brittle, with a limited color range. *Transparent* chrysoberyl ranges from yellow and brown to blue-green and olive. *Translucent* chrysoberyl is called cat's-eye chrysoberyl and is noted for its chatoyancy and cat's-eyes. Although rare and highly desirable to collectors, chrysoberyl is relatively unknown except for the cat's-eye variety.

Alexandrite

A relatively new discovery, alexandrite is rare and extremely expensive, it is dichroic, showing two colors depending on the light. It was discovered in the Russian Urals in the 1830s. Miners looking for emeralds found some gems that looked like emeralds, that is, until they took them back to camp. There, they noticed that in firelight the stones turned red. The mysterious gem was named alexandrite in honor of the heir apparent to the Russian throne, who later became Czar Alexander II. It became popular in Russia because its colors— red and green—were the colors of Imperial Russia. The stone is also found in Ceylon, where the stones are less emerald in color and are a browner red.

Alexandrite Substitutes. Alexandrite has been synthesized in the laboratory with a distinct and beautiful color change. Synthetic alexandrite is not cheap, however. It may sometimes be called Alexandrine. What is often sold to unwary travelers in other countries as "alexandrite" is a cheap synthetic corundum with a color change from blue-gray to lilac. Considering the high cost of genuine and even synthetic alexandrite, a cheap price is a tip-off that the gem is not what it is supposed to be.

Cat's-eye Chrysoberyl. Historically, the only genuine cat's-eye is the cat's-eye chrysoberyl. The most desirable cat's-eyes are yellowish or greenish yellow that show a narrow slit of silvery blue light. Gray, gray-green, and brown colors are less desirable, as are cat's-

eyes that are broad, dull, or white in the formation of the slit.

Cat's-eyes have traditionally been supposed to bring good luck to the wearer—and to avert the bad luck associated with the number 13. They are also supposed to ward off evil spells, to protect the wearer from financial ruin, and to be good for asthma.

Cat's-eye Substitutes. Cat's-eye chrysoberyl has not been synthesized. Cat's-eye effects, however, occur in many different stones, none of which is as valuable or expensive as chrysoberyl. For this reason, make sure you know what the gem is.

CHRYSOPRASE

See Quartz

CITRINE

See Quartz

CORAL

Coral is not a mineral but an animal product—the calcified accretion of a marine animal called the coral polyp *(Corallium rubrum)* that creates what we know as coral as its home. Coral comes in many colors: white, a pale red or pink called Angel Skin or *pelle d'angelo,* orange, rose, and several shades of red. Deep red coral may be called "oxblood" coral and is one of the most valuable, although color preference can depend on local tastes. In Europe, for example, Angel Skin is more popular. Black coral (see below) is entirely different from this kind of coral.

The hardness of true coral is about 3¾ on the Mohs scale. It may be polished in natural sprigs or twigs, but is tough enough to be carved into beads, cabochons, and cameos.

In ancient Rome and much later, red coral was associated with health. The coral was supposed to lighten in color and become pale if the wearer were ill or even exposed to illness—or were given poison. The coral would then darken as the wearer recovered. The same attribute was associated with a woman's menstrual periods, which the coral was supposed to "share" with women. Coral was also associated with stopping the flow of blood from a wound, curing

madness, imparting wisdom, and calming storms. The magic held good only if the coral were in its natural shape and not carved. Once broken, the coral lost its powers.

Good coral can be expensive. Again, price may be an indicator of whether the coral is genuine or a substitute.

Coral Substitutes. Gypsum, a soft mineral readily scratched by a fingernail, is sometimes sold as coral. Plastic, wood, and wax are other substitutes.

Black Coral. Black or king's coral is not true coral. Rather, it is the skeleton of another kind of polyp *(Antipathes spiralis),* not a calcified accretion. It is much lighter in weight and is found in far fewer places. One of those places is parts of the Caribbean. Because of overharvesting, it has been placed on the endangered species list, which means you should inquire about an import certificate before buying it.

CORDIERITE

Cordierite or iolite is an inexpensive gem, from 7 to 7½ on the Mohs scale with no definite cleavage, making it fairly durable. Although it comes in several colors, the only one you are apt to see is blue, which is sometimes called "water sapphire." A major difference between blue cordierite and sapphires is that cordierite is trichroic, showing a sapphire blue, light blue, and colorless. It may be cut to show only the light and dark blue. Since only perfectly transparent cordierite is cut for gems and most stones are imperfect, cordierite is not important as a gemstone.

CORUNDUM

Corundum is the species name of ruby and sapphire. Its hardness of 9 on the Mohs scale makes it the second-hardest mineral. It is also tough and durable with low cleavage properties. The luster is not adamantine or diamond-like but is vitreous or glassy. Rubbing corundum with leather or cloth electrifies the stone.

If corundum is red, it is ruby. If it is any other color, including the "sapphire blue" usually associated with sapphires, it is sapphire. Rubies and sapphires may be transparent or translucent with stars.

Rubies. A ruby must be a vivid red, ranging from medium to dark red in shade. The most precious ruby is the pigeon blood ruby

from Burma. If it is light or pale pink, it is more properly a pink sapphire. Large, flawless rubies—like emeralds—are rare and are more expensive than diamonds. Since color is the result of impurities, in this case, chromium, rubies may contain flaws. A star ruby is the result of specific flaws or inclusions. The three intersecting lines should be centered, and the six points clearly defined. Star rubies are rarer than star sapphires, with perfect star rubies even rarer.

Rubies have been valued throughout the ages, their red "fire" often being associated with fire itself, with the result it was thought they could boil water or melt wax. To the Hindus, rubies were the Lord or King of Precious Stones, and they divided them into four castes. The best ruby was the Brahmin ruby, whose owner was kept safe even in the midst of his enemies. Such a ruby was never to be kept with inferior rubies or it would lose its potency. The ruby's virtues have included other qualities at various times, such as removing evil thoughts, controlling amorous desires, dispelling pestilential vapors, and reconciling disputes to assure the owner of a life of peace and contentment. More specifically, the ruby was supposed to be a cure for flatulence or gas and biliousness.

Ruby Substitutes. Rubies were the first gems to be synthesized in the laboratory and are produced in volume today. Some of these synthetics may be so perfect that only exacting gemological analysis can detect them, although many can be detected with a microscope because the inclusions are identical. Star rubies are also manufactured. They are so perfect that they can be easily detected. Both are inexpensive.

Beware of any qualifying word used with ruby. Ruby spinel is spinel, a gem so much like ruby in appearance that it has often been taken for ruby in the past. The Black Prince's Ruby in the British crown is a spinel, for example, not a ruby. Ruby spinel may also be called balas (ballas) ruby. Cape ruby and Adelaide ruby are names given to red garnet, Bohemian ruby is rose quartz, and Brazilian ruby is red tourmaline. Oriental ruby may be any of a variety of stones.

Sapphires. Sapphire is corundum of any color except red. It may be white, green, yellow, or purple. Some of the colors may be sold under other names. An aquamarine color may be called "Oriental aquamarine"; a deep green, "Oriental emerald"; a yellow-green, "Oriental chrysolite"; a pure yellow, "Oriental topaz"; a yellowish or brownish red, "Oriental hyacinth"; and a violet-ruby color, "Oriental amethyst."

The rarest, most expensive, and most desired sapphire is the rich blue described as being cornflower or velvet blue, with a slight tinge of violet. Kashmir in the Indian Himalayas produces some of the finest sapphires. Burma and Ceylon also produce fine sapphires. Australian sapphires tend to be dark. One problem with sapphires is that the darker blue they are, the more they are apt to appear dead or black at night. For this reason, a lighter blue is preferable to a darker blue if you cannot get a true sapphire blue.

Although star sapphires are more common than star rubies, fine stars are rare. While inclusions are necessary for the distinctive chatoyancy, too many inclusions can cause the gem to be whitish or cloudy.

Sapphires have always been considered precious stones. They became particularly popular after the twelfth century when the Bishop of Rennes praised the stone lavishly. It began to be considered ideal for ecclesiastical rings because it symbolized chastity. At the same time, it was popular with witches and magicians, since it was supposed to enable them to understand even the most obscure oracles and influence spirits. Another attribute of sapphires was their curative power for boils and eye diseases, which was a power attributed to all blue stones. In addition, sapphires were supposed to protect the wearer from envy and captivity.

Star sapphires are potent in their own right. They have been called a stone of destiny, with their three intersecting lines representing Faith, Hope, and Destiny. They were also thought to ward off bad omens and the Evil Eye and to act as a guiding star. Still another attribute makes this sapphire unique as a talisman—it is supposed to continue to protect the original owner even when that person has sold the star sapphire or given it away. One of the largest star sapphires is the Star of India, which weighs 563 carats, and is on display at the American Museum of Natural History in New York City. In contrast, the Rosser Reeves Star Ruby at the Smithsonian Institution in Washington, D.C., is only 138 carats.

Sapphire Substitutes. Sapphires, like rubies, are easily synthesized, both in transparent and star forms. Gems that closely resemble sapphires are cordierite ("Water Sapphire"), blue tourmaline, blue topaz, and blue spinel. All of these stones are much softer than corundum and are easily scratched by it.

DIAMOND

Books could be—and have been—written about the diamond. Diamonds are pure carbon, and the nearest relative is graphite. Yet, the hardness of diamonds of 10 on the Mohs scale makes them unique and desirable despite their high cleavage properties, while graphite is so soft that it is used as a lubricant. The hardness accounts for a word such as *adamant,* which comes directly from *diamond,* and means unyielding and inflexible.

White or colorless diamonds are the most valuable, although diamonds cover the spectrum in color. Only the best diamonds are used as gems, although "best" means "best in comparison," with the rest being used for a vast range of industrial purposes.

Diamonds, like gold, are found on the surface near rivers or streams, on beaches, and deep within the earth. The surface diamonds are naturally the first to be found and lead to the digging of mines. Almost all diamonds nowadays come from mines. About 10 tons of rocks will produce several small diamonds adding up to 1 carat, but 250 tons must be processed to produce a single rough diamond large enough to be cut into a 1-carat stone. In proportion, much more than 250 tons of rock is needed to produce even larger stones. Thus, a 1-carat stone is much more expensive than two 0.5-carat stones, and a 2-carat stone is more than twice the price of a 1-carat gem.

In addition, according to one expert, flawless stones get increasingly rare the deeper the mines are, which is why there may be no more top-quality, large stones in another thirty or forty years. As it is, top-clarity and top-color stones account for only *2 percent* of all diamonds.

The value of a diamond is determined by the "four *C*s"—carat weight, color, clarity, and cut. Which is more important can depend on to whom you talk. How large a diamond you buy can depend on your pocketbook, but the best investment is usually a brilliant-cut diamond (see Chapters 3 and 5) since other cuts can depend on fashion. Experts disagree on whether a flawless diamond that is off-color is better than a white diamond that may be slightly flawed. If color is important, you may be happier with a white, slightly flawed diamond. On the other hand, you may prefer the slight color, and colored diamonds, which are called "fancies," do have a following.

The marketing of both gem and industrial diamonds, regardless

of where they are mined, is controlled by the Diamond Trading Company owned by DeBeers Consolidated Mines, Ltd., a publicly held stock company. One purpose is to control the supply of industrial diamonds. Women may be able to do without their diamond engagement rings, but industry needs diamonds for many purposes. In effect, then, DeBeers also sets the prices of diamonds. At one time, the United States considered a suit against the monopoly, but it was dropped because of the need for industrial diamonds. The Russians have gone along with DeBeers in marketing their rough (uncut) diamonds. The reason is profit. In an uncontrolled market, the prices of all diamonds would be affected: flooding the market might ruin the economies of countries like the Union of South Africa, but it would also reflect on the Soviet income from their diamonds. As a result, the price paid is a worldwide one.

For this reason, you should be wary of diamonds advertised at great reductions in prices. While prices can vary because of markup and overhead, diamonds of top clarity and good color are too valuable to be sold at cut-rate prices. One further note on prices: at times, DeBeers has been suspected of holding back diamonds to make them scarcer and demand a higher price. Whether or not this is true, the prices of diamonds have increased in recent years—but so have the prices of all other jewelry, and especially of gold jewelry.

In the United States, the terminology that can be used with diamonds is controlled by the Federal Trade Commission. A diamond can be called flawless but not perfect. "Perfect" is meaningless. What flawless means is that the diamond shows no flaws when magnified to 10 times the size you see it with the naked eye, although greater magnification may show flaws. In addition, a diamond can be white but not blue-white. A white diamond is a transparent, colorless diamond, and all such diamonds will show blue flashes due to dispersion of light, called "fire," depending on the inclusions. Blue-white, therefore, is not a descriptive term. In other countries, other terms may be used, some of which are misleading. One term is "eye perfect," meaning only that no flaws can be seen with the naked eye—although flaws might be seen under 10-power magnification. In short, be wary when you hear any terms with which you aren't familiar and be sure to ask what they mean.

The history of diamonds is so old that it is lost in time. In addition, many other clear and colorless gems were once confused with diamonds, despite the fact that they are not as hard. For one

thing, diamond cutting, as we know it today, began only about five hundred years ago. Before that time, gems were generally polished in their original shape. Thus, many gems were confused with diamonds, including white sapphire, topaz, zircon, beryl, and even crystal quartz. For example, the Braganza weighs 1,680 carats and was part of the Portuguese crown jewels. It came from Brazil and is probably a topaz, according to experts.

Diamonds, nevertheless, summon up numerous attributes. Although they are brittle and not tough, diamonds were supposed to be indestructible. Their history begins in India, where almost all diamonds came from in olden times and where diamonds were traded at Golconda at least four centuries before the birth of Christ. India was more than the one-time sole source of diamonds, it was also the source of many legends concerning what was called the King of Gems. Diamonds were the symbol of wealth and power, of fearlessness and invincibility, and of modesty and purity. The Hindus put diamonds in four castes according to color, and only kings were allowed to possess red and yellow diamonds. Their virtues were often supposed to be powerful only if the diamond was a gift. Purchasing a diamond caused it to lose its powers.

One of the most famous diamonds in the world, in fact, is more noted for bad luck than for good luck. The magnificent, deep blue Hope Diamond, now at the Smithsonian Institution in Washington, D.C., is thought to have been cut from the French Blue. That gem became part of the crown jewels of Louis XIV in 1668. Marie Antoinette was supposed to have worn it once before going to the guillotine. The French Blue was stolen along with other of the crown jewels in 1792. Then, in 1840 a 44.5 carat stone, identical in color, appeared on the market. It was probably cut from the original stone and was bought by Henry Thomas Hope of England, from whom it got its present name.

Despite its name, tragedy seemed to follow it. One owner, while she was wearing it, was killed by her husband. Another drowned at sea. Mrs. Evalyn Walsh McLean, who owned it in this century, associated it with bad luck in her family. After her death, it was bought from her estate by Harry Winston, Inc., who gave it to the museum.

Aside from luck, good or bad, diamonds had medicinal associations, also good and bad. They were thought to cure jaundice, pleurisy, and leprosy. How efficacious the remedy is was demonstrated

by Pope Clement VII, who in 1534 was treated with diamond powder and the powders of other precious gems and died anyway. Diamonds were additionally supposed to protect their owners from the plague, a superstition that may have a grain of truth to it since the poor were the first to suffer because of the living conditions of the time.

Diamonds were associated with poison, too. In some cases, they were supposed to darken in the presence of poison, while in others they were an antidote. Interestingly enough, some people considered diamonds a potent poison. The goldsmith Benvenuto Cellini, when he was imprisoned in 1538, believed his enemies were poisoning him with diamond dust after he found a sliver in his food. To his relief, the gem cutter who had been paid to grind the diamond had substituted another gem and had kept the diamond for himself and his poor family. In England, during the reign of James I, the Countess of Essex used diamond dust as a slow poison to do away with an enemy.

In short, a diamond can do whatever you want it to. It can chase nightmares, produce sleepwalking, and even make the wearer invisible. Watch out that you don't put a diamond in your mouth, however, because it can fracture teeth.

India lost its prominence as a diamond center in 1725, when diamonds were found in Brazil. Prices of diamonds fell and fear that they would fall even further made Brazilian diamonds difficult to market. As a result, they were sent to India, where they could be sold as Indian gems. The discovery of diamonds in 1870 in South Africa changed the diamond market even further. Few, if any, diamonds are found any longer in India or Brazil, with the vast majority of the world's supply coming from South Africa, although diamonds are found in other countries, including the U.S.S.R., Australia, Borneo, other parts of Africa, the United States, and Venezuela.

If you would like to try your hand yourself at finding diamonds, the only place you can go where diamond mining is not strictly government controlled is Crater of Diamonds State Park in Murfeesboro, Arkansas. In fact, it is the only diamond mine in the world where you can keep what you find, regardless of value. Although most of the diamonds are industrial diamonds, gem-quality diamonds—as well as opals, amethysts, and quartz—have been found. The largest was the 40.23-carat Uncle Sam Diamond, found in 1924. Other large diamonds from this mine are the 34.25-carat Star of

Murfeesboro, the 15.31-carat Star of Arkansas, and the 16.34-carat Amarillo Starlight. Experts are on hand to weigh and certify finds, and the only charge is for admission to the park.

Diamond Substitutes. In the past, various transparent white gems have been used for diamonds. None has the diffusion or fire of a real diamond, and such substitutes can easily be detected today. Over the years, the value put on diamonds has meant that a substitute has been sought. General Electric has produced a diamond in the laboratory with the same hardness and dispersion as a natural diamond. It is, in fact, a real diamond of pure carbon, but the cost of making it is so high that it has no advantage over natural diamonds.

Other synthetics have not been as successful. Two of these are Yttrium Aluminum Garnet (YAG) and Gadolinium Gallium Garnet (GGG). While YAG has a hardness of 8, it is low in dispersion with none of the fire of a diamond. GGG is as hard as YAG and has about the same dispersion as a diamond, but it tends to turn brownish with wear. Another synthetic is synthetic rutile, called Titania. Although natural rutile is opaque and red, synthetic rutile can be made in any color, including the transparent white of a diamond. The problem is that it is relatively soft and shows too much dispersion. More important than any of these is a synthetic stone called Cubic Zirconium or Zirconia developed by the Russians in the late 1960s and now being manufactured in the United States under both of those names as well as trade names such as Diamonair II. With a hardness of 7½ to 8½ on the Mohs scale and a refractive index and dispersion that balance out to come startlingly close to a genuine diamond, it can fool even an expert without a magnifying lens.

Diamond doublets are another substitute. The top is genuine diamond, and the bottom is another material.

EMERALD

See Beryl

FELDSPAR

Feldspar is one of the most common minerals on earth. With a hardness of 6 to 6½ on the Mohs scale, it is relatively soft for gem use, although several types of feldspar are used in jewelry. It has good cleavage properties.

Moonstone. Moonstone is the best-known feldspar. Nearly opaque moonstones may be pink, green, yellow, beige, brown, gray, or white. They have a distinct sheen with a spot of light concentrated at the top. This light may be in the form of a cat's-eye, and the gems are called cat's-eye moonstones. The more familiar moonstone is colorless and translucent, reflecting a bluish or milky or silvery light when the gem is turned.

Moonstones were popular for all types of men and women's jewelry until about the mid-1920s. They have always been highly favored in the Orient, where the opalescence is said to be due to a living spirit in the gem. In India, it was a sacred stone. Because of their relationship with the moon, moonstones are supposed to dim and regain color with the waning and waxing of the moon. In addition, if a moonstone is put in the mouth at the time of the full moon, it will tell whether you are lucky or unlucky in love. It is also supposed to arouse love and cure epilepsy and nervousness.

Sunstone. Sunstone is similar to moonstone, except that the color is a golden brown. It has a brilliant red reflection or glitter, like the sun, which is the reason for its name.

Other Feldspar. Other feldspars may be used in jewelry, but they are mainly for collectors. Orthoclase is transparent and a golden yellow in color; it is found in the Malagasy Republic. Amazon stone is green, sometimes tinged with blue, and usually opaque. Since it has no luster when polished, it is used in jewelry mainly for the color. Labradorite may be transparent yellow, although more often different colors form in layers that result in a play of lights in the stone.

Substitutes. None.

GARNET

When we think of garnets, we think of a red or purple stone. Nothing could be further from the truth. Garnet is only a species name for a number of gems, some of which are red and some of which may be a variety of colors. The hardness varies from 6½ to 7½ on the Mohs scale, and there is no distinct cleavage, making it durable.

The name comes from the Latin word for pomegranate, because garnet crystals in rocks looked like pomegranate seeds. Garnets were far more important in olden times than today. They have been found in Egyptian tombs, and the carbuncle that lit Noah's Ark during the

flood was a garnet. Today, a carbuncle is still a cabochon-cut garnet, although any red gem might formerly have been called a carbuncle.

A garnet was a remedy for bleeding and inflammatory diseases. In fact, it was a cure-all. It was supposed to prevent incontinence, to be a heart stimulant, protect travelers, and preserve one's honor and health, especially when carved with a lion. You could get "too much" of a garnet, however, in which case the heart stimulation could become a heart attack or bring on insomnia.

Almandine. This is the most common garnet, ranging in color from a dark red to a brownish red. It is probably the original carbuncle. Adelaide rubies are almandine garnets.

Pyrope. Pyrope is so similar to almandine that they are often confused, even by experts, because a gemological examination of their chemical and other properties is needed to tell them apart. Their low cost makes this kind of an examination impractical. The finest pyrope is blood red and resembles the ruby in color. It may be tinged with purple or brown. Cape rubies from South Africa are pyrope.

Demantoid. Demantoid is green, shading to a yellow-green. The best emerald-green demantoid is expensive and rare.

Rhodolite. Rhodolite is another rare garnet. It is purplish red in color, shading to an amethyst-violet. Other types of garnet are sometimes called rhodolite, but the difference in price makes gemological and especially chemical testing a necessity to make sure the gem is rhodolite.

Other Garnets. Grossular garnet, which comes in many colors, and spessartine, which is reddish brown to yellow-orange, are uncommon enough to be little known as far as jewelry is concerned.

Garnet Substitutes. Ironically, for a gem that is as common and as inexpensive as the well-known garnets are, there are several substitutes. Synthetic corundum and spinel may be used instead of genuine garnets for birthstone jewelry. Beware of the intrinsic difference between "genuine" and "synthetic," if you buy garnets. Why not buy the genuine stone for about the same price?

HELIOTROPE

See Quartz

IVORY

When we think of ivory, we think of ivory from the tusks of elephants. Whalebone and other bone are similar but nowhere as beautiful. Ivory has a spiral structure and a cross-hatched grain, with a soft, flat finish that makes it look waxed when polished. The color is an off-white or ivory. Bone, on the other hand, is white and drier looking.

Because elephants are on the endangered species list of the U.S. Government and other countries, the ivory trade is strictly regulated. Ivory from certain countries may not be imported into this country.

Ivory Substitutes. Bone is sometimes sold as ivory. So is plastic, which may be called French ivory.

Care. See Chapter 9.

JADE

As with diamonds, books have been written about jade. The Chinese called it *yu,* which means "a precious stone of great beauty." They revered jade above all other gems and valued diamonds as gifts because the diamonds enabled them to cut the tough jade easily. Despite the fact that jade is associated with China, it was also found and worshipped in Mexico by the Aztecs—and the name has Spanish origins. The Spanish conquerors called it *piedra de i jada,* or "stone of the loins," and *piedra de los rinones,* "stone of the kidneys," because of its reputed use to cure kidney disease. Sir Walter Raleigh is sometimes given credit for coining the word "jade" out of *i jada,* which he learned about from captured Spanish treasure ships. Another story is that the French called it *pierre de l'ejade,* which became *le jade* through a printer's error and was picked up by the English.

Jade is actually two separate and distinct minerals, as far as chemical composition is concerned. One is nephrite, which is calcium magnesium silicate. The name nephrite comes from the Latin translation of *piedra de los rinones* as *lapis nephriticus,* or kidney stone. Ironically, the jade found in Mexico wasn't nephrite; it was jadeite, which is sodium aluminum silicate. Nephrite is about 6½ on the Mohs scale, while jadeite is 7. Despite their comparative softness and the difference in hardness, both are among the toughest stones

known because of their fibrous composition and are cut and carved only with extreme difficulty.

Although we think of jade as being green, jade is naturally white, with impurities accounting for different colors. Both kinds come in a variety of colors, with jadeite coming in the widest range of white, pink, lilac, brown, red, orange, and black as well as green. Some jadeite will even combine several colors. Neither jade is ever transparent, but the more translucent it is, the more intense the color, the more valuable it is.

The original Chinese jade was nephrite. Although it may have been mined in China in ancient times, what we know about came from Turkestan. Only in 1784 was jadeite found in Burma and used to any great extent in China.

Regardless of the difference between the stones, however, the legends are similar wherever it was found. To the Chinese, it had all the cardinal virtues. Confucius said that it shone like benevolence, was strong and dependable like wisdom, had sharp edges like justice but did not cut, and did not hide its flaws like truth. Other attributes were endurance, beauty, and faithfulness in marriage. The Taoists, in addition, believed it possessed the magic elixir of eternal life.

The Aztecs used jade for many purposes, both decorative and practical. Jade axes, in fact, were made by the ancient Chinese and the Maoris in New Zealand, where jade was found, too. The value that the Aztecs put on it can be explained by one story. Montezuma is supposed to have given Cortez some stones called "Chalchithils," to be given to the Spanish king in his name. Each stone, Montezuma said, was worth two loads of gold. The stones were jade. According to another story, Montezuma told Cortez that he valued jade first, then turquoise, the green feathers of the quetzal bird, and finally gold.

In buying jade, you will be more apt to get nephrite than jadeite, since the latter is rarer and is becoming far more rare. One thing you will not find is very old, antique Chinese jadeite, since the Chinese made use of it only after 1785. Imperial jade usually refers to the brilliant green jadeite of Burma. Actually, "imperial" to collectors means that it belonged to the imperial collection before the downfall of the old empire, but the term has come to mean jade fit for imperial use.

Jade Substitutes. Many materials have been used as substitutes for jade, including plastics and soapstone. True jade cannot be cut

by a knife. If a blade is pressed and drawn against it, the knife will leave a black mark. If a white mark shows, the material is not jade.

Beware of other words used to describe jade. Soapstone and serpentine are often called "Soochow jade," after the city where it was originally made. "Jasper jade" is jasper; "pink jade," dyed quartz; "Mexican jade," dyed onyx; "India jade," adventurine; and "Australian jade," chrysoprase. Other names you are apt to find are American jade or Californite, Colorado jade, Fukien jade, Manchurian jade, Honan jade, Oregon jade, Silverpeak jade, Korea jade, Transvaal jade, Amazon jade, and a wealth of others. None of these is genuine jade, either nephrite or jadeite.

JASPER

See Quartz

JET

Jet is an extremely hard kind of coal. Although it has a hardness of only 2½ to 4 on the Mohs scale, it is very tough and durable—as anyone who owns antique jet can testify. It was popular during the Victorian era for mourning jewelry and was used in all forms of jewelry. Its toughness means it takes a good polish.

Jet Substitutes. Whitby, England, has been the source of the finest jet. Another variety of coal sometimes used is cannel coal, but it is very brittle. Other substitutes may be black glass, black onyx, black tourmaline, black garnet, and dyed chalcedony, all of which feel cold to the touch, while jet feels warm. Vulcanite, a form of rubber, and Bakelite, a plastic, are other substitutes. While jet is inexpensive and not popular today, it does have value to antique collectors—as long as it is genuine jet.

KUNZITE

See Spodumene

LAPIS LAZULI

Lapis lazuli has a hardness of 5½ to 6 on the Mohs scale. Its sky-blue color, sometimes flecked with white or gold from impuri-

ties, takes a good polish, making it as desirable today as in ancient times. The best lapis has a violet tint and comes from Afghanistan. Lapis from the Andes in Chile is paler, sometimes greenish, patchy in color with gray impurities, making it much less expensive.

The name comes from an Arabic word for sky or blue, *allazward*. Experts believe that it is the sapphire of ancient times, on which the Law given to Moses by God was written, since sapphires were not known in that part of the world and no sapphire could be large enough. The ancients, in fact, put lapis on a par with gold. It was good for the eyes, counteracted evil and the spirits of darkness, and was a cure for melancholy. Many of the treasures of Tutankhamen are gold and lapis lazuli. The Russians used lapis lazuli in building, and Catherine II had several rooms paneled with it.

Lapis Lazuli Substitutes. "Persian lapis" is what lapis from Afghanistan is sometimes called, but "German lapis" is dyed chalcedony. Glass and dyed agate are used to imitate the stone. A synthetic lapis produced in Paris is so similar to genuine Persian lapis that it even contains the same impurities.

MALACHITE

Malachite is only 3½ to 4 on the Mohs scale, but it is a vivid and attractive green. The best malachite has darker color bands, which add to its desirability. The stone was used for beads and cabochons since long before the birth of Christ, and mines in Sinai were worked as early as 4000 B.C. It was particularly potent as an amulet or talisman for children, whom it protected from evil spirits and insured peaceful sleep. It was also supposed to protect the wearer from falling. If it cracked or broke, the wearer could be sure that some disaster was impending. Malachite engraved with the image of the sun was particularly powerful, adding the light of the sun to the stone's ability to banish the spirits of the night and protect from enchantments.

The stone is common and not widely enough used for substitutes to be necessary.

MOONSTONE

See Feldspar

NEPHRITE

See Jade

OBSIDIAN

Obsidian has the same hardness as glass, 5 to 5½ on the Mohs scale. It resembles glass and is actually a kind of volcanic glass. It is opaque and brittle, breaking easily into sharp splinters. It may be black, gray, brown, yellow, red, green, or blue in one color or streaked. Tumbled gems are used in inexpensive jewelry. Native Mexican silver jewelry often contains black or gold obsidian cabochons, either plain or engraved.

The ancient Mexicans used obsidian for a variety of purposes, including weapons. So adept were they that they were able to strike an edge sharp enough for use as a razor or as a knife for their human sacrifices. Another use was as a mirror whose purpose was to foretell the future. One of these mirrors may have been used by a Dr. Dee, a fortuneteller favored by Queen Elizabeth I of England.

OLIVINE

See Peridot

ONYX

See Quartz

OPAL

Opals are the most fragile of all gems. They are between 5½ and 6½ on the Mohs scale. Although they have no cleavage, they are very brittle. Yet they are sometimes called the Queen of Gems because of their unique beauty. The name comes from a Sanskrit word, *upala,* meaning "precious stone."

Common opal is translucent or a milky gray or yellow and has no value unless it is transparent enough to facet. What we think of as opal is precious or noble opal. It has opalescence, a play of lights or fire of different colors that has been likened to the flash of fireflies against a snowy background. Not that all opals are white. The partic-

ular fire is due to inclusions that contain water, and an opal may contain as much as 10 percent water. For this reason, opals are far less durable than most other gems and no historic opals have ever been found.

The idea that opals are unlucky is relatively recent. To the ancients, opals were powerful amulets, protecting the wearer against myriad misfortunes, with even the power of rendering him or her invisible. According to Pliny, the Roman senator Nonnius had an opal that Marc Antony wanted. Given the choice of losing the opal or leaving Rome, he fled Rome and took only the opal with him. Opals were also supposed to be good for the eyes, and in Elizabethan England were called "opthal," from which ophthalmic, pertaining to the eyes, comes. In the Middle Ages, an opal necklace was considered good insurance by blondes that their hair would not darken or fade.

The association with bad luck has been traced to a novel, *Anne of Geierstein,* by Sir Walter Scott. An enchanted princess, Lady Hermione, wore a dazzling opal in her hair that reflected her moods, sparkling when she was gay, flashing red when she was angry, and losing its radiance when sprinkled with holy water. One day, she collapsed in a faint and was taken to her bed. The next day, all that remained of both her and her opal was a pile of ashes. The gem could have been any gem, but the fact that Scott made it an opal, even though he never alluded to it as being unlucky, seems to have led to that superstition. As a result, the Empress Eugenie, wife of Napoleon III, refused to wear opals, as did many other women. Queen Victoria, on the other hand, was so fond of opals that she gave them to her daughters as wedding gifts.

The bad-luck association may also be due to the fact that opals crack for no reason and are so fragile that they are difficult to mount or set. At any rate, if you are superstitious and like opals, have someone give you an opal. Giving an opal as a gift is supposed to remove any aura of bad luck.

Australia, with the best precious opal, is the major source. Other opals come from Mexico, Honduras, Nevada in the United States, and a few other countries. There are several different kinds of opals:

Black opals have color flashes against a black, gray, or blue-gray background. They are found only in Australia and are rare, despite the new find in 1978, and expensive.

White opals, described above, come from several places.

Fire opals are found only in Mexico and are called that because they are red, reddish orange, or orange-yellow. "Fire" is actually a misnomer in the sense that fire opals may or may not have the play of lights associated with that term—and usually do not.

Common opals include *water opals,* which are transparent, although they have the familiar play of fire or opalescence of opals. *Jelly opals* are translucent to transparent with a white body color. If common opal has a good enough color and fire, it may be faceted.

Opal Substitutes. Because of the thinness of veins of opal, slabs too thin to be made into cabochons may be used for doublets and triplets. Sometimes, white opal is cemented to the backing material with black glue, making it look like a black opal. Although opals—with the exception of the Australian black opal—tend to craze, that is, split into myriad cracks for no reason, doublets and triplets do not craze, perhaps because of the cement.

A Parisian firm has produced synthetic black and white opals that are so real they may need extensive laboratory testing to detect the synthetic from genuine opal.

Care. See Chapter 9.

PEARLS

Pearls are the Queen of Gems. If a diamond is like a knight of old, the pearl is his lady, pure and fair to look at and the symbol of modesty and purity.

Oriental pearls, regardless of where they come from and whether they are fresh- or salt-water, are natural pearls. Until the 1930s, all pearls were Oriental, and a well-matched strand could command a million-dollar price. Cultured pearls are natural but are "raised" at special pearl farms. With their introduction to the market in the 1930s, real pearls came within the reach of everyone instead of a wealthy few.

Both Oriental and cultured pearls are animal products, the result of a foreign body or object introduced into the shell of an oyster or, in the case of fresh-water pearls, of a mussel or clam. The mollusk defends itself by secreting a smooth hard substance, called nacre, in layers. The resulting pearl may take years to form. The only difference between Oriental and cultured pearls is that the foreign body accidentally gets into the pearl oyster in Oriental pearls and is im-

planted by man in pearl oysters in cultured pearls. One further note: pearls are *not* found in any or all oysters; they are found only in a specific kind of oyster. This oyster is not the kind you buy to eat in restaurants or fish markets.

Pearls have a hardness of 3½ on the Mohs scale. They come in a wide variety of colors, including several shades of white, black and gray, blue, green, red, yellow, purple, and violet. The five-point criteria used to determine the value of pearls are size, shape, luster, color, and surface. In general, the rounder the pearl, the more valuable it is. The luster should be luminous and deep-seated, not on the surface. The surface should be silky smooth and free of blemishes or roughness. The color should be subtle, pure, and clear. Rose or pink pearls are the most preferred, but the best color for you is the one that suits your skin color and hair. If pearls are matched, all pearls should be of equal size, regardless of that size. Graduated pearls should be symmetrically graduated.

Pearls come in many shapes. They may be round or pear-, egg-, or teardrop-shaped. Irregularly shaped pearls are called baroque pearls and can be lovely, while very tiny pearls are called seed pearls. Blister or mabe pearls are pearls that grow against a shell, forming half a pearl. They are used for rings, earrings, and pins where roundness in three dimensions isn't necessary. Biwa pearls are fresh-water pearls that come from Lake Biwa in Japan and are mussel pearls.

Pearls are said to bestow love, happiness, and good fortune on their owners. In ancient India, wise men held a "talisman pearl" in one hand to secure enlightenment. The ancient Greek word for pearl implied "perfect purity," while to the Romans it suggested sweetness and pleasure. They were also jewels of love, and Cleopatra is said to have dissolved pearls in wine as a love potion for Mark Antony. Green pearls were symbolic of happiness.

A more recent, true story about pearls concerns the world-famous jewelers Cartier. In 1916, Cartier sold a strand of Oriental pearls for $1 million. Instead of taking money, it exchanged the pearls for a house, then worth $925,000, on Fifth Avenue and 52nd Street in New York City; the area had become too commercial for the owners. In 1956, after cultured pearls had depressed the market, the pearls were auctioned in two strands for $151,000, but the house—still occupied by Cartier's—was worth $1,500,000.

Pearl Substitutes. Imitation pearls are plentiful and cheap. They are made of glass or plastic beads that have been dipped in an

enamel containing ground-up fish scales. Majorca pearls are imitation pearls.

Care. See Chapter 9.

PERIDOT

The major attraction of peridot or olivine is its unusual bottle-green color that may shade toward yellow or a true green. Despite its unique color and glassy luster, it has little brilliance and no fire and is relatively soft, with a hardness of 6½ on the Mohs scale. It has no distinctive cleavage, making it durable.

Peridot is sometimes called "evening emerald" since it turns bright green in artificial light. Gold colors were once called "chrysolite" or topaz because they came from Topazos, an island in the Red Sea now called Zebirget or St. John's Island. Brown peridot is rare, and most brown peridots are actually a stone called sinhalite that is not related to peridot. Peridots are also found in the United States in Arizona, in Burma, and in other countries.

The association of peridot with the sun meant that it could break evil spells and dispel the mysteries of darkness and bad dreams. It could also cure a variety of illnesses.

Peridot Substitutes. Synthetic spinel and even glass are used to simulate peridot. Spinel is harder than peridot, however. "Oriental chrysolite" is corundum, which is much harder.

QUARTZ

If quartz were less common and abundant, it might rank higher as a gem. It has all the other qualities to make it desirable—a hardness of 7 on the Mohs scale, no distinct cleavage, and beautiful colors in the transparent crystalline variety. The range of quartz is enormous, from a clear and transparent crystal to an opaque solid mass.

Crystalline Quartz

Amethyst. Amethyst is the most precious quartz, ranging in color from pale violet to deep purple. The larger the amethyst, the greater is the tendency for it to have flaws, with the result that large, flawless stones are rare. The name comes from a Greek word, *ame-*

thustos, which means "not to be drunken," and the stone was supposed to protect the wearer from overimbibing. It was also supposed to control evil thoughts, calm the passions, quicken intelligence, and make the wearer more shrewd. Perhaps for these reasons, it was often used in ecclesiastic rings. At any rate, it is all-powerful, with the ability to prevent warriors from being wounded, help the hunter find game, protect against disease, and put demons to flight—the last being particularly true if the stone were engraved with a bear. "Oriental amethyst" is corundum, a much harder stone.

Cairngorm. This is the name of a dark brownish or smoky yellow quartz found in Scotland's Cairngorm Mountains. It was highly popular in clasps used to fasten the plaid or shawl worn with the kilt in the Scottish national dress.

Citrine. Citrine is the French word for "lemon-colored" and describes the color of this yellow quartz, although the yellow may shade to red-orange and red-brown. Citrine comes mostly from Brazil. One problem is that the color is so similar to some topaz, a more costly stone, that it may be called "quartz topaz" or "citrine topaz."

Inferior-color amethysts, when heat-treated, turn shades of citrine, but citrine may be sold under names that seem to indicate it is topaz, such as "Palmyra topaz" for yellow-color stones and "Madeira topaz" for the reddish brown shades.

Milky Quartz. This quartz has a milky color, similar to moonstone but without the bluish sheen that makes moonstone desirable. However, it may sometimes be sold as moonstone.

Rock Crystal. Rock crystal is colorless and crystalline. Although it does not have the fire and brilliance of diamonds or zircons, it is often used as substitutes for them. It was popular during the Victorian period, and genuine rock crystal of that time has a value above its actual value to collectors. It was and is used for the crystal balls of fortunetellers. In ancient China and Japan, it was thought to be ice that had been frozen for so long it couldn't be thawed. The Japanese considered it the "perfect jewel," a symbol of purity and the infinity of space as well as of patience and perseverence.

Rose Quartz. Rose quartz shades from pink to rose and is usually somewhat cloudy, rather than transparent. It may occasionally show a weak star.

Smoky Quartz. Smoky quartz shades from a smoky gray color to black. Black quartz is sometimes called "morion." Again, the color

is similar to smoky topaz, and you should beware of names that incorporate "smoky" with other words to describe the stone.

Others. Transparent or crystalline quartz may occur in other colors. Deep blue quartz is rare and may be called "sapphire quartz," the sapphire referring only to the color. Iris quartz is also rare and has a flash and fire that are opalescent.

Cryptocrystalline Quartz

This variety of quartz ranges from translucent to completely opaque. The latter may be called chalcedony.

Agate. Agate is chalcedony that comes in a variety of colors and patterns. *Dendritic* agate has a pale background with a pattern that resembles trees or plants. *Moss* agate has a green moss-like pattern. *Snowflake* agate has a snowflake-like pattern against a dark background.

Agate was one of the first stones worked by primitive man and one of the first to be engraved. Some of its attributes were as a cure for insomnia, to make its owner prudent and cautious, and to bring victory in battle.

Aventurine. Aventurine is weakly translucent with a speckled, metallic sheen due to inclusions of small mica crystals. It is generally green, although it may be reddish brown, yellow, white, or blue.

Bloodstone. Bloodstone is sometimes called "plasma" or "heliotrope." It is an opaque green chalcedony dotted with red, which accounts for its name. The dots may also be white or yellow. Bloodstone with red markings was supposed to stop bleeding as well as lightning, thunder, and rain. The Aztecs carved it in the form of a heart.

Carnelian. Carnelian is opaque chalcedony ranging in color from a rich clear red to a yellowish and brownish red. It was often used for seals because wax doesn't stick to it. It protects the wearer from falling roofs and walls (good in earthquake country), brings good luck and bravery, and drives away phantoms. Another attribute is to bring comfort to women in pain.

Cat's-eye. Cat's-eye quartz is usually gray, black, brownish, olive green, and greenish yellow. It is chatoyant and the cat's-eye effect is sharp. While attractive, it has nowhere near the beauty and the value of cat's-eye chrysoberyl.

Chrysoprase. This is the most valuable and beautiful cryptocrys-

talline quartz. It is a rich, highly translucent green, sometimes called apple green. At one time, it was often mistaken for jade, and Australian jade is actually chrysoprase. It is lovely in itself and is to be prized for itself. If a thief was sentenced to death and placed a stone of chrysoprase in his mouth, the stone was supposed to help him escape his executioner. Chrysoprase has sometimes been called "victory stone."

Jasper. Opaque, colored chalcedony that doesn't fall into other categories is called jasper. It may be patterned or plain, comes in a wide range of colors (browns, reds, greens, yellows, etc.), and takes a high polish.

Onyx. Onyx is chalcedony with black and white bands. The black onyx sold today is generally any kind of artificially colored chalcedony, as is brightly colored "onyx."

Sardonyx. Sardonyx has bands of sard or carnelian alternating with white and sometimes black bands.

Tigereye. Tigereye quartz is translucent quartz that is highly chatoyant, with shimmering bands of brown or brownish yellow and yellow. A variety with blue and blue-green bands is known as hawk's-eye or falcon's-eye.

There are other varieties of quartz, but these are the ones you are most apt to find. The town of Idar-Oberstein in West Germany has been an important center for cutting all types of quartz, especially the chalcedonies, since A.D. 31.

ROCK CRYSTAL

See Quartz

RUBY

See Corundum

RUTILE

Natural rutile has a hardness of 6 to 6½ on the Mohs scale. It may be opaque or a deep red color. Although the natural form isn't important as a gem, synthetic rutile that resembles a diamond is a diamond substitute. See "Diamond."

SAPPHIRE

See Corundum

SPINEL

Spinel has a hardness of 8 on the Mohs scale, with no cleavage properties, and is durable. It is a brilliant gem that comes in a variety of colors. Yet, it is one of the most unfamiliar of gems, owing to lack of exposure. Of particular note is red spinel. It is so much like the rubies with which it is often found that in the past it was mistaken for ruby. As noted before, the Black Prince's Ruby in the British royal crown is actually red spinel.

The red may be purplish (almandine spinel), orangish (rubicelle), the rose red of ruby (balas or ballas ruby), or deep red (ruby spinel). Other colors include translucent grass green, dark yellow-brown, or green-brown. It may also be an opaque dark green, brown, or black.

Spinel Substitutes. Despite the fact that genuine spinel is unfamiliar and not expensive, synthetic spinel is in wide use. Interestingly enough, synthetic spinel—which has been made since 1915—is not used to substitute for itself as much as it is used to substitute for other stones, mostly in class rings and inexpensive birthstone jewelry. If you see "topaz," "aquamarine," or "tourmaline" used with the quotation marks, the stone is most likely to be synthetic spinel.

SPODUMENE

Most spodumene is an unattractive gray—with two exceptions. The exceptions are hiddenite and kunzite, both of which have a hardness of 7 on the Mohs scale and have high cleavage properties, making them fragile. Both are trichroic or pleochroic, and both were discovered in the nineteenth century in the United States.

Hiddenite. Hiddenite was discovered in North Carolina in 1879 and was named after A. E. Hidden, the manager of the mine where it was found. It is a deep green with low dispersion, but it shows emerald green, bluish green, and yellow-green, depending on the angle at which the light strikes it. It is sometimes called lithium emerald.

Kunzite. Kunzite was first found in Connecticut in 1879 and

about twenty years later in California. It gets its name from George F. Kunz, a famous American gemologist. Kunzite is colorless, violet, or deep violet in different directions.

Gem-quality spodumene has been found in other countries. Brazilian spodumene may be pink, yellow, and yellow-green, as well as violet.

SUNSTONE

See Feldspar

TANZANITE

Tanzanite is the only member of the zoisite family used as a gem, except for a pink variety called "thulite" found in Norway. Tanzanite has a hardness of only 6 on the Mohs scale, making it better for jewelry other than rings. The best Tanzanite is a rich blue with high dispersion that rivals the beauty of blue sapphire. Brown, pink, yellow, and green tanzanite may be heat-treated, which turns them a desirable violet-blue color.

Tanzanite is found only in Tanzania, near Mt. Kilimanjaro in East Africa, where it was discovered only in 1967. It was given the trade name of tanzanite by Tiffany & Co., which markets it in partnership with the government of Tanzania, which owns the mines.

TIGEREYE

See Quartz

TOPAZ

Topaz, with a hardness of 8 on the Mohs scale, is a brilliant and sparkling gem. It has high cleavage properties. Although we tend to think that all topaz is yellow and all yellow stones are topaz, topaz actually comes in a variety of colors. The most familiar topaz is yellow, shading from a clear yellow to a golden brown and darker shades. Other topaz may be a rare pink color, an increasingly popular blue color, and green. Some topaz is heated or irradiated to achieve the blue color, and these treated gems are impossible to detect.

According to the Roman Pliny, topaz was named from the island of Topazos in the Red Sea, where it was mined. (See "Quartz.") It may also have come from a Sanskrit word meaning "fire" or "to shine." It was supposed to be good for the eyes if it was soaked in wine for three days, with the wine then being used to moisten the eyes. Dreaming of topaz before a trip means a safe journey. A Roman physician of the fifteenth century claimed to have cured plague by touching the sores with a topaz that had belonged to two popes.

Topaz Substitutes. Topaz hasn't been synthesized, although a synthetic corundum of a topaz color is sometimes called "synthetic topaz." On the other hand, many other gems are similar in color— but less expensive and not as hard—and may sometimes be passed off as topaz. Beware of any word used with topaz except "precious" or "imperial." To protect yourself, be sure to get certification of the stone's authenticity and natural origin and any other verification you can get from the jeweler. Terms such as the following, however, invite immediate suspicion: "Smoky topaz," usually quartz; "citrine topaz," citrine; "Bohemian topaz," citrine; "Occidental topaz," citrine; and "Oriental topaz," yellow corundum.

TOURMALINE

Tourmaline comes in a wide variety of colors, all with lovely fire. It has a hardness of 7 to 7½ on the Mohs scale, with such low cleavage that it doesn't chip or crack easily and is durable. The name comes from an ancient Singhalese (Ceylon) word, *turmali*, meaning "mixed precious stones," because tourmaline was often confused with other gems and mixed in with more precious gems.

Colorless tourmaline, or achroite, is rarely used for gems. Red tourmaline (rubelite or siberite) may range from pale rose to dark red, sometimes with a violet tint. The best green tourmaline is a rich emerald green, but it may be any shade from light to dark and a yellow-green. Blue tourmaline (indicolite) is rare and may shade from light to dark, sometimes resembling a sapphire and sometimes an aquamarine. Brown tourmaline (dravite) may be yellow and all shades of brown. Tourmaline is generally dichroic, showing two colors, and may be translucent and chatoyant with good cat's-eyes, usually green or pink.

Tourmaline Substitutes. Since synthetic tourmalines are difficult to detect, tourmaline should be authenticated before purchased.

TURQUOISE

Turquoise comes in different shades of blue, including blue-green that impinges on green. It has a hardness of 6 on the Mohs scale, but its compactness makes it so durable that it has been found in ancient tombs.

Although we tend to think of turquoise as being an American stone, it is found in many countries. The ancient Egyptians, for example, mined it in Sinai, and it is also found in Iran (Persia). The best turquoise is Persian turquoise. It is a pale sky-blue color and is so dense that it takes a high polish. American turquoise may be in all shades of blue and green. The best is a deep blue that shows off well in the ornate Indian silver jewelry in which the Persian turquoise would be lost because it is so much paler in color. Green shades are less valuable that blue colors.

Since turquoise is found in other rocks, some of that material or matrix may be mixed with it. If the matrix has a lacy pattern, the turquoise is known as "spiderweb turquoise."

Turquoise is porous, and its porosity means that it will absorb color additives and may be waxed or oiled or treated with plastics or silicate to improve the color. Any turquoise sold as being of "natural" color—and especially the expensive "squashblossom necklaces"—should be questioned concerning how and with what the stones have been treated.

As with all blue stones, turquoise was associated with the eyes: it had curative powers and was good protection against the Evil Eye. In addition, in Persia turquoise on a horse's bridle assured the rider the horse wouldn't stumble or throw him. In Europe during the Middle Ages, wearing a turquoise was an assurance that the wearer wouldn't fall, whether from a horse, a building, or a mountain. In the New World, turquoise was indispensable to the medicine men. A turquoise on a bow or gun was a sign that the missile would find its mark. A better gauge of the value of turquoise was the story that what lay at the end of a rainbow was a turquoise, not a pot of gold!

Turquoise Substitutes. A Parisian company has synthesized a turquoise that is similar to Persian turquoise. Agate is sometimes dyed turquoise colors, as well.

ZIRCON

Zircon has a hardness of 6½ to 7 on the Mohs scale. Although it does not have distinct cleavage, it is still very brittle and chips and cracks easily. Colorless zircon has a dispersion and brilliance that is so similar to the diamond it has often been used as a diamond substitute. Most colorless zircons were originally other colors that have been heat-treated. Zircons, in fact, may be different shades of red, blue, green, yellow, brown, gold, orange, and purple.

Use of zircons goes back to the most ancient times, with carved zircons having been found at more than one archaeological site. In the Bible and other old literature, it is called by several names, such as *jacinth, hyacinth,* and *jargoon.* Jacinth was supposed to protect the wearer against plague and wounds and injuries, insure a cordial reception at any inn, increase its owner's riches, and endow him or her with prudence. It could also induce sleep.

Zircon Substitutes. None

5.
HOW TO
BUY FINE JEWELRY

When you buy a car, you buy the one you like and you can afford. The purchase is emotional as much as it is practical, since cars in some ways are extensions of ourselves. In addition, you know what you are buying, especially if you are buying a luxury car like a Rolls-Royce, a Mercedes-Benz, an Alfa-Romeo, a Cadillac, or a Lincoln Continental. There may be features in other cars that resemble or imitate the best of the best, but the genuine article is usually unmistakable. You know what to look for, what to expect, about what you are going to pay, and even where to go to buy the car.

Fine furs have more of a mystique than the average car and they may seem more risky to buy. Yet, with time and patience, you can learn to differentiate among furs and to distinguish fine furs from inferior furs. Granted, you will never have the expertise of the experienced furrier, but you will be able to learn the difference between mink and muskrat as well as between the best-quality mink and mink of an inferior quality. In short, you can easily learn what to look for, what to expect, about what you are going to pay, and where is the best place to buy the fur.

Both an expensive fur and a fine car are far more than purchases to keep you warm and provide transportation. They are also luxuries and status symbols. At the same time, the primary reason for the

purchases is practical—you buy the car to drive and the fur to wear. You do not consider either an investment that appreciates in value. The criteria are that you like what you buy, that you have a use for it, that you can afford it, although you do want to get the most for your money.

Jewelry should be bought the same way, regardless of whether it is fine jewelry of karat gold, platinum, or silver, has precious gems or not, or whether it is costume jewelry. Even fine jewelry, which is a luxury item and can be as much a status symbol as a sable coat or a Rolls-Royce although far more permanent and enduring, should be bought because you like it, can use it, and can afford it. Jewelry, after all, is a form of adornment and decoration: if you cannot wear it, you should not buy it; if you do not like it, you should not buy it; above all, if you cannot afford it, you should not buy it.

One criterion you do *not* want to use for jewelry, any more than you would use it for buying a car or a fur, is whether the jewelry is a good investment or not. Some jewelers, who are reputable and reliable in other respects, offer jewelry as "an investment." Fine jewelers, in general, however, prefer to point out that jewelry is not really an investment except in beauty. Jewelry, in fact, is a purchase, just like a fur coat or a car. You should appreciate it, of course, although appreciation in that sense is not the same as the appreciation or increase in value of an investment.

Since fine jewelry is an expensive purchase, nevertheless you want to consider how to get the most for your money, just as you do with a car or a fur. Depending on how much money you have to spend, you are probably better off avoiding high-fashion jewelry that tends to be faddish. A stickpin or chains may be the latest look in 1980, but how long will the fashion last?

At the same time, fads can be exceptionally long lasting. The two outstanding examples are the 18-karat-gold "Love" bracelet designed by Aldo Cipullo in 1970 and "Diamonds by the Yard" designed by Elsa Peretti in 1974. The "Love" bracelet comes with its own screwdriver, the idea being that once the bracelet is secured on the beloved's wrist, only the screwdriver can remove it. "Diamonds by the Yard" come in various lengths of 18-karat-gold chains that may be strung with from one to twelve diamonds. Both have at least doubled in price since they were introduced. The point is, however, they were only two of hundreds of fad items that were introduced at the same time and quickly faded. There is no way of

telling how long such a fashion will last—or how long it will continue to give you pleasure. If you can afford from $500 to several thousand dollars for such jewelry, fine. If you cannot, you have another option.

The option, as Ralph Destino, president of Cartier's in North America, suggests is that you consider costume jewelry for high-fashion designs instead of precious metals and gems. As he says, costume jewelry has an important role to play in any jewelry wardrobe.

What you should buy in fine jewelry, particularly platinum and karat gold, depends on you, your life-style, and your preferences. You may be a woman who does not feel dressed without earrings, in which case you may want gold or diamond earrings that you can wear often with enjoyment. Or you may be a man or woman whose taste runs toward rings. A necklace or a bracelet could also be indispensable.

In any case, shop around. Look at styles and prices before you buy. Get an idea of what jewelry costs and how that compares to what you have to spend. Once you see an item you like, check its price against the prices of similar items in other stores. The major purpose is to give you an idea of value and to help you be satisfied, in all respects, after you have made the purchase.

Look in jewelry stores and the boutiques and better department stores that often carry fine jewelry. But don't look for or expect or wait for sales. The finest jewelry stores rarely discount fine jewelry. If a style does not sell, it is more profitable for them to melt down the metal and reset the gems than it is for them to sell at a big discount. In this respect, fine jewelry is like no other luxury purchases, since the components can be reused.

Stores other than the finest jewelry stores may offer jewelry at a discount. It may be a style that has not sold well, or the stores may be willing to make less profit or their overhead may be less. These are legitimate reasons to discount the price of fine jewelry. If the discount is much over 20 percent, however, you should ask, "40 or 50 percent off what price?" Despite laws prohibiting misleading advertising and the stand of reputable jewelers' associations against it, there are still fraudulent advertising and selling practices going on.

For this reason, you want to read the next chapter, about where to buy. Where to buy can be as important as how to buy jewelry. So is understanding what are the kinds of jewelry, especially the kinds of jewelry on the market today.

KINDS OF JEWELRY

Jewelry has traditionally been divided into fine jewelry and costume jewelry. Fine jewelry is composed of precious metals, with or without gems, and is expensive. Costume jewelry is of lesser quality and ranges from frankly cheap upwards. Regardless of how upwards in price costume jewelry may go, the price gap between it and fine jewelry is a large one, so large that while fine jewelry is hoarded, costume jewelry is often thrown out once you are tired of it or its beauty has faded or it has been damaged.

The rising prices of precious metals, especially gold, have changed the types of jewelry available. Gold-filled jewelry in 1978, for example, could cost what karat gold cost in 1958 or even in 1968. As a result, the price gap between fine and costume jewelry grows even wider every year.

Beginning about 1975, that gap began to be filled in by designers, jewelers, and other stores that realized there were plenty of customers who wanted better jewelry than costume jewelry and yet could not afford the rising prices of fine jewelry, in particular jewelry with diamonds, rubies, sapphires, and emeralds. The consequence is what is often called "bridge" or "boutique" jewelry because it fills the price gap.

Bridge jewelry may be karat gold or gold-filled. Or it may combine karat gold with sterling silver. Damascene and vermeil jewelry are examples of this kind of jewelry. The addition of silver lessens the amount of gold used and puts the jewelry into a price category ranging from about $20 to $200 or a little more. The point to keep in mind is that this is still fine jewelry, because it uses precious metals. Sometimes, too, it may contain the less precious gems, such as quartz, tigereyes, or agates.

The lower price range has worked out advantageously for designers. It permits them to use their imaginations and experiment on designs that they may be reluctant to try on more expensive jewelry at the same time that they are still working in precious metals and with gems. It also means that younger designers, with less financial backing, can move more easily between handicraft and costume jewelry and fine jewelry.

The interest in this jewelry by designers and stores is definitely to your advantage. It enables you to buy fine jewelry made by leading designers at reasonable, if not low, prices.

At the same time, do not expect karat-gold bridge jewelry to be identical in design to the fine jewelry for which you would pay a much higher price. A 14-karat gold chain, for example, will be much more delicate in bridge jewelry than a 14-karat chain in the more expensive jewelry department. Any decorative tab or pendant will be similarly scaled down in size. The delicacy may appeal to you, or you may want to look at the gold-filled jewelry or jewelry combining gold and silver, despite the fact that the latter does not have the same intrinsic value as karat-gold jewelry. The point is to buy the bridge jewelry because you like it and will be happy wearing it, not simply because it *is* karat gold.

In looking at bridge jewelry, nevertheless, you want to keep in mind that it is fine jewelry and use the same judgment, care, and criteria in buying it that you would for more expensive fine jewelry. That means looking around to compare prices, although this is not always necessary. At least one trade name is being nationally advertised, which means it is the same price—within a few dollars—wherever you go. The same price is not always the case with finer jewelry. Little karat-gold, much less precious-gem, jewelry is nationally advertised by the manufacturer, although it may be advertised locally by stores and shops. Thus, with finer jewelry, you do not always know the manufacturer, and stores have greater leeway in the prices they can charge. A trade name and national advertising, therefore, can be advantageous: you have both a store and a manufacturer standing behind the jewelry—and you are assured of an equitable price.

FINE JEWELRY AS A PURCHASE

When you buy even the finest jewelry, you are buying a manufactured item, no matter how handcrafted it is. The reasons begin with the metal, because precious metal used in jewelry is never pure.

Gold, platinum, and silver are all alloyed for various reasons. The greater the amount of the alloy, the less value the precious metal has as precious metal. For example, the price of gold on the commodities market and the world gold market is based on 24-karat or .9999 gold. Thus, the value of the gold in jewelry is worth only as much as the percentage of gold used. Twenty-two-karat gold will have more gold than 18-karat gold, and 18-karat gold will have more gold than 14-karat gold, but none has the amount of gold as pure—

24-karat—gold. The same considerations hold true for silver and platinum.

The first reason why jewelry is not an investment, therefore, is that you are buying karat gold, not "pure gold," and gold is not valuable simply because it is gold. Since the world market is based on "pure" gold, the gold in jewelry has less value, depending on the karatage. That value will increase—or decrease—with the price of gold, but it will never equal the price of pure gold. If you sell gold jewelry as gold, moreover, it must be melted down, perhaps separated from the alloy, before it can be used, with that cost being deducted from the price you get.

The manufactured metal is further manufactured in jewelry in design and workmanship, both of which add to the cost of the gold. If you buy a one-of-a-kind piece, regardless of whether you buy it from the person who made it or from a store, you are paying for design, workmanship, and exclusivity—all of which add to the price of the gold and may cost more than the gold. If you buy mass-manufactured jewelry, the cost of design and workmanship is spread out among all the pieces of jewelry of that design. You are also paying for increases in cost along the sales chain until the jewelry reaches you. The manufacturer, the wholesaler, and the jeweler all increase the actual original cost to allow for their overhead, costs, and for their profit. In short, each step along the way in turning "pure" gold into karat gold, for example, and karat gold into jewelry increases the cost of the jewelry and lessens the value of the gold in comparison to the cost of the jewelry.

To put it another way, say you buy an 18-karat gold ring for $700. The ring may be worth $700 because of design and craftsmanship, but as gold it is worth only 75 percent of the market price of gold. If gold is selling at $400 an ounce and the ring weighs an ounce, the gold is worth only $300, with $300 covering the cost of making the ring, overhead, and profit.

Granted, you may be able to sell the ring for the $700 you paid for it, or even more. That means you must find a "willing buyer," a buyer willing to purchase it at or above the price you paid. If you take the ring to a jeweler to sell it, however, despite its being in mint condition, chances are you will get only about $350, the wholesale price, or less. A jeweler will pay you only the amount of money for which he can get an equivalent ring. If the design or condition is such that he can't resell it at the price you paid for the ring, you may get

only the price of gold, or $300. Gold, therefore, would have to more than double the market price of $400 an ounce for you to get back even what you paid. If you keep the ring long enough, the price of gold may rise that high. People who bought gold jewelry when the price of gold was stabilized at about $35 an ounce could probably get back many times what they paid. In the meantime, though, the gold is not paying interest or dividends. It may even be costing you money in the form of insurance and a safe-deposit box to protect your "investment."

Gold in the form of coins, such as the South African Krugerrand, the most popular coin, is another matter and beyond the scope of this book. For your information, however, Krugerrands are 22-karat, or .916 gold. If these or any other coins are used in jewelry, they become jewelry and subject to the same cost inflation as all jewelry.

The same considerations hold true for jewelry with gems. Jewelry with gems may even be a worse investment than plain gold jewelry. The price of gems has risen drastically—as have the prices of furs, cars, and just about everything else in recent years as well as the precious metals—but the value of gems is quirky, often depending on fashion and demand, among other factors.

Diamonds are one example. Prices of diamonds have risen, although the prices have escalated drastically only for certain diamonds. One reason for the rise in general is demand. The United States alone accounts for more than 50 percent of the world diamond jewelry market. Thanks to aggressive advertising campaigns, that percentage has held true, regardless of how the market in other parts of the world has increased. Japan was almost nonexistent as a diamond market ten years ago. Today, it buys 22 percent of the world's diamond jewelry. Third are Canada, Brazil, France, and Italy, each of which accounts for 3 percent of the market. Thus, the price increases along with the number of people vying to buy diamonds, as soon as the market doesn't meet the demand.

Another reason is that the market is controlled by DeBeers Consolidated Mines Ltd., through its subsidiaries. Although the organization is South Africa and London based, it controls sales of 85 percent of all diamonds from all over Africa, the Soviet Union, and elsewhere. Monopolistic as it is, the argument offered by DeBeers that keeps even the Soviet Union in line is that diamonds are a luxury item, with an intrinsic value unmatched in any other such item, but that value can be maintained only by strict control. Without that

control, the market could be flooded in times of high prices, resulting in diamonds being made as worthless and profitless as they are during a depression when no one has the money to buy them.

The strategy has worked successfully for everyone in the diamond market except consumers. In recent years, moreover, DeBeers has been charged with, or at least suspected of, buying back its own top-quality diamonds in order to push prices even higher.

A third reason is there are fewer top-quality diamonds on the market for the very good reason that there are fewer in nature. Large diamonds are usually found along beaches and near riverbanks, for much the same reason that alluvial gold is found in nuggets in similar locations, and close to the surface of the earth. As the diamond mines go deeper and deeper, fewer and fewer large diamonds are found, particularly those that meet the standards of the four Cs. That means that top-quality diamonds that are colorless, flawless or nearly flawless, of ideal cut, and of 1 carat or larger in size account for only 2 percent of all the diamonds being mined and are getting rarer to the point that there may be almost none found after the next twenty to forty years. Thus, it is that a 1-carat diamond ring, with a diamond of top clarity, color, and cut, that sold for $6,000 in 1977 was selling for $18,000 in 1978 and $24,000 in early 1979.

All diamonds, however, have not risen in value and are not in short supply. DeBeers, to broaden the market for diamonds, has appealed to the middle-income consumers with a variety of lesser-quality—and cheaper—stones. These diamonds are smaller in carat weight and of poorer color and clarity. In fact, most of the diamonds you will find in jewelry today are not of top clarity, color, and cut, regardless of their size—and these diamonds may have scarcely increased at all in price. All you have to do is look at advertisements and you will find plenty of diamonds being advertised for a few hundred dollars or even less. There is no shortage of these diamonds. Be very wary, therefore, of any talk of "diamonds" as an investment—unless you can afford an investment-quality diamond of top quality, clarity, cut, 1 carat or larger in size. (See "Buying Diamonds," below.)

Remember, too, that diamond jewelry is manufactured. Diamond jewelry, per se, then, is no more an investment than gold jewelry. Prices would have to soar much more dramatically in most cases for you to recoup what you paid.

Jewelry with colored stones, too, should be considered simply

as a purchase. The supply of colored stones—rubies, emeralds, sapphires, and others—is not as tightly controlled internationally as the diamond supply. Individual countries may control their own production, but the worldwide market is a fluid one. A basic problem is that colored gems go in and out of fashion, especially in the United States, with fashion helping to set the demand and the price. In 1978, as the prices of diamonds rose, however, so did the prices of colored stones, because people turned to them for price reasons instead of diamonds. Those prices could just as easily go down, if top-quality diamond prices were to fall, or rise, if diamond prices go higher.

For all of these reasons, in buying jewelry, the first rule is to buy jewelry—with or without gems—because it appeals to you emotionally and you like and can afford it. Do *not* buy jewelry purely for the purpose of an investment. If the past inflation is any indication, you would have to keep the jewelry at least six to ten years just to break even on the purchase price, not allowing for any profit. You may even have to take a big loss if you need money and have to sell in a hurry.

GETTING WHAT YOU PAY FOR

The second rule in buying jewelry sounds simple. It is to expect to pay for what you get—and to get what you pay for. To put it another way, jewelry that's a "steal" may literally be stolen or it may not be genuine.

Simple as that sounds, unfortunately, buying jewelry is not simple. Knowing what to look for in jewelry can and may help protect you from being cheated, but the primary protection is not to listen to the larceny in your soul. Human nature may be such that we all want something for nothing, especially expensive "somethings." Yet, getting fine jewelry—such as karat gold and diamonds of top clarity, color, cut, and size—for next to nothing is impossible. Nobody "gives away" such valuable items, or any other valuable item, out of the goodness of his heart or because you have an appealing face.

To go back to cars and furs. No one interested in buying such a car could mistake a Cadillac for a Rolls-Royce. Anyone interested in furs can learn about them, but all that glitters is not gold—or platinum or silver. All that is diamond-bright is not a diamond. And all that is ruby-red is not a ruby. What the jewelry may actually be

is the most difficult knowledge to get or learn of all luxury purchases, in that what we see is not always what it seems to be.

The only way to be absolutely sure of what you buy is to buy it from a reliable and reputable jeweler (see Chapter 6) who stands behind what he sells. That way, if the jewelry turns out to be different from what it was sold as, the jeweler will refund your money or replace the jewelry for the sake of his reputation.

There may be times when you do not know a reliable jeweler, when you may be tempted to buy because of jewelry you see in a store or window, or when you want to buy jewelry away from home. In those instances—and there are probably others—you want to know what to look for and what to ask. Those considerations hold for both precious metals and gems.

PRECIOUS METALS

Whether you are buying plain metal jewelry or jewelry with gems, inspect the metal carefully. In the United States and other countries, especially in Europe and the British Commonwealth, laws require the quality standard to be marked or stamped on precious metal. Don't take anyone's word that the jewelry is "solid gold," "pure gold," or "genuine gold," or that it is sterling silver or any other kind of silver. What you want to see and see for yourself is the quality standard marking, even if you need a jeweler's loupe or magnifying glass to do so.

Remember, too, standards of what can be called gold vary tremendously around the world—and that's another reason for insisting on seeing the quality marking. The U.S. minimum is 10-karat, with lesser quantities considered to contain too little gold to retain the characteristics of real gold. France and a few other countries put the minimum higher, at 18 karats. Still other countries accept 8 karats or 9 karats as being gold.

In short, just calling an item "gold" tells you nothing. The metal should be marked as follows:

22 karat	or	.916
18 karat	or	.750
14 karat	or	.585
10 karat	or	.417

You may find other karatage, although these are the most common. Still, by knowing these, you can use them as a gauge for judging 15-, 12-, 9-, or 8-karat gold.

Silver jewelry standards are universal in comparison to gold. Sterling is marked "sterling" or .925. You may also find other markings, such as .800, which is used for some jewelry in some countries. This jewelry may not be sterling, but it still can be beautiful—as long as you know what you are getting.

Hallmarks may be used as well. In the United States, a hallmark is the stamp or mark of the manufacturer of the jewelry. In Great Britain, it is the mark of the assay office that assayed the metal for precious metal content: gold, silver, or platinum. Great Britain uses a sponsor's mark as well, indicating the manufacturer of the item, and a date letter for the year in which the article was marked. (Note: The Assay Office of Great Britain publishes a booklet on both old and new British hallmarks. The title is "Hallmarks," and it is available from the Assay Office, Publications Department, Goldsmith's Hall, Gutter Lane, London EC2V 8AQ, England. The booklet is free, but you must send a self-addressed envelope, at least four-by-nine inches in size with enough money to cover one ounce of postage from Britain.)

Other countries use a variety of markings, to indicate both hallmarks and quality. In the Netherlands, for example, a lion rampant with the figure 1 or 2 means the gold is 22 (1) or 20 (2) karat, with the hallmark varying. The point is that if you see a lion, a lion's head, a lyre or harp, an ear of grain, or any other symbol, you should not take it for granted the item is precious metal. You need to have any symbols explained to you—and you may want to check what you are told in at least one other store.

In general, however, marks and symbols are signs of quality. Most countries that use them have stiff penalties for their misuse. At the same time, not all countries are strict about enforcing the regulations. (See Chapter 6.) For this reason, you want to look at the jewelry just as carefully for other tests of quality.

First, rub the jewelry *hard* with your thumb. The base metal will show through jewelry that is thinly electroplated. At the same time, check for any rough edges. Most better gold jewelry is cast with the lost-wax method, which leaves no casting marks. Less expensive jewelry may be more cheaply cast or stamped, leaving the marks of the mold or stamping that have to be filed off afterwards. Any time

you find rough edges or bumps, you should double-check the quality markings. You should, in fact, beware of them. Fine precious metals are too expensive to be used in any except the most finely made jewelry. If you like the jewelry anyway and the price is so inexpensive (another indication that it may not be a precious metal) that you feel you can afford to take a chance, go ahead. Otherwise, back off.

In buying vermeil jewelry, you want to be especially careful. By definition, vermeil is sterling silver with at least 10-karat gold electroplated on it in a design. There are no laws or regulations enforcing this definition, however. As a result, the silver base may be any silver-like metal and the gold only a thin wash or not gold at all. Sterling silver has to be marked. So, in buying vermeil, be sure to look for the sterling (.925) marking and to rub the gold. Keep in mind, too, that the gold—regardless of how heavy the coating is—is only electroplated on the silver. That means vermeil must be cleaned very carefully to avoid "cleaning off" the gold if you have to polish the silver.

SETTINGS AND CLASPS

In buying any jewelry, you want to look at more than the quality marking. Sometimes what you want to look for depends on the type of jewelry. Here are two general guidelines:

*Be satisfied that the metal is what it is supposed to be.

*Inspect the clasps and settings, if gems are involved.

Check any and all links carefully, regardless of the type of jewelry. This precaution holds true for belts that may be made of metal as well. Any chain is only as strong as its weakest link—and any jewelry is only as strong as its weakest link. The links may be an integral part of the jewelry or they may be used to connect the jewelry to the clasp or catch. The links should be well made, with no separation where the link is joined to form a circle. A link that is bent or is slightly apart may give way under wear, letting the rest of the jewelry or part of it slip through.

An earring, for example, may have a drop of some kind attached to a button (bobby drop) by a link or series of links. A necklace may have a pendant attached by a link. And, of course, charm bracelets always have the charms attached by links. The links may sometimes be soldered. Sometimes you can have them soldered. If you have any doubts about how secure the links are, discuss them with the

jeweler. If you still have doubts, you may be better off looking elsewhere.

Keep in mind the intrinsic qualities of the metals, too. Platinum and silver are harder than gold, which is relatively soft in its purest forms. The purer the gold, the softer it will be and the more apt it is to wear thin or lose its shape with wear.

Rings. Regardless of the kind of setting, check the stone and make sure it is held firmly in the setting, whether the setting is open or closed. A stone such as an opal tends to expand with heat and contract with cold because of its moisture content. That means you want to be sure the stone is held in such a way that it cannot fall out of the setting.

In an open setting such as the high or Tiffany setting and the low or Belcher setting, examine the prongs. They should grip the gem at the girdle, closing firmly just above it. The prongs should be smooth. Remember, the higher the setting, the more stone will be visible, with a greater tendency for the prongs to catch on gloves or clothing. You want to be sure the prongs are made in such a way that there are no rough edges that could catch or that could lead to the prongs being bent or broken and the loss of a stone.

In a closed setting, examine the rim or bezel that holds the gem. Some gems or coins may be set just below the rim and may have prongs at the back holding them against the rim. In this case, make sure the prongs are tight and well made to hold the coin or other material in place. As far as gold coins go, make sure the coins are mint perfect, not bent or scratched or damaged by the setting. Gold coins can have a value of their own as long as they are in excellent condition. A damaged coin reduces the value of the ring.

Cabochons are usually set in a closed setting, with the dome higher than the setting. Again, the setting should be made in such a way that the gem cannot fall out. This is particularly true if the gem has a tendency to contract or expand. A gem may feel very slightly loose, but by trying to move it you should be able to feel the firmness of the setting.

The fit of the ring is as important as a well-made setting. A too loose ring may fall off your finger, while a snug one may be difficult to get on and off. Making sure the ring fits in a store is not enough. You want to take into account whether your fingers have a tendency to swell in warm weather or not. If they do swell, you may want to consider a slightly large ring on which you can have a ring guard put.

A ring guard can be preferable, especially for rings with narrow backs. A wide ring is more difficult to fit with a guard, but it is also less apt to slip off or slip around your finger. If you do decide to have a ring made smaller, remember you are losing precious metal. At the same time, more precious metal will be needed to make the ring larger.

Earrings. The choice of earring backs is strictly personal. Earrings with screw backs should be checked carefully to make sure the screws are in good working order and are tight enough for you to fasten securely in or on your ears. Clamps should be tight, although not so tight that they are uncomfortable to wear. Comfort and a secure fastener, in fact, are probably more important for earrings than any other jewelry, since there is no way you can add a guard or safety catch as you can for other jewelry. All you can do is make sure the backs are good ones and they work well—and that means on both earrings. Try putting both earrings on and taking them off several times. To put them on correctly, pull lobe down, place earring, and adjust back. When you have them on, shake your head vigorously to make sure the earrings don't loosen or fall off. Shaking your head will also assure you of another factor: are they so heavy that they bother you or so light that you can't feel them and could lose one just by using the telephone?

A store may sometimes not want you to try on earrings, in which case you should ask to see the manager or go to another store. You need to try earrings on to judge whether the design and color flatters you because they are so close to your face. Then, there are size and weight. Not all earlobes are the same. Earrings that may fit one ear may be too large or heavy for other earlobes. Most necklaces and bracelets will fit anyone, but not most earrings. In short, in buying expensive earrings in particular, you need to try them on before deciding you like them and can wear them.

Clasps and Catches. All clasps and catches, both regular and safety ones, should be worked several times, on you and off you. Do they fasten easily and firmly? Can you work them yourself without help? Make sure you try the jewelry on yourself as well as letting the clerk help you. If you find that you can't put the jewelry on by yourself, it may be a bad buy—regardless of cost—unless you always have someone available to help you.

Make sure the clasps are appropriate to the rest of the jewelry, that they are not so fragile they are apt to break or bend. The more

expensive the jewelry, the more you want to be sure that the jewelry has a safety clasp or catch of some kind. A safety clasp or catch is like a hand brake on a car—you may never need it, but when you do it is indispensable. For this reason, any very expensive piece of fine jewelry, especially with gems, that does not have a safety clasp or catch should have one added. The lack of one on jewelry with a big price, moreover, may indicate the jewelry is not what it is supposed to be. In any case, ask the jeweler to suggest a remedy— and be sure to look for quality markings.

You want to be just as careful of catches and safety catches on pins and brooches. Even better costume jewelry pins generally have safety catches, but make sure both the catch and clasp are sturdy and fasten firmly and easily.

In all kinds of jewelry, make sure there are no rough edges that can catch on clothes. You do not want to run the risk either of losing the jewelry or of its snagging or tearing clothes or catching on fabric when you put on or take off a coat. These are other reasons for checking necklaces and bracelets and all jewelry to see how well catches and links are attached to the rest of the jewelry. A good catch flimsily affixed is little protection against loss. In addition, necklaces and bracelets that are strung should be well strung on good string and tightly knotted to clasps.

GEMS

Before buying any jewelry with gems, you want to read Chapters 3 and 4 carefully. Familiarize yourself with the various terms used and with the various gems. Most important, check over the terms used for substitute gems, especially those of any gems in which you might be interested. Although no reliable or reputable jeweler would knowingly pass off one gem for another, if you are going to shop around you're going to have to expect to run into jewelers who may be less fussy.

Keep in mind that you cannot always tell what a gem is by looking at it. Emeralds are green. So are tourmalines—and that name itself comes from the Singhalese word for mixed gems. Smoky quartz can outwardly resemble the more precious smoky topaz. Then, there are the gems of which few consumers have heard, like spinel.

There is no rule of thumb of what you can expect to pay. Any price list today is out of date before it is printed. The only way you

can tell what is a fair price is to ask jewelers. If you don't have a regular jeweler whom you trust, it is even more important to shop around and check the prices of particular gems. If you want a smoky topaz, look at smoky topazes in as many stores as possible to get a general idea of the current price, although prices will vary with size and quality as well as setting. Still, you can get a fair idea of a fair price—and of what you want—by looking at as many smoky topazes, or other gems, as possible.

Although the terms "precious" and "semiprecious" have little meaning as the prices of all jewelry increase, the less expensive gems are probably safer buys from the point of view that there is less reason for anyone to try to sell a gem that isn't what it is supposed to be. However, some inexpensive gems, such as turquoise and zircon, can have nature improved on by various kinds of treatment, and spinel and garnet can be synthetic.

Another problem in buying jewelry with gems is that the gems are already set. Once a gem is in its setting, you may not be able to see all the inclusions—nor may an appraiser—because the setting can hide them. A setting can also make up for imperfect cutting. That doesn't mean you should buy only unset gems. The average person can be as taken in by unset gems as by set ones. It does mean that *where* you buy can be more important than how to buy.

Still and all, there are some precautions you can take in shopping around and looking at gems. These precautions hold particularly true for diamonds, which are the most common gem purchased, and for a few other stones.

Buying Diamonds. A diamond is not a diamond, any more than all that glitters is gold. There are two broad categories of diamonds, gem and industrial diamonds, and the first is the one that concerns the consumer.

The term "gem diamonds," however, covers a broad spectrum of quality, based on the four Cs of clarity, color, cut, and carat weight. Although the terminology can vary from store to store and from country to country, more and more jewelers in the United States are using the standards and terminology established by the Gemological Institute of America (GIA). These and other standards and terminology you may hear or see are given in Appendix II. Granted, you may find still other terms, but any reliable jeweler should be able to translate his terminology into GIA terms, particularly if he has taken GIA courses. The GIA standards and quality

certificates, incidentally, are accepted and may be used worldwide, especially for investment diamonds.

Investment diamonds are at the very top of the standards used to judge gem diamonds. At the lower end are jewelry diamonds, the diamonds you are most likely to find in jewelry. In between are diamonds that are too good for *ordinary* jewelry. They are used in the best jewelry but are *not* good enough for investment purposes.

Although buying diamonds for investment purposes is entirely different from buying diamond jewelry and diamonds for jewelry, whose purpose is adornment, you should be aware of—and beware—talk of investing in diamonds for the sake of diamonds. Diamonds have long been bought by investors in Europe, some South American countries, and Asia, and they are beginning to be thought of as being investments in the United States because of their dramatic increase in value over the past few years.

What you want to beware, as mentioned before, is the fact that the diamonds that have increased in value so much are the top-quality stones and not all diamonds. David Rosental, president of Kohinoor International, Ltd., of New York, a diamond brokerage house, points out that an investment diamond must be flawless or nearly flawless, be of top color (D through H on the table), and at least 1 carat in size. Cut and color are more important to a diamond's attractiveness in jewelry than minor inclusions that can be hidden by a setting, but even the tiniest inclusions can lower a diamond's value as an investment.

You also want to be aware that diamonds meeting the investment criteria are rarely found in jewelry. For one thing, they are usually bought before they can reach the jeweler. For another, the cost at retail, often 100 percent above wholesale price, would not only make such a diamond prohibitive in price to the average consumer but also mean that the diamond would have to be held a considerably longer time. In addition, prices would have to rise much more dramatically for the average consumer to break even on his investment.

Buying investment diamonds, therefore, means going to a wholesaler—whom the average consumer doesn't know and doesn't have access to. In addition, a wholesaler must be picked with all the care of a retail jeweler. All the experts interviewed warn against buying diamonds for the sake of diamonds and especially to avoid offers of packets of diamonds. The packet may cost more than what

it would cost to buy *all* the diamonds individually at retail, and
chances are slim that any of the diamonds would meet the standards
of quality and size essential for investment diamonds. An investment
diamond, moreover, is so precious, both in the sense of rarity and
price, that it would never be included in a packet.

Despite the fact that investing in diamonds is a subject far too
complicated for this book, if you are thinking of diamonds in this
sense, you want to:

*Consider only diamonds of very top quality, color, and cut *and*
of at least 1 carat in size. The smaller the stone, the less demand there
is for it and the less it will get on resale.

*Buy the stone out of the setting, if possible. The gem must be
removed from its setting for GIA certification anyway.

*Make sure the seller gives you a GIA certificate attesting to the
four Cs. With so much money at stake and so few people knowing
much about diamonds, there is always the possibility of fraud. A
company or person that will take thousands of your dollars without
providing GIA—and only GIA—certification of quality may not al-
ways be fraudulent but should be treated warily.

*Try to get a Gemprint, which is a photograph made with a laser
beam that "fingerprints" the stone. (See Chapter 10.) No two dia-
monds are ever exactly alike, and the Gemprint is proof both of the
gem's authenticity and identification.

*Plan to keep the diamond for at least two years. Diamonds are
a long-term investment, according to Rosental, taking *at least* two
years to show a profit.

*Above all, make sure you can afford the investment and the
gamble that diamond values will continue to go up. Diamonds, par-
ticularly those rare top-quality stones, may continue to increase in
price—but they can always go down for a number of reasons. One
reason is a recession. Another reason is that some dealers feel prices
are so high they will have to level off or no one will be able to afford
diamonds. In addition, in the early 1980s, diamond mines in Bot-
swana are expected to be in full operation, doubling the present
caratage available, which also could mean a leveling off or a de-
crease in prices.

Many of the above points pertain to buying diamond jewelry
and diamonds for jewelry, too. To begin with, you want to familiarize
yourself with the terminology. Then, you have to consider how much
money you want or have to spend, keeping in mind that you will

have a far greater selection of diamonds to choose from for jewelry than you would have for investment purposes.

The benchmark in price is 1 carat, regardless of the kind of diamond. For example, in early 1979, a 1-carat, D-color, flawless diamond of ideal cut cost between $23,000 and $24,000. In comparison, a one-half-carat diamond of the same quality would have cost about $3,000—a considerable difference. Even a .96-carat stone, only 4 points less than a carat, would have cost far less than the 1-carat stone.

So, the smaller the stone, the less valuable it is and the less value it has. Pavé diamonds are a good example. The diamonds themselves are so small that they have little value. Yet the jewelry has a very high markup, partially because of the work involved. The markup and the size of the stones, therefore, make the jewelry a bad buy in the sense that you will probably never be able to get back what you paid. At the same time, the jewelry is highly attractive; it may be attractive in price to you, too, as long as you realize its actual worth.

Size, then, is the first factor to consider because of its relationship to price. The second factor is color. Colors D through H are the whitest, most transparent stones. The problem with color is that it can be deceiving. The color you see may not be what you get, depending on lighting, the background against which you look at the diamond, and the setting of the gem. Rosental, whose firm buys and sells only investment diamonds, offers the following suggestions for jewelry buyers:

*Look at the diamond only under direct lighting. That means real light, which may be daylight or pure white fluorescence. Blue light will make any diamond sparkle with the desirable blue fire, and any diamond looks good in simulated candlelight. In addition, never buy a diamond at night, when no daylight is available. Rosental and other experts further advise that you walk out of any store any time the only light available is blue light or candlelight.

*Look at the diamond against an off-white or white background. The best diamonds are transparent, even those that may be tinged with yellow, and the slightly off-white will give a truer idea of the true color than any other color background. By the same token, yellow surroundings may make even the bluest-white diamond appear yellow. Thus, the background against which you look at a diamond can

change the color or give the illusion that the stone is whiter or more transparent than it actually is.

*Look at the top of the diamond, how the table disperses and refracts the light, to see how much fire and dispersion the diamond has.

*Look at the diamond at a 45-degree angle to the crown, the one-third of the diamond above the girdle or setting, to tell the color. The top or table is only an indication of brilliance.

*Try to buy or look at the diamond unset. A setting can hide inclusions. In addition, a diamond with a yellow tint will look better in a yellow gold setting, while a white diamond will look better in a white gold or platinum setting. Remember, too, a setting can hide inclusions, making it look better in the setting than it may look unset.

*With a diamond of 1 carat or larger, insist on a GIA certificate. Any reliable jeweler (Chapter 6) should get you one for a small fee. Even though you are not investing in diamonds, the GIA certificate is your assurance that the diamond is what it is supposed to be, what the jeweler tells you, and what is written on your sales slip. Although the gem will not be appraised for price, it will be appraised for all the other qualities. Most, if not all, reliable jewelers will be willing to get you the certificate for a small fee—that is well worth it, considering what you are spending. In any case, your sales slip should specify what the diamond is, as far as the four Cs go—and you should make sure it does or that you are given a certificate that spells them out. Both will also come in handy for insurance (Chapter 10). In this respect, make sure you get a complete sales slip, identifying the diamond exactly.

Based on these criteria, what you may have to decide is whether size or quality is more important, depending on what you can afford. Is size important? You may have to settle for an included stone with a slight yellow tint, if you want a stone of 1 carat or larger. Is color important? You may have to settle for a white (D-H color) stone, with the number of flaws depending on the size and cut. Is clarity important? You may have to settle for a very, very slightly included stone of lesser color, again depending on size and cut. The prices of these examples may be the same or so similar that there is little difference. So, how do you decide?

No jeweler or expert can answer the question of which is the better stone because each has its own drawbacks. One stone is better

from the point of view of size, another from color, and another from clarity. Still, color is what the average person sees. Clarity is actually less important for jewelry, as long as the inclusions don't interfere with the gem's fire or brilliance. On the other hand, you may go along with the people who prefer a colored or "fancy" diamond—and truly yellow diamonds, what are called "canary," are as valuable as any fine white diamond of equal clarity. They may even be more expensive, because they are rarer.

The decision, therefore, is one only you can make. That brings up two other points that are covered more completely in Chapter 6: don't buy a diamond under pressure and don't bargain. A jeweler willing to lower his price may have overpriced the diamond to begin with.

The GIA, incidentally, also appraises stones for individuals. You must make an appointment, however, because although laboratory facilities are extensive in equipment they are limited in size and space. In addition, the diamond must be at least 1 carat in size and must be unmounted. For the GIA addresses, see Chapter 6.

Other Gems. Diamonds aren't the only gems you want to be careful in buying. Diamonds, at least, have standards of quality in the four Cs, but there are no similar standards for colored stones. However, you can learn a lot by looking around and asking questions.

In buying any gem, ask the jeweler to explain any term you don't understand. As noted before, Chapter 4 gives a listing of some of the terms used with substitute gems. Beware of any term used with a gem other than "genuine." Remember, a balas ruby is no more a ruby than an evening emerald is an emerald. The more expensive the gem, the more important it may be for you to ask about a GIA certificate.

Robert Crowningshield, director of the New York City GIA, says certification is important for emeralds, rubies, and sapphires. For one thing, there are so many different kinds of these gems being simulated in the laboratory that even a reliable jeweler may not be aware of all of them. One purpose of the GIA, on the other hand, is to keep abreast of developments in simulated gems. In the case of colored stones, the gem may be of any size and may be set. What is certified is simply the authenticity of the gem. The lack of standards for colored stones and the fact that color can be very much a matter of personal preference preclude a detailed rating.

In many fine jewelry stores, there is a certified gemologist on the staff. A certified gemologist (Chapter 6) has been trained in gem

detection and has been certified by either the American Gem Society or the GIA after passing courses and stiff examinations. He or she is qualified to certify gems, although the certificate will not be issued by the GIA. In cases of doubt, however, the facilities of the GIA are available to these jewelers and to you.

Emeralds, rubies, and sapphires are not the only gems for which you should insist on a guarantee of authenticity. You also want one for smoky and yellow topaz, since too much quartz and citrine is sold as the more valuable topaz. The same verification should be a condition of your buying rhodolite or grossular garnets. Both gems are far rarer and more expensive than ordinary garnets.

You want to check the prices of colored gems. Too low a price, in the range of a couple of hundred dollars, is one indication that none of the above gems is what it is supposed to be. Don't be so eager for a bargain that you forget your common sense. No jeweler who knows what he is doing is going to offer a gem worth $1,000 or much more than that for a few hundred dollars or less. So, listen carefully to the terms being used and insist on certification of authenticity when you have any doubts.

Star and eye gems require other precautions. You want to be sure the star and eye are centered. To do so, hold the gem under a light and move the gem from side to side. Part of the value lies in the centering of the eye or star, and any jewel that is off center is not worth a top price. If the gem is inexpensive enough, it may be able to be recut and set but you will be adding to the original price.

Again, the type and color of the lighting are important. A blue light, for example, will affect the color of any gem. You want to see the gem under daylight and/or regular lighting. Move the gem from side to side, examining it from all angles. Unless the gem is pleochroic, the color should be intense throughout with no shadings or dark or light spots. By the same token, if holding a gem up to daylight is a good test of color, it is *not* a gauge of its clarity or quality. You should need a loupe or microscope to see most inclusions, except for those gems which depend on the inclusions for their special effects. Some gems, such as emeralds, are also more often flawed than not, but most flaws should not be seen with the naked eye— at least as far as the better and best gemstones are concerned.

CARE

In buying any jewelry, you need to consider what care you should take with it once you purchase it. All jewelry needs to be stored. How should you store it? Will any of the gems fade in light, as some topazes or amber may?

Jewelry needs to be cleaned, too. Although ammonia, soap, and water is safe for most jewelry, it is *not* safe for all jewelry. In addition, if the jewelry is strung, special care may be needed to keep the string dry since wet string can affect the gems.

You also want to know whether the gem will chip, break, or scratch easily—how hard it is and how fragile. This is particularly important for rings, which take the most punishment. You may be able to wear some gems almost all the time, while other gems may have to be removed even when you're washing your hands. Although all of these questions are answered in other chapters of this book, you should ask the questions and be told the answers when you are looking at jewelry. They are an important part of how to buy jewelry and how to be satisfied with what you buy.

Any reliable jeweler should be able—and willing—to satisfy your curiosity. But how do you know a jeweler is reliable? That question is answered in the next chapter.

TEN RULES FOR BUYING JEWELRY

Before going on to where to buy jewelry, however, here are ten rules that summarize the guidelines for buying jewelry:

1. Buy jewelry as you would any other luxury item—because it's beautiful, you like it, and you can afford it.

2. Do not buy jewelry as an investment. You have to consider manufacturing costs, overhead, and profit, all of which increase the cost of jewelry above the value of the gems and precious metals used.

3. Do not look for bargains or "sales" in fine jewelry, both of precious metals and gems. You get what you pay for, and you pay for what you get in most cases.

4. In buying precious metals, insist on seeing the karat, platinum, or sterling silver marking. Look for hallmarks as standards of quality.

5. Inspect precious metals and settings for rough spots or edges that indicate less than quality care was taken in finishing the jewelry.

6. Beware of blue, colored, or tinted lights that can change the color of gems. Insist on seeing a gem in daylight or under white fluorescent light. Make sure the light is good and is strong.

7. Check gems from all angles, moving them under the light. Although this precaution is essential with star and eye gems, it is also necessary for other gems.

8. Ask about a verification or certification of authenticity from the GIA of any gem that might be questionable and of all diamonds of 1 carat in size and above.

9. Ask about names or terms you don't understand. Make sure you are satisfied before you buy.

10. Be sure you understand what care you should take in wearing, storing, and cleaning jewelry before you buy it.

6.
WHERE TO
BUY FINE JEWELRY

You are walking down the street and you see a street peddler or someone approaches you. The person offers you a "genuine 14-karat gold chain" for $45, less than half the price in a store. You hesitate. The seller takes advantage of your hesitation and offers the chain to you for $35 because he needs the money. Would you buy it? If you did, you would not be the first—and you won't be the last to find out later that you had bought a chain electroplated in 14-karat gold that you could have bought in a department store for less than $10, although it may have a 14-karat clasp.

You are window shopping, perhaps wasting time before meeting a friend for lunch, and notice a famous brand-name watch in the crowded window of a small store. Since you have always wanted that particular watch, you go into the store and ask to see the watch. The clerk shows it to you, telling you the price. When you hesitate, he offers it to you at a lower price. Would you buy it? If you did— and again you would not be the first—you would find out later that what you had bought was a cheap imitation.

You are looking at diamonds in a jewelry store, and the clerk offers you a diamond for cash, without a sales slip *or* sales tax, for a price lower than the original one. Would you buy it? If you did—

and still again you would not be the first—you are likely to find on having it appraised that it is worth half what you paid.

You see a sign, "Going out of business. Must sell all gold jewelry at 50% off." Would you go into the store, much less buy anything there? Needless to say, your chances of getting what you pay for are no better in this instance than they are in the other instances and no better that you will ever get your money back.

All of these examples are examples of precisely where you should *not* buy fine jewelry. In buying fine jewelry, you are buying jewelry you want to keep and treasure, not throw away the way you may do with costume jewelry. For that reason, not to mention what you may have to pay, you want to be careful where you buy jewelry. And the more you pay, the more you want to be sure the store is reliable, with a reputation of standing behind what it sells. Those qualifications automatically rule out street peddlers, strangers, hole-in-the-wall or fly-by-night stores that may be here today and gone tomorrow, and stores with continual going-out-of-business sales. But where *not* to go is not much help in finding the store where you should go.

If you have a jeweler with whom you have dealt in the past and with whom you have always been satisfied, you will want to continue going to him. On the other hand, perhaps you have moved or you are making your first purchase of fine jewelry or your jeweler doesn't carry the type of jewelry you want. How do you go about finding the right place to buy a piece of karat-gold jewelry or a diamond or other gemstone? How do you know whether you are getting the best advice available? How do you know the store has the kind of business and professional ethics that will mean a fair price backed up by assurance that what you buy is genuine?

One way is to ask people you know about their jewelers, just as you would ask about their dentists or physicians. The key word is jeweler. You do not want a watchmaker, unless you are interested in buying a watch or having one repaired. A watchmaker is an expert, but he is an expert only in watches and not in fine jewelry, although watches may sometimes come under the category of jewelry. A jeweler, on the other hand, may sell watches but he should be an expert in precious metals and gems, with training, experience, integrity, and a reputation in the field to protect. These qualities are important, because with the price of jewelry being what it is you

cannot afford an expensive mistake: you need a guarantee that a piece of jewelry is what it is supposed to be, since you cannot always tell just by looking at it. In this sense, jewelry is a blind purchase.

To begin with, therefore, you want a jeweler and not a watchmaker.

A jeweler is a person who makes or repairs jewelry or who deals in jewelry, precious stones, watches, and perhaps silverware and china, according to Webster's Dictionary. More important to you is the fact that a jeweler should not only deal in those items but also be an expert in them and stand behind what he sells and the work done.

Whether or not you have the names of several jewelers, start out to find the one for you by looking around in various stores. Some jewelers may specialize in certain types of jewelry. If you are interested in diamonds, make sure the store carries a good selection of diamonds. If you are interested in colored stones, make sure it has a good selection of those, including the ones you may want to buy.

A jeweler may have a wide choice of diamonds, which is good as long as you want to buy a diamond, and only one or two rubies, sapphires, or emeralds—which is not as good for you when one of those is the gem you want. Use the same precaution for topazes, opals, or tourmalines, which can be costly, as well as for stones that are less expensive. If you want one of the lesser-known gems like peridot or spinel, for example, you want a jeweler who is familiar with them. A jeweler who does not display those gems may still have them or be able to get them, but you want assurance he is familiar with the gems.

Once you have found a jeweler or jewelers who carry what you want in styles that appeal to you, you still want to know more about the store. That brings up professional ethics and sound business practices.

WHAT TO LOOK FOR IN A JEWELRY STORE

You want to keep in mind that the warning of "Let the buyer beware" is not limited to jewelry stores or jewelers or one country or another. Retailers everywhere indulge in the same practices. Going-out-of-business sales with supposedly large discounts are a common ploy to make consumers think they are getting big bargains and better buy now—before they have a chance to look around—or the

bargains may be gone. The idea is buy now or lose your last chance to make a bargain. The same warning holds true for the other practices mentioned at the beginning of the chapter.

Such stores and people count on human nature, on people wanting to get something for nothing, and on impulse buying. They should be avoided on general principles, regardless of what you are buying. As consumer protection agencies warn, your chances of getting your money back should the item be faulty or not what it is supposed to be are slim. If the item can be repaired, your chances of having that done are equally slim since such stores or people only want to sell and are not interested in keeping you as a customer. Above all, you may even pay more for an item than you would for the same item at a reliable and reputable retailer.

So, in looking around, avoid such stores. At the same time, there are other, less blatant clues you want to check out.

ADVERTISING

Advertising is a good way to check out a jeweler, both advertising in newspapers and in-store advertising, as well as on radio or TV. Sales offering discounts above 20 percent, and especially more than 40 percent, are grounds for looking warily at a jeweler. Granted, markups tend to run from as little as 30 percent to as much as 100 percent or even more above cost, but fine jewelry is a limited commodity.

Although jewelry is manufactured, perhaps mass-manufactured, the materials used come out of the ground and are limited in supply. Any time when demand is equal to or greater than the supply, as is the case with gold and precious gems today, prices will be high to the dealer, manufacturer, middleman, retailer, and consumer. The basic materials cannot be manufactured or increased on demand. As a result, neither the retailer nor anyone else along the sales chain needs to offer huge discounts to get people to buy, unless something is wrong.

The sale may be "bait" to get you into the store, in which case you will find relatively little selection at that price. Instead, the store personnel will try to switch you to a higher-priced item.

Even if you find a large selection, you should question sales offering such large discounts. What was the original price and was that price fair? The only way you can tell is by having an idea of what

similar jewelry sells for at other stores and jewelers. For example, if similar gold chains of comparable karat-gold weight are selling elsewhere for $100, and these are marked at 40 percent off an original price of $150, are you really getting much of a bargain for $90 and is that the kind of store you want to give your business to?

Another practice that should make you wary is advertising or pictures showing blown-up illustrations of pieces of jewelry. Sometimes, the entire piece may be shown; other times, one part may be shown larger than another. The Federal Trade Commission requires that such pictures state that the jewelry is enlarged. Otherwise, a minuscule diamond could look as large as, or larger than, a 1-carat stone. Most reliable jewelers will state "shown in actual size," if that is the case, or "the .75 diamond is enlarged for detail," unless the scale is apparent, such as showing a ring on a hand.

Still another type of advertising to be wary of is advertising that emphasizes credit terms rather than merchandise. The prices may be marked up to conceal carrying charges. Thus, you may be paying for credit, regardless of whether you buy on credit or pay cash.

Advertising that exploits "throw-ins" or giveaways is a clue to a store you should avoid, too. Such "gifts" are generally not gifts. They may have little value, for one thing. Second, you pay for them in one way or another. Their cost, in fact, is probably hidden in the cost of the jewelry. The intrinsic value of fine jewelry is too high for anyone to be able to afford to give it away.

In short, advertising should be conservative. Merchandise should not be misrepresented, either in pictures or words or in the availability of jewelry in that price range.

THE STORE

The store should be an established one with a good reputation for reliability and integrity in the community. The longer the time a jeweler has been in business, the more you or your friends may know about him. That does not mean that a new store is not reliable, although it may be best to choose one that has been in business at least a year unless you know the jeweler.

Look around the store to see the type of jewelry and the selection. The larger the city or community, the larger the selection of the jewelry in which you are interested should be. No matter how reliable a jeweler may be, if he doesn't carry a selection of what you

want, you may be better off going to another jeweler. Of course, he may have other kinds of jewelry not on display. So, if you like the store in other respects, be sure to ask about what you want.

You want to notice, too, how the jewelry is displayed. The various pieces should be shown in such a way that you can get a good idea of them just by looking at the display. A jumble of jewelry is a sign of a jeweler who does not appreciate quality and value— and probably does not carry it. Each piece should be displayed in such a way that it is protected from being scratched or damaged by other jewelry.

Lighting is an important part of the display. The store should be lit well enough for you to get a good idea of the jewelry, both inside counter cases and outside. There should be at least one lamp with a strong bulb under which you can examine gems from all angles and get an idea of the true color. In this respect, you want to check the *color* of the lights. The best lighting is white fluorescent lights or daylight. As explained in Chapter 5, walk out of stores with only blue lights or candle-type lighting, both of which make any gem look good and can improve the color of gems.

Price tags are another indication of a store's reliability and integrity. They may not always be visible, particularly in window displays, but each piece of jewelry should be marked and marked clearly. Markings in addition to price may vary, although tags on diamonds often include carat weight, color, and clarity as well as price. A tag that indicates only a carat weight and code instead of a price should turn on a caution light in your mind. A code can be an indication that the price is not fixed and the jeweler is willing to bargain. It can also be a sign of questionable quality, since clarity and color are as important as weight in determining the price of a diamond.

Bargaining is not the way to buy jewelry. It does not mean that you *get* a bargain. The prices of diamonds (or other jewelry) of similar quality and size may vary slightly among stores, depending on settings and factors such as costs and overhead, but the difference is usually not great. Jewelers know the cost and what markup they must charge to cover expenses and profits—and stay competitive. A jeweler willing to bargain is probably inflating the original price, just to make you think you are getting a bargain. Reliable jewelers realize that the average consumer is not an expert, and they neither take nor want to take advantage of you. That is why their jewelry has a price

tag. A code puts you at a disadvantage—and a big one, as does the lack of other information to which you are entitled, such as color and clarity in a diamond, in order to make a good decision.

To sum up: look for tasteful displays, a good selection of the type of jewelry in which you are interested now and in the future, good lighting that avoids blue light or candlelight, and clear and well-marked price tags.

TRADE NAMES

Certain names are trademarked and are an indication of the highest quality. This is particularly true of the world's finest jewelry stores that put their own hallmark or name on jewelry made for them and sold only in their stores. In recent years, however, their designs and names are being used illegally on cheap copies that are available in a variety of stores and countries. The same situation is true of records and clothing. The fakes may be sold at the same or even higher prices than the original.

These fakes are not the same as the frankly fake, the imitations being sold under other names at prices far below those of the originals. When you buy the frankly fake, you know you are getting an imitation and you do not expect to get the quality of the original. The fakes to beware are those that pretend to be the original, down to the copying of the trade name.

You can protect yourself from being taken in by these fakes. The Cartier tank watch is a good example. This watch was originally designed by Cartier in 1918 as a gift to American tank commanders, in thanks for their contribution in saving France during World War I. The distinctive design struck the fancy of far more people than the tank commanders, and Cartier's began making the watch for sale in its stores. Nowadays, it sells some 50,000 of these watches a year to both men and women in 18-karat gold and in vermeil. The original watch is available only at Cartier stores and at licensed dealers, but the popularity of the watch as a status symbol has made it the ideal target of counterfeiters. As a result, counterfeit watches are being sold in a variety of stores and countries at prices ranging from the same price as Cartier's to much lower, despite the fact they are worth perhaps $25.

Ralph Destino of Cartier's tells of walking by a store not far from Cartier's on Fifth Avenue and seeing the fakes in the window. Pre-

tending to be a customer, he walked in. At first, he was told that the price was the same as the genuine vermeil watch. The more he hesitated, the lower the price became. He of course knew better than to be taken in.

You should know better, too. If you want a piece of jewelry that is exclusive with a certain store, that bears its name or trademark, buy only from that store. You cannot get the genuine article, with the original quality, anywhere else at any price—and especially not at a cut-rate price.

SELLING TACTICS

The misleading practices mentioned above are indicative of the kind of stores with the kind of selling practices you also want to avoid. Hard-sell advertising usually means hard-sell or pressure tactics once you start to buy. Reliable jewelers naturally want to sell you jewelry, too. They need sales to stay in business, but they do not need or want to make the type of sales pitch that pushes you into a purchase you may regret or with which you will not be satisfied.

Pressure tactics of any kind should be a warning to walk out of a store. So should a willingness to bargain and any suggestion that the store will not charge you sales tax as long as you pay cash and are not fussy about a sales slip. Granted, if you state that the price is more than you wanted to pay, you should be shown other jewelry—but you should not suddenly find the price of the piece of jewelry you are looking at being lowered. By the same token, if you ask to see a particular piece of jewelry that was advertised at a certain price or is marked a certain price, you should not be shown higher-priced jewelry in such a way that you are influenced to buy the higher-priced item.

Showing you jewelry in different price ranges to point out differences in quality or size is legitimate and a form of comparison shopping that is invaluable. The decision of which to buy, however, is yours, and the selection should be shown with that purpose and in a way that gives you the freedom of choice to make up your mind what you like and can afford.

Keep in mind that the first criterion in buying jewelry is that you like it and it appeals to you emotionally. The second is that you can afford it. If you do not like a piece of jewelry, say so. If it is too expensive, say so. Any pressure or attempt to influence you to

change your mind in either respect is the kind of selling tactic that is not representative of a reliable, reputable, and established jeweler. Such a jeweler wants you to be satisfied in all respects in order to get and *keep* your business.

At the same time, bargaining has another aspect, and that is when you have a piece of jewelry you want to sell or trade in for a new item. Appraisals vary for legitimate reasons. One jeweler may offer more of an allowance than another jeweler. In selling jewelry, what you usually get is no more than the wholesale price of an equivalent piece of jewelry and you may get less. If the jewelry has no resale value except the value of the precious metals and gems, you will get that amount.

Thus, when you have jewelry you want to sell or trade in, you may want to shop around a little to learn the value of your jewelry. The offers may vary, but any offer that seems much higher than the others should be treated warily. The high offer may be an indication that other prices are higher than they should be or an attempt to get you to buy a higher-priced item by making you think you are getting a bargain. An offer too much lower than the other offers may mean the jeweler does not understand the value, which can happen with antique jewelry. For more information, see Chapters 9 and 10.

Selling tactics, nevertheless, can also be an indication of a jeweler's knowledgeability. How much information does the clerk or jeweler volunteer? A well-marked price tag is one way of informing you voluntarily. You may need more information, however, particularly when buying gems. With diamonds, the terminology used regarding color and clarity should be explained, so you know exactly what you are buying. The inclusions should be shown to you through a loupe, pointed out and explained. Some jewelers will even draw you a "map" showing you the inclusions to help you identify them yourself.

Above all, no gem of any kind should ever be simply held up to a window or light to show you how "perfect" it is. The jeweler should let you hold the gem in a good light to let you move it around to your satisfaction, to check the color, the fire, or a star or cat's-eye, but you cannot tell flawlessness without a loupe or microscope.

You should be told any special care or precautions you should take with any gem, especially fragile or soft stones, although it never

hurts to ask before you are told. The more interest you show and the more appreciative you are of fine jewelry, the more help you will probably get because a jeweler who appreciates fine jewelry will appreciate your interest. That is human nature.

In buying diamonds of 1 carat and above, the expensive colored stones, or those gems with substitutes (Chapter 4), the jeweler's willingness to supply or get you a Gemological Institute of America certificate is another indication of reputation and integrity. Although that willingness is not a selling tactic in the strictest sense, it is a buying tactic. A jeweler who refuses may have something to hide. A jeweler who tells you it is not necessary may be right. Still, the more you pay for a gem, the more you want to be sure you are getting what you think you are buying. And you can always make an appointment to send the gem to the GIA yourself (see below), if you are satisfied with the jeweler in all other respects.

Getting an appraisal can sometimes have another side to it. If you are considering a diamond, some stores—particularly in the diamond district of West 47th Street in New York City—will offer to let you have the stone appraised before you buy. In fact, they will help you get the appraisal. The jeweler or someone from the store will go with you to an appraiser's or another store. If this happens to you, make sure the person waits outside and doesn't accompany you into the appraiser's. The jewelers and their assistants are all known to one another, with the result that the appraisal and the price will probably be the same. When you are alone, the appraisal could be far different. In addition, do not volunteer any information about the diamond, as to price or quality: let the appraiser set the value and quality without your help.

Once you have made up your mind to buy any kind of fine jewelry, you want to be sure the sales slip fully identifies the item. Karatage in gold, sterling in silver, and quality of platinum should be listed. So should the four Cs for diamonds. For other gems, specifics of weight, color, cut, and kind of other gem should be given. The type of setting, including information on any gems used in the setting, should be listed as well for all gems. You will need that sales slip in case another appraisal disagrees and you want your money back. You will need it, too, if you want to insure the jewelry. When a jeweler cannot or will not give you a specific sales slip, don't buy— regardless of any other respects that satisfy you.

CONSUMER PROTECTION

No matter how careful you are in choosing a jeweler, there may be times you have complaints. In addition, you may want to know more about a jeweler's reputation and standing in the community, especially if neither you nor your friends know anything about the store.

In these cases, you can consult the local Chamber of Commerce, Better Business Bureau, and/or consumer protection agencies. The last two should be able to tell you whether they have any complaints reflecting on the jeweler's reliability or integrity or selling practices. Granted, not all complaints may be reported and some that are reported may not be valid, but any jeweler who consistently indulges in less than ethical business practices will sooner or later come to the attention of at least one of these organizations. That means, moreover, that you should report any jeweler or other businessman you find operating in such a way that you feel is fraudulent or misleading, to protect others and yourself.

THE GIA AND JEWELERS ORGANIZATIONS

Despite all the warnings, you do have shortcuts in finding a reliable and reputable jeweler; specifically, start out by learning whether the jeweler is a member of a trade organization or society that promotes and stands for ethical business practices. To do that, you need to know what the organizations are.

Of course, membership in an organization and displaying its symbol or certificate is not an absolute mark of ethics or integrity. Most of the organizations listed below do try to monitor members and to keep standards high. As a result, they are generally responsive to consumer complaints.

GEMOLOGICAL INSTITUTE OF AMERICA (GIA)

The Gemological Institute of America is basically a scientific and educational institute and not a trade organization. Its branches, at 580 Fifth Avenue, New York, NY 10036, and 1660 Stewart Street, Santa Monica CA 93404, provide gemological training and extensive gem-testing laboratory services to jewelers. The laboratory services are also available to the general public.

The GIA offers correspondence courses in gemology, both in diamonds and colored stones, and provides in-laboratory training in testing, recognizing, and evaluating gems. The courses and training are thorough and extensive. Passing the courses is a mark of genuine achievement, and any certificate indicating a jeweler has passed a course is an indication, the best indication, in fact, of a jeweler's knowledgeability in that field.

As far as gem testing goes, there are other laboratories but experts agree that the GIA testing is the only one that counts. The GIA, for example, was responsible for establishing quality standards for diamonds, both for color and clarity. These standards, as noted before, are internationally accepted and are often used by dealers worldwide in buying and selling gems. The GIA keeps in contact with gemological societies in other countries, such as the Gemmological Association of Great Britain. As a result, it keeps as abreast as possible of developments in the gemological field, including the laboratory synthesis of gems.

You should know about the GIA because of its role in settling any doubts about the quality of diamonds and the authenticity of other gems. Only the GIA in New York or California can issue its certificate. The logo or symbol has sometimes been imitated, so make sure any certificate also has a GIA file number and is signed by a gemologist from the Gem Trade Laboratory.

One last point: Asking for a GIA certificate is not a reflection on a jeweler's integrity. Stores such as Tiffany's and Cartier's will obtain one for you at a small charge. The principal reason for wanting one is that there are so many synthetics being made by so many different people that an individual jeweler may not know about all of them and may not have all the equipment (which can be very expensive) necessary for testing. The GIA, on the other hand, is fully equipped to test gems. Since its primary purposes are educational and testing, it is concerned with authenticity and quality, not price. To find out whether the price you paid is a fair one, therefore, you have to go elsewhere.

AMERICAN GEM SOCIETY (AGS)

The American Gem Society has a membership of some 1,400 retail jewelry firms and 3,200 individual jewelers in the United States and Canada. It was formed in 1934 by the founder of the Gemologi-

cal Institute of America and several leading American jewelers, with the goal of creating a professional society capable of maintaining high gemological standards and business ethics.

Members are encouraged to pursue further studies in gemology, and the AGS awards the titles of Registered Jeweler, Registered Supplier, and Certified Gemologist to those taking recognized courses and passing comprehensive examinations. The Society, whose headquarters are at 2960 Wilshire Boulevard, Los Angeles CA 90010, monitors members and is responsive to complaints that reflect not only on a member jeweler's integrity and ethics but also on the AGS as a whole.

To be a member, a store must be in existence for at least a year before its application and must have a good reputation in the community. It should have a representative stock of jewelry of good quality which it offers at the same price to all consumers. Advertising and other practices must be straightforward and in conformance with rules and regulations of the Federal Trade Commission and the Bureau of Standards of the Department of Commerce, as well as of the AGS and the Association of Better Business Bureaus. In other words, the practices must conform to the ethics stated at the beginning of this chapter.

The seal, bearing the letters AGS with a brilliant-cut gem in a decorative, elongated circle, therefore, is generally a symbol of reliability. However, Alfred L. Woodill, Executive Director of the AGS, says, "Any certificate is not an exact mark of ethics." He adds, "There are many jewelers not in the AGS who have done considerable gemological studying." Still, the symbol is a good one to look for when you are trying to find a reliable and reputable jeweler.

When you see the certificate of Registered Jeweler, or Registered Supplier for a wholesaler, you know that the person:

*Has had at least three years of experience (two, if there is another Registered Jeweler on the staff) in gem merchandising.

*Is affiliated with a firm that has already been elected a member firm of the AGS, has a binocular gem microscope, and has a set of at least three master color grading diamonds. The diamonds are important in appraising other diamonds for color, an important feature in the four Cs.

*Is actively engaged in buying or selling diamonds and other gems, unless there is another Registered Jeweler already doing so on the staff.

*Has proven his gemological knowledge by:

Passing the correspondence courses offered by the GIA in diamonds or colored stones and from the AGS in merchandising and selling.

OR

Passing the AGS's special examinations in gemology and in grading diamonds and identifying common gemstones.

OR

Passing European courses as offered by the Gemmological Society of Great Britain and by the AGS in selling and merchandising.

When you see the certificate of Certified Gemologist, you know the jeweler:

*Has already qualified as a Registered Jeweler or Registered Supplier and has held that title for a full year *and* has:

Passed the more advanced special examinations of the AGS.

OR

Taken the remainder of the GIA correspondence courses in diamonds or colored stones, depending on which was taken for the title of Registered Jeweler, and in gem identification, and has passed the final examinations for the courses as well as the final examination on the entire curriculum.

These titles are renewed annually, with the person taking and passing examinations on new developments in gemology. The person must also satisfy the AGS that the title is being used in such a way as to reflect credit to the AGS and the industry as a whole.

APPRAISERS ASSOCIATION OF AMERICA (a/a/a)

The symbol of the Appraisers Association is an owl holding a scroll with a/a/a on it, surrounded by a circle around which is written Appraisers Association of America. Membership is limited to individuals, rather than firms.

Among the Association's goals are the providing of ethical standards for appraisers and regulating and supervising the conduct of its members, including settling and adjusting differences among them.

A directory of members is available from the Association at 541 Lexington Avenue, New York, NY 10022, for a small fee. It indexes members alphabetically and by specialty and state, giving their business or firm address.

Many members are jewelers as well as appraisers. In addition, since the Association monitors members, you have an added assurance of reliability.

JEWELERS BOARD OF TRADE

The Jewelers Board of Trade is basically a credit organization, providing members with information and assistance in matters relating to the credit of its members. It is not involved with consumer credit, only that of its members, both jewelers and suppliers.

Because of the large amount of money involved in offering a representative stock of fine jewelry, a good credit rating is important to a jeweler. Thus, a jeweler who belongs to the Jewelers Board of Trade is probably more reputable than one who is not.

BUYING MAIL-ORDER AND WHOLESALE JEWELERY

Jewelry and gems are blind items in that what you see is not always what you get or pay for. When you do not see them before buying, you are doubly at a disadvantage. Ordering precious jewelry or gems by mail, therefore, is very much a matter of "let the buyer beware."

You are more apt to find unset gems being offered through the mails at cut-rate prices than jewelry. Although gems are not jewelry until they are set, buying them by mail deserves a mention.

The gems are usually offered as "investments," with the offering pointing out how much gems have increased in value over the past few years. True enough—except you have to remember that only gems of top quality and size have increased in value to any great extent. You are rarely, if ever, going to be offered this kind of a gem. No dealer in his right mind, in fact, would offer such a gem at less than market price when he can get top dollar for it from any jeweler to whom he shows it. Small diamonds and diamonds and other gems of lesser quality may also have increased in price but hardly enough to make them an investment. The prices are more likely to have kept pace with inflation.

If you read any advertising, brochure, or other material very carefully, you can tell soon enough exactly the kind of gems you are getting. For example, one promotion says, "Always at 60 percent less than the price your jeweler or gem dealer charges for items of common, commercial quality." No gem of common, commercial quality has risen much more than the inflation rate. You want to remember, too, that any time you sell gems or jewelry, what you get is equivalent to what it would cost for the same quality at wholesale prices. Thus, even at 60 percent off, when you sell the gem you get what you paid for it and perhaps less, depending on how the buyer appraises the stone.

The same promotion mentions emeralds, rubies, and sapphires for $10 a carat that are worth between $20 and $35 on the retail market. Considering that any of these precious stones of good quality and color could command thousands of dollars a carat, what kind of a gem is it that you can get for $10 or $35? The rubies are supposed to be Indian rubies, which are called "the major source for fine rubies." The finest rubies are Burmese pigeon-blood rubies, followed by rubies from Thailand and Ceylon. The certification offered is not GIA certification but from a society whose address is the same as the company offering the gems. Should you decide to have the gem appraised yourself, the cost will be more than what you paid for the gem.

At the same time, are you being cheated? The promotion does specify "common, commercial quality" and guarantees that the purchase "is as perfect and valuable as claimed." In short, you are probably getting exactly what you are paying for.

There are also a number of gem clubs, offering members special prices, such as wholesale plus a commission. Since all you see is a single price that includes both, you have no idea of what you are actually paying for the gem and what you are paying in a commission. The total may even be closer to retail than wholesale. Again, there is the problem of certification. What kind of certification, if any, is provided? If you want GIA certification, who gets it?

Buying wholesale has hidden dangers, too. First of all, few consumers have an opportunity to buy wholesale. You have to know or have access to a wholesaler, and most wholesalers only trade with dealers and not anyone who walks in off the street. At the same time, some wholesalers in major gem-cutting cities may sell to individuals. If you have a chance to buy a gem wholesale, you want to use the

same criteria as you would in buying retail. Lighting, layout, and the attitude of the seller are just as important in buying wholesale. If you are buying a diamond or colored stone, you still want to insist on a GIA certificate and you may want an outside appraisal. In some cases, you may find what is being sold as wholesale is the same price as retail. And if you do get a gem wholesale, remember you still have to have it set.

BUYING JEWELRY ABROAD

If you are planning a trip to another country and think you might want to buy jewelry for yourself or as presents, you should do a little checking first. The national tourist office of that country, its airline, or your travel agent may have helpful information, both on what to look for and where to shop.

You want to know particularly about gold and silver quality markings, whether there is a minimum standard for calling an item gold, how karat gold and sterling silver are marked, and about any hallmarks. If the country is noted for any particular kind of jewelry or handicrafts, the agencies mentioned above should know where you are apt to find them. In general, buying such items where they are made is a good idea, if possible, because prices are apt to be cheaper and the selection will be wider.

Another question you want answered is whether prices are generally fixed or bargaining is the rule. Outside western Europe, you will probably find a mixture—the finer shops having fixed prices while smaller shops rely on bargaining. Some countries have government-authorized stores where prices are fixed. In other countries, shops and stores may be members of national travel or other organizations. In these cases, the authorization or membership is a symbol of reliability, of paying a fair price and being able to get your money back. If, after buying an item, you have a complaint or find out that it is not what it is supposed to be, the organization should help you when the store or shop is not responsive to your complaint.

You also want to find out about local taxes. In the United States, taxes are *added* to the price. In other countries, the price tag may *include* local taxes. Some countries, however, may offer discounts for purchases in foreign currency, while other countries may not charge tourists the taxes, provided the purchases are bought in certain stores or they are shipped to a plane or ship or out of the country.

Duty-free shops, nevertheless, can be misleading. Airport duty-free shops, for example, vary widely in prices. In some shops, the prices are about the same as in local stores, while in a few shops the prices may be even higher. Remember, too, "duty free" means free of duty in the country in which you buy the item. It may not always mean it is duty free in the country into which you import it. For this reason, you want to check on customs duties before you leave home. Regulations can be changed between one trip and another, both as to overall allowance and as to the duty on certain items and what constitute duty-free items.

Last but not least, before you go abroad, check prices at home. If you are interested in gold, what would you have to pay at home for a gold necklace, ring, or earrings that you like? If you are interested in gems, what would you have to pay for a gem of the species, quality, size, and setting that you are thinking about? Just because South Africa, for example, is a major source of diamonds, or Israel is a major diamond-cutting center, doesn't mean you will get diamonds cheaper there than you would at home. The prices of diamonds are pretty well set by DeBeers, and the diamond bought in one of those countries or anywhere else may end up more expensive after you pay duty on it than a similar diamond bought at home. In addition, fine gems are a source of foreign currency, and the best gems may be sold abroad rather than inside the country mining them.

So, above all, check prices at home. You may not have the satisfaction of saying, when someone compliments you on a piece of jewelry, "I bought it in France," or Israel or Africa or India or Hong Kong, but you will have the satisfaction of knowing you bought the best for the least money. The exception is native jewelry or handicrafts. Even then, you may be able to find the same thing at home at a similar price and not have to concern yourself with carrying it or having to pay duty.

At the same time, buying at the source can have an advantage. For example, Idar-Oberstein in West Germany has been famous for centuries for cutting and polishing less expensive gems, such as agate, quartz, garnets, amber, and others. The shops are both small family businesses and large concerns. If you were to want rose quartz, for instance, you may find an unparalleled selection to choose from at prices less expensive than elsewhere.

Diamonds have been mentioned above. But what about Hong Kong for jade or Japan for pearls? As far as Hong Kong goes, first of

all, be sure to read over the section on jade in Chapter 4. Unless you are careful about the reliability of the dealer or know something about jade, you may end up with "Soochow jade"—soapstone. Another problem is that you will find genuine jade made both in Hong Kong and in China. The types of carvings are entirely different, at least to an expert, and the problem lies in bringing it into the United States. Hong Kong jade has been dutiable at a lower rate than China jade, because the duty on items from Communist countries is higher than on items from other countries. What matters to U.S. Customs is where the jewelry is *made,* not where it was bought. You can ask in buying an item where it is from, but regardless of what you are told, *you* probably cannot tell the difference between Hong Kong and Chinese jade—although U.S. Customs officers can.

You may want to think about duty in bringing pearls into the United States, too. You will probably find a much wider selection of colors and sizes of pearls in Japan than in most jewelry stores elsewhere in the world. A major factor in whether they are a good buy or not, however, could well be your decision to buy unstrung or strung pearls. Unstrung—or temporarily strung—pearls are dutiable at a much lower rate than strung pearls. If you do buy temporarily strung pearls, however, be sure there is no catch. Even a separate catch automatically puts the pearls in the class of jewelry, which is dutiable at a much higher rate than temporarily strung pearls or unset gems. This can make the difference between the pearls being a good buy or much the same price as they are in the United States.

In short, do not think that because you are buying at the source you are always getting a "good buy." Price aside, workmanship can be a factor, too. Most ivory comes from Africa, but Africa may not be the best place to buy well-made ivory jewelry. Ivory is also carved in Hong Kong and Idar-Oberstein. The author, for example, has ivory beads carved in Idar-Oberstein and beads bought in Africa. The color and quality of carving in the German-bought ivory are far superior to that of the African ivory, although the African beads were much lower in price.

For all of these reasons, you want to comparison shop *before* you leave home. That is the only way nowadays, what with inflation and the changing currency-exchange rates, to tell what is a good buy in other countries, regardless of where you go.

SHOPPING ABROAD

Once you are abroad, looking around and comparison shopping is also a must. Compare both prices and quality, being sure to look for gold and silver markings and keeping in mind that not all countries are fussy about enforcing standards. For this reason, the more expensive the item, the more you want to look for the kind of store in which you would shop at home. Look for price tags that mean the item is offered to everyone at the same price, and look for a good selection of the type of jewelry in which you are interested.

Listen to the salesclerk. Is the person interested only in making a sale or does he or she want to help you find the piece of jewelry you want? Does he or she explain the quality markings and/or hallmarks? Are you given time to make up your mind or are you being pushed into buying? If gems are involved, what kind of an authentication can you get that the gem is what the person says? Are you familiar with the terms the clerk is using? Keep in mind that less expensive gems often masquerade under a variety of terms that lead you to think they are more expensive gems. Language can often be misleading, even when it is your native tongue; when you are dealing with a foreign language or a person to whom English is a second language—or third or fourth—it is all the easier for you to be misled.

Buy only after you are satisfied with the reliability and reputation of the store. Whenever you have doubts, don't buy, or check first with a local travel or tourist association that may be helpful or can tell you where to go for further information. In any case, avoid sidewalk sellers or peddlers, any store that "promises" extravagant bargains, and hole-in-the-wall shops that may be here today and gone tomorrow.

When it comes to bargaining, you are on your own. Bargaining is an art in itself, and one in which most Westerners are novices and automatically at a disadvantage. In countries in the Middle East and Asia, moreover, it is not only an art but also a way of life.

A cardinal rule to follow is never bargain when you are in a hurry. The more expensive an item is, the more important it is for you to take—and have—the time to bargain. A gem dealer told the author about buying a diamond in India several years ago. He spent a week bargaining before he decided to buy the diamond, because he had to leave and he felt he had made a good buy. A few years later, he learned that he could have bought the diamond even cheaper, had

he had more time to spend on the bargaining. So, keep in mind that bargaining can be a lengthy and time-consuming process. If you don't have the time, don't bargain—at least for expensive items.

You also want to keep in mind that you have no idea how the price was set at the beginning of the bargaining. Without a price tag in front of your eyes, you have no idea how high the actual selling price is jacked up or whether there are two prices, one for natives and one for tourists. Your only gauge is the comparison shopping you did at home, which can help you decide whether the item is a bargain—at least to you.

If you decide to buy, insist on a proper sales slip that fully identifies the jewelry and gives the price you paid. There are two reasons: first, you will need the slip for customs; second, if the jewelry has been bought from a shop or store that has a branch in your country, that branch may make good on the jewelry, should it not be what it was sold as. So, be sure to declare the jewelry, particularly when it is an expensive item.

A customs officer told the author about a jewelry dealer who bought a piece of jewelry for several thousand dollars. He considered it a good buy, but when he brought it home and had it appraised he learned that several of the gems were not genuine. He took the jewelry to the New York representative of the store and the representative immediately offered to reimburse him as long as he had the sales slip and customs clearance. The dealer had no choice except to go to customs, admit he had "forgotten" to declare the jewelry, and pay the duty plus a fine. The dealer, nevertheless, was fortunate in that his money was refunded because the mistake was an honest one on the part of the store and the store had a reputation to uphold.

You may not be so lucky. Once you get home and have an expensive piece of jewelry bought in another country appraised, it is often too late to do anything. You would have to take another trip abroad to return the jewelry. Even then, if the store is not reliable or it was bought in a bazaar or from a street peddler, there may be nothing you can do.

Expensive jewelry should always be appraised once you get home. You will want to know the value at home in order to have it insured, for one thing. For another, you want to ascertain how genuine it is, if for no other reason than to know that you paid the correct customs duty. If it is not genuine, you can challenge the duty and get your money back.

In buying abroad, you also have to consider the rate of currency exchange in the country where you are buying the jewelry. At one time, when the price of gold was $35 an ounce and the value of the dollar was high, jewelry could often be bought in other countries at far less than what it sold for in the United States. With gold reflecting a free-market price and the dollar low, similar jewelry today may be more expensive in other countries. The exchange rate, therefore, is one consideration.

Another is whether you know what you are getting and whether what you are buying is actually what it is supposed to be. Remember, even experts can be fooled because of the multitude of synthetics and their quality. The average tourist is not an expert. Too many people, when traveling, will rush into buying an item that they might think over twice at home. They may be in a hurry because of time and want a souvenir, in which case jewelry seems a "good buy" because it is so easily packed. They may also be fooled by sharp tradesmen offering "genuine" gold and gems at prices too good to be true. If a price is too good to be true, wherever you are—and you can get a good idea by shopping around—it probably is not true, any more than the jewelry is genuine.

Unless you know where you are buying or the jeweler is highly recommended by responsible sources of information, you are probably better off buying inexpensive jewelry or jewelry representative of the particular country. Even then, ask yourself whether you really like it and will wear it at home and whether you can afford it. As long as the jewelry is under $50 or $100, whatever limit you set that you feel you can "lose," it may be well worth the money for the pleasure you get out of it—even if the price may still be high for what the jewelry is actually worth.

The last factor is the customs duty you have to pay when you get home. Although you should check before you leave, because customs regulations change, there are some general rules that can be helpful.

U.S. CUSTOMS

As of the end of 1978, the amount of items that you can bring into the United States duty-free is $300. As long as the jewelry you buy in combination with other purchases is worth less than $300, you do not have to pay duty.

That doesn't mean you can bring in anything you want, however. Remember, not all gems are minerals.

Ivory comes from elephants, and elephants are on the endangered species list of Kenya, certain Asiatic countries, and the United States. That means that ivory from Kenya cannot be legally sold or exported and cannot be legally imported into this country. If you do bring it in, it will be confiscated. Thus, if you buy ivory in other African countries where it can be legally sold and from which you can import it into the United States, you must have a sales slip specifying where it was bought. Some countries insist you have an export/import certificate from the store, stating the object was made legally, that is, not from poached sources.

The same guide holds true for black coral, which is a sea animal. It, too, is on the endangered species list in certain areas.

The fact that both are illegal to sell does not mean you might not find either or be offered them. It does mean that you should be aware you are breaking the law, and you may be liable for fines.

Other than ivory and black coral, there are no restrictions on the kind of gems and jewelry you can import. The duty you may—or may not—have to pay depends on the kind of jewelry: whether the jewelry is antique or contemporary, whether the jewelry is precious or costume jewelry, whether gems are set or unset or strung or unstrung.

Antique Jewelry. Antique jewelry, regardless of cost, is duty free as long as it is 100 years old or older. Although Art Deco jewelry from the 1920s and 1930s is being considered "antique" and is prized by collectors and dealers, it does not meet the 100-year-old criterion and is dutiable. In buying antique jewelry, be sure to get what is called a provenance (certificate of origin) or statement guaranteeing the authenticity of the jewelry.

Precious Jewelry. As far as customs is concerned, the definition of precious jewelry is based on the chief value of the precious metal (gold or platinum), of the precious stones (diamonds, emeralds, sapphires, or rubies), or of the combination of both. There is a 12 percent duty on precious jewelry.

Costume Jewelry. Costume or nonprecious jewelry is all jewelry that does not fall in the category of precious jewelry, regardless of cost. It is dutiable at 27½ percent of the price you paid for the jewelry.

Unset and Unstrung Gems. These are not considered jewelry

as long as the elements of jewelry are not there. For example, a cut diamond is dutiable as a gem, but it becomes jewelry if there is a setting, even though the gem is not in the setting. Unstrung or temporarily strung pearls are dutiable as gems; the inclusion of a catch or clasp or spacer beads makes the pearls jewelry, as does the pearls being strung on individually knotted string. Duty varies, depending on the gem. Diamonds below ½ carat are dutiable at 4 percent and diamonds above ½ carat at 5 percent, with color and clarity also being considered. Cultured pearls are dutiable at 2½ percent, as are jade and quartz. Unset rubies and sapphires are dutiable at 4 percent, while emeralds are duty free.

Remember, all these rates are only guides, because regulations and laws can change. In addition, there are exceptions. Gems and jewelry from Communist countries are dutiable at higher rates than the above. Gems and jewelry from some countries may be brought in at even lower rates because the particular country has "most favored nation" status, meaning that trade is encouraged with those countries.

Keep in mind that customs officers at various ports of entry are usually familiar with the type of jewelry and gems they are most likely to see. Officials at ports of entry on the West Coast and Hawaii, for example, are likely to know as much about the value of jade and pearls as many experts. This is where the importance of getting and keeping sales slips comes in. If they feel you have valued a piece of jewelry or a gem too high or too low, they may charge a duty based on what they feel is the actual value. Few travelers would contest or want to challenge a low valuation. A high valuation is another matter. The law, however, gives you the right to challenge any duty you have to pay.

Should you feel you have been charged too much duty, pay the duty, get a receipt, and file a challenge. The Customs Department has gemologists on its staff who will examine the jewelry or gem and give their appraisal of the value. If you are still not satisfied, you have the right to ask for a third party, an independent expert, to appraise the jewelry. In any case, if you have overpaid, the money will be refunded.

You also want to remember that what is important to customs officers is not only the value of the jewelry but also the country of origin. Regardless of where you buy Chinese jade or Russian niello, once it is recognized as being from mainland China or the Soviet

Union, you are assessed duty at a higher rate than for jewelry originating in other countries.

One final point: customs officers at the New York Customs House who deal daily with jewelry and gems being brought into the United States by both tourists and dealers confirm that you get what you pay for—and sometimes far less—wherever you go. In today's market, there just are not any bargains at prices too good to be true. So, if you are going to buy expensive jewelry, buy at reliable jewelers and don't "bargain hunt."

7.
HOW TO BUY COSTUME JEWELRY

A special outfit or a special occasion sometimes cries out for special jewelry. More often than not in those cases, the jewelry you buy is costume jewelry because it offers you a flexibility in fashion and price that fine jewelry does not have. Another big difference between costume and fine jewelry is how you buy it.

Fine jewelry is a purchase that requires thought: you do not go out and spend a few hundred or a few thousand dollars on jewelry without thinking it over and trying to get the best value. Costume jewelry, on the other hand, tends to be bought impulsively: the few dollars it costs in comparison to the cost of fine jewelry does not represent a sacrifice. Yet, costume jewelry can be better or best— a good value—or mediocre or poor in quality—a bad value. It should not be bought so impulsively that you do not check or look for quality and value.

Costume jewelry, moreover, is indispensable nowadays, again unlike fine jewelry. You do not have to have fine jewelry, but you do have to have jewelry. As a result, it has become so indispensable that it is hard to believe we did not always have the flexibility in price, in fashion, in beauty, in the wide choice, and in the quality we have today.

Costume jewelry is not really a twentieth-century development.

Inexpensive beads of glass and other materials have long been available, but costume jewelry as fashion jewelry definitely belongs to the twentieth century, starting especially in the 1920s and 1930s. The flashy Art Deco look depended on plastics. Chanel, the foremost French fashion designer, popularized chains of both metal and stones in the 1930s. Rhinestones, particularly clips, were the rage at the same time, and gold-toned initials were a "must" for purses.

One of the problems of the costume jewelry of earlier times, notably of plain metals, was that gold and silver electroplating did not always stand up under wear. Electroplating had been developed in the nineteenth century, but not until technological advances in the 1930s and 1940s were real-looking, long-wearing plated metals possible. Then, just as costume jewelry was attaining a position as a genuine fashion accessory, World War II came along, bringing with it a shortage of the base metals used in the jewelry. In addition, the finest imitation stones, which came from Austria and Czechoslovakia, were impossible to get. After the war, however, the art of design blossomed along with the growing popularity of costume jewelry, as fashion succeeded fashion, with costume jewelry keeping pace in a way that fine jewelry could not and cannot.

If fashion was one reason for costume jewelry's popularity, price was—and still is—another reason. Although clothing has risen drastically in price, the price of even the best costume jewelry has remained relatively the same since the late 1940s and may even be cheaper. As a result, costume jewelry is the ideal way to keynote this year's fashions and to update last year's dress or suit at minimum cost. In addition, the quality of the best costume jewelry means that it will outlast a pair of shoes, a dress, a coat, or any other clothing.

Some costume jewelry, moreover, is so good that it is difficult to tell from fine jewelry, at least in the United States. American costume jewelry is the best in the world, according to experts and everyone who has ever looked at it elsewhere. For one thing, Europeans and others put a much higher emphasis on the gold in the jewelry than on the jewelry itself. Americans tend to think of jewelry as an accessory, as a part of their wardrobes. Although they might want and like karat-gold jewelry—and own it—fashion is equally or more important than the gold for the sake of gold. Costume jewelry permits women *and* men to enjoy many looks and not be locked into the one look of karat-gold and precious-gem jewelry.

The result is that costume jewelry in other countries has not

benefitted from the talent of top designers and quality manufacturing. It is generally poorly made, with little of the attention to detail or quality of metal and workmanship found in the better and best American costume jewelry. What you find in other countries instead of good costume jewelry is "gold jewelry" or "gems" being sold as their more expensive counterparts. This counterfeit jewelry, however, is not the same as our costume jewelry, which could better be called "fashion jewelry."

Yet, what is costume jewelry? To insurance companies, costume jewelry is any jewelry made of metal of lesser quality than precious or semiprecious metal and stones. This definition would include metals electroplated in gold and silver, jewelry with fake or paste stones, and even a sterling silver charm bracelet as costume jewelry. To U.S. Customs, costume jewelry is any jewelry that is not made of karat gold or platinum, with or without diamonds, emeralds, sapphires, or rubies. A better definition is probably that costume jewelry is any jewelry that has no intrinsic or resale value: it may be gold or silver electroplate or wash; it may have glass or fake gems; or it may be made of a variety of materials, including plastic, wood, shells, beads, or even feathers. In short, it may be so exquisite that you cannot tell it from fine or precious jewelry or it may be frankly fake.

Regardless of what it is, however, there is probably no one— man or woman—who does not own at least one piece of costume jewelry. It plays a big role in our lives and in fashion, even among people who have the money to buy only fine jewelry. A good reason for buying costume jewelry, and why everyone does, is that fashions and trends come and go. The cost in karat gold could make you think twice, especially about a piece of jewelry that might cost several hundred dollars or much more and that might be dated in a year or two. In addition, jewelry can be so highly styled that, even if it does not go out of fashion, you tire of it or its wear is limited. Most people simply cannot afford to buy fine jewelry and take those chances. On the other hand, the same styles in costume jewelry could cost you under $20 or less, giving you much more than your money's worth in terms of fashion, with the additional advantage of being able to update last year's clothing.

Another reason for buying costume jewelry is that there are times when you do not want to wear fine jewelry. Traveling is one of those times. You may not want to carry more fine jewelry than what you can wear, although you want a change or changes of

jewelry for special outfits. In addition, more and more people are preferring to keep fine jewelry that is not worn regularly in safe-deposit boxes because of the increasing risks of robbery and burglary. Jewelry in a bank is safe, but not readily available, and people still want a selection of jewelry. Good costume jewelry is the solution.

QUALITIES OF COSTUME JEWELRY

Although costume jewelry can be made of a variety of metals, or materials, the kinds you should know about are the gold and silver look-alikes, with and without stones. This is the category in which quality can vary the most, from inexpensive items in the local variety or drug store to the more expensive items in better shops and department stores.

Is there a difference between the jewelry for one or two dollars and the jewelry that costs more, or is one just as good as the other, except for the trade name of the manufacturer or the name of the store? The answer is that there is a difference, a big one. You are not paying for a name—and the reason lies in the manufacturing. To understand why, you have to know a little about the way costume jewelry is made, a process that, in the case of the best costume jewelry, is not very different from the way fine jewelry is made.

MAKING COSTUME JEWELRY

First, the design is created by a designer. According to Ralph Destino of Cartier's, many of the finest jewelry designers today either work or started to work in costume jewelry, where they have much more freedom to use their imagination and to experiment than they have in fine jewelry.

The design is then translated by hand into a model or prototype that combines all the component parts, such as links, clasps, pin stems, earring backs, or whatever else is needed. Two or three models, in fact, may be made to anticipate any production problems. Once the design is approved, a mold or cast is made from the model.

The mold used for costume jewelry is usually in two pieces and can be used time and time again, unlike the lost-wax method most common for fine jewelry in which the mold is broken to remove the item. In both cases, however, molten metal is forced into the mold

and allowed to harden. Once the piece of jewelry is removed from the mold, it goes through innumerable stages of polishing and grinding to remove any excess metal and rough edges. Although machines are used to grind and polish, each piece is perfected by hand. The jewelry is then assembled. Certain of the component parts may be soldered or riveted, while others may be affixed in other ways, with this stage being completely done by hand for costume jewelry as it is for fine jewelry.

The jewelry will be polished again before being put through a series of washes and baths and going into the electroplating bath. The length of time of the electroplating depends on the desired thickness of the gold or silver. The thickness can also depend on the number of times the item is electroplated. Monet, one of the oldest fashion jewelry houses, for example, triple plates their jewelry, first with an electroplate of 24-karat gold that is followed by 14-karat gold to get a distinctive, long-wearing finish. The resulting finish is also uniform, so uniform that jewelry from several years ago can be worn with this year's jewelry without any difference in color.

After electroplating, the final touches are put on the jewelry. If there are no stones involved, parts will be checked, any additional parts such as safety chains added, and the item cleaned and polished a last time. If stones are involved, they must be set at this time.

METAL FINISHES

Not all costume jewelry is made with such care, and that care is the difference between better costume jewelry and what you will find at next-to-nothing prices. The cheap jewelry may go straight from the mold to the electroplating without any polishing or grinding, leaving the marks of the mold and rough edges. In addition, the jewelry may not even be electroplated but simply "washed" or "flashed," processes that deposit the barest minimum of precious metal, so little that the jewelry is only faintly colored. Sometimes, the precious metal will be blown at high pressure onto the base metal. In the last case and in washing and flashing, all you really get is a "gold" or "silver" color that easily and quickly wears off or can be washed away with water.

In short, in costume jewelry as in fine jewelry, you get what you pay for, both in quality and wearability. A chain costing $1.00 may

wear less than a few months, while one costing $10.00 can last several years or longer.

Another difference lies in the base metals used in the alloys. The cheapest jewelry is made of the cheapest base metals, and there may be little or no quality control in making the alloy. As a result, the jewelry may be too soft to hold up or be brittle and break easily.

The top houses rely on their reputation and reliability to sell their costume jewelry in the same way as a jeweler who sells fine jewelry. Although the formulas are closely held secrets, their alloys have been developed with special attention to wear and tear, both from the standpoint of the type of jewelry and the jewelry's ability to retain the electroplate, as well as to giving the weight and feeling of real precious metal. In this respect, you may often find rhodium-plated jewelry instead of sterling silver-plated. Rhodium, an element of platinum, the most precious of all metals, looks like silver but has the advantage of not tarnishing, making it more suitable than silver for costume jewelry because it does not need polishing and will retain its finish for a longer time. What you want to be careful about is to get a silver-like look, especially if you intend to wear the jewelry with sterling, since rhodium can have a too bright, shiny look.

ALLERGIES

The fact that the metals in costume jewelry are alloys has caused some people to relate the jewelry to allergies. According to top manufacturers, the alloys have been laboratory tested and are no more likely to cause allergies than precious metals, especially when the alloys are thoroughly electroplated with gold, silver, or rhodium.

As Monet points out, "Karat gold and sterling silver are also alloys." Logically, since 14-karat gold, for example, is 14 parts pure gold and 10 parts base metal or metals mixed together in molten form, one could be just as easily allergic to the base metal in the 14-karat gold as to the base metal in the 14-karat gold electroplate used for costume jewelry. The black marks that sometimes are left on the skin have nothing to do with allergies. They are what is known as "jewelry smudge," caused by a reaction with cosmetics. For example, if you wear face powder or pancake makeup and have dangling earrings on, as the earrings touch your face they may leave a black mark due to the reaction of the metal with the talc in the makeup. Acids in your body and perspiration can sometimes react

with the metals in jewelry, too, causing it to tarnish and leave marks on the skin. Even air pollution may have the same effect. Some people may have a higher acid content or be more sensitive to the factors causing the tarnish and thus be more prone to have a black ring from a necklace or even a finger ring than others.

Another factor can be perspiration or even water that gets trapped under a wide, close-fitting ring or a wide bracelet or watch. The skin may simply chap from the moisture, but again the result is not an allergy.

QUALITY MARKINGS

More of a problem than allergies is the quality marking of costume jewelry. Unlike precious metals and gold- and silver-filled metals, electroplating does not have to be disclosed. And it seldom is. Gold-flashed or gold-washed jewelry is more apt to be marked, but that's little help when it comes to electroplating.

Although you have no way of telling how thick a layer of gold or silver is electroplated on a piece of jewelry, the Federal Trade Commission does define what can or cannot be called electroplate. To be considered "Gold Electroplate" (or silver), the jewelry must have an electroplate of at least 10-karat gold (or sterling) that is 7 millionths of an inch thick. "Heavy Gold Electroplate" (or silver) must be at least 100 millionths of an inch thick. The latter naturally wears longer because it is thicker. You do have some protection in that such items cannot be called "gold" or "silver" in such a way that you are led to believe they are a precious metal. Still, the fact that electroplating does not have to be disclosed means that your very best protection in getting value in finish as well as in quality of workmanship is in the trade name of the manufacturer, in his reputation and reliability. (See below.)

STONES

Another big difference in the quality of costume jewelry is the kind of stones used and how they are set. The least precious gemstones may be used, as well as laboratory-made synthetic and imitation stones. The most common synthetic is spinel, which can be created in a vast range of colors to look like a variety of precious gems. It has the advantage, too, of being a hard stone, which makes

it durable and less susceptible to chipping and cracking. Glass is the most common material used to imitate gems. As with spinel, it can be made in any color, although it does not have the depth or the brilliance of either genuine stones or synthetic spinel.

Rhinestones, one of the most popular of the imitation stones over the years, are basically glass made to resemble diamonds. The less expensive jewelry uses rhinestones made of glass pressed into the desired shapes. Better rhinestones are cut by hand from glass, with the quality also depending on the quality of the glass. The stones are generally backed by foil or metal for additional sparkle, instead of being set open, as diamonds are. According to Trifari, another of the oldest costume jewelry houses and one that specializes in stone jewelry, the best rhinestones come from Austria. These rhinestones are not foiled or backed. As a result, the sparkle is more subdued than the hard brilliance of the foiled and backed stones.

The way the stones are set is probably a bigger "giveaway" as to the quality of the jewelry than the type of stones, which may not be apparent or marked. The cheapest stone jewelry uses stones that are simply glued into indentations in the metal. As a result, the stones can be easily lost, especially if the jewelry gets wet. In the better jewelry, the stones are "hand-set" in one of two ways: in the first way, the stones are "nicked" into undersized settings that are firmer and longer lasting than glueing; in the second way, the stone is set in prongs in the same way that precious stones are set in fine jewelry. By looking carefully at the jewelry, therefore, you can tell whether the stone is glued or hand-set, and the better the setting, the longer the jewelry will wear.

IMITATION AND SIMULATED PEARLS

Cultured pearls are natural or genuine pearls. An irritant is introduced into certain species of oysters, which then surround the irritant with layers of nacre or "pearl." Simulated or imitation pearls have nothing to do with cultured pearls, nor do Majorca pearls, which are imitation pearls.

An imitation pearl is made of a glass or Lucite bead coated with a substance to give the bead the appearance of a pearl. As with metal finishes, the beauty and the luster of imitation pearls—and the price—depend on the thickness of the coating and the type of coat-

ing used. Some imitation pearls are so well made that they can be difficult to tell from genuine pearls, although the imitation will never have the depth of luster and color of the genuine pearls. In this respect, keep in mind that the more expensive the imitation pearls are, the thicker will be the coating and the longer they will wear because the thicker coating will be more resistant to perspiration and body acid. The better imitation pearls, incidentally, are strung individually on knotted string, which is less apt to break and cause you to lose the beads; the knotting also makes the string or rope suppler and more wearable.

Imitation pearls, like genuine pearls, may be either smooth or baroque. Baroque means the pearl is irregular in shape and has an uneven surface. Both come in a variety of natural pearl colors as well as pastel or dark colors that are fashion colors rather than natural colors.

WHAT TO LOOK FOR

The way costume jewelry is made, from start to finish, therefore, determines its quality. The finish and the thickness of the electroplate are important to metal jewelry. The type of stone and setting are important to stone jewelry. In both, the amount of polishing and grinding is important to give you a finish and surface comparable to those in fine jewelry. There are other characteristics of costume jewelry you want to be aware of, too, to make sure you get your money's worth. But first you want to check the finish and the polishing:

Is the finish gold-like in color or brassy? The best costume jewelry can often be difficult to tell in color from genuine gold of the same karat weight. As Monet, which makes both costume jewelry and a line of bridge or boutique jewelry (Chapter 4), points out, the more gold-like the color is, the more you can combine precious and costume jewelry. You may want to wear a karat-gold chain with costume jewelry earrings or bracelets, or vice versa, as many women do. For this reason, you want as gold-like a color as possible—and it is obtainable in better costume jewelry that uses a good gold electroplate.

Is the finish silver-like in color or "tinny"? Much good costume jewelry uses rhodium electroplate instead of silver, since rhodium does not tarnish, but the danger with rhodium is a "too shiny" look.

The plating should have a finish that resembles sterling as closely as possible.

Is the finish, either gold or silver, even? Make sure the color is evenly distributed and consistent throughout the jewelry and not patchy or streaked.

If you have trouble answering any of these questions, test the finish by rubbing the jewelry hard with your thumb. The best costume jewelry is triple coated and the finish will not rub off, but a thin wash or flash will. Granted, if the metal is brass, that will not wear off, but the color should tell you that the jewelry has not been well electroplated.

Your thumb will also disclose any costume jewelry that is not well polished and ground. Feel around the edges for any casting marks or rough edges that indicate inferior quality. You may want to rub the jewelry against your clothing as well to find any rough spots that would catch on material but might feel relatively smooth to the touch.

Once you are satisfied as to the jewelry's finish and polish, examine how it is made. Keep in mind that, although costume jewelry is an impulse purchase, you do not want to be so impulsive that you get less than your money's worth. Good costume jewelry is an important addition to your wardrobe, and it can wear longer than any other item in that wardrobe, lasting many seasons and providing the right fashion touch to many an outfit. For these reasons, again ask yourself some questions before buying:

Are the catches or links appropriate to the weight of the major component of the jewelry? A heavy, large piece of jewelry requires a heavier catch and type of link than a light, dainty item. The catch and links should be scaled to the weight and size of the jewelry.

How secure are the catches? The best costume jewelry has the same types of catches you are likely to find on fine or precious jewelry. It may be a fold-over riveted double catch, a tong-like catch, or a snap-catch with a safety bar that fastens over it—all signs of the quality of the jewelry. Bracelets may have a safety catch or safety chain to prevent your losing the bracelet should the catch open or break. Again, the catch should be smooth and the finish should be consistent with the rest of the jewelry. Try the catches several times. With necklaces and bracelets, be sure to try them on—not only to make sure you can put them on by yourself but also to make sure

the length is right. The length can be particularly important for close-fitting or choker necklaces. In both cases, particularly the latter, an adjustable closing that lets you fasten it more tightly or loosely may be preferable to a regular catch.

In buying earrings, are the backs comfortable and consistent with the weight and design of the earrings? Try both earrings on, to make sure *both* backs work and are comfortable. Monet suggests that the right way to try on an unpierced earring is to pull the lobe down, position the earring where it looks best and is comfortable, and then adjust the back. In a clip earring, you may find adjustable clips that can be squeezed to fit the size of your ear as well as one-position clips. Should the clip be too loose or too tight, in either case, a minor adjustment by a trained clerk is all that is necessary to make it fit. After all, not all earlobes are the same, and a clip that may be too tight on one person could be too loose on another. Shake your head several times to make sure the earrings do not slip. If your ears are pierced, you may want to look for 14-karat gold posts—which are found on the best costume jewelry. The earring itself is electro-plated, but the post is solid 14-karat gold. These earrings generally have posts that are comfortable and have safety features like more expensive jewelry.

In buying chains, what are the color and finish like? The best chains, regardless of size, are as much a work of art as what you'll find in fine jewelry. Some may even be impossible to tell apart because of the work that has gone into the hand polishing and cutting of the metal. Monet, for example, uses a diamond cut process that gives the chains a sharpness of design, no matter how fine or intricate the links are.

In buying pins or brooches, are the catches secure and appro-priate to the weight of the pin? The catch should be sharp enough to go through material easily. Check the safety catch to see it oper-ates easily and closes firmly. Make sure, too, that the pin is not top or bottom heavy and is the right size and weight for the type of clothing on which you will wear it. The larger and heavier a pin is, the more likely it is that it will be too heavy for light material.

In short, look for—and expect—the same craftsmanship in cos-tume jewelry as you would in fine or precious jewelry. Just because it is costume jewelry does not mean it has to be "junk jewelry."

WHERE AND HOW TO BUY COSTUME JEWELRY

You will find costume jewelry in a wide range of stores, from five-and-ten-cent or variety stores and drugstores to the finest department stores. The quality often depends on where you buy it. The less you spend, nevertheless, the less you can expect from the jewelry, while the more you spend, the more you should be able to expect.

As with anything else, you can't expect to get a $10.00 piece of jewelry for $1.00, for example. You get what you pay for, and the purpose of this book is to help you understand how to get the best value for your jewelry dollar. If you decide to buy cheap or junk jewelry—as all of us have done at one time or another—be aware you may be getting such little value you may have to throw it out after a few wearings.

The better costume jewelry is another matter. Expect to find it in the better department stores and shops. Those are the stores, moreover, that will stand behind the jewelry they sell in the same way a fine jeweler stands behind jewelry.

You have a twofold guarantee behind the better costume jewelry, in fact, from the store that sells it and the manufacturer that makes it. Should a catch break or an earring back loosen or a link snap, for example, the store will repair it. If not, you can return the item to the manufacturer for repair, as long as the repair relates to normal wear. If you drop an earring and step on it, bending it completely out of shape or breaking it, that is not normal wear and tear.

Knowing the manufacturer, then, is a good way to buy costume jewelry. Unlike fine jewelry, which is rarely trademarked in the United States, the more expensive costume jewelry is made by a number of houses that are so proud of what they make that they put their names on it as a mark of quality. The trade name means that you will find it selling at the same price, within a few cents, wherever you buy it. It also means that once you find a brand you particularly like, you can look for it. You may like a certain catch, for example, because it is easy for you to fasten, or you might like a certain finish. The quality control exercised by the top houses means that you can add to a collection any time you want, even several years later when you might want new earrings to go with an old necklace, just as with gold jewelry. Although the style may be different, the color will be the same. In these cases, buying costume jewelry has an advantage

over buying fine jewelry, since the store where you bought the jewelry is not important. You can buy the jewelry country-wide, simply by knowing the manufacturer and looking for that trademark.

The best costume jewelry is marked in two ways. It may have the entire name stamped on larger pieces, or it may have a tiny tag with either the name or a trademarked initial stamped on that. Both are signs of quality.

Still and all, buying the best costume jewelry won't assure you of long wear unless you give it the proper care. Regardless of what it costs, costume jewelry cannot be treated like "junk jewelry" or it will end up junk.

CARE OF COSTUME JEWELRY

Start off the right way in taking care of costume jewelry by storing it properly the minute you bring it home. If it came in a box, you can always leave it in the box. If you put it in a jewelry box, you want to use the kind of jewelry box with separate compartments for each piece of jewelry. If the box is simply a box, put each piece of jewelry in a plastic bag. The plastic protects the jewelry from being scratched, and you can easily tell what is inside the bag.

Whatever you do, do not drop it in a box where it's jumbled with other jewelry. Any metal will scratch other metal, and some metals are softer than others, making them more susceptible to being scratched. Granted, certain metals and finishes get a desirable patina with wear, but that patina is not the same as scratched or gouged metal. In addition, jewelry with stones is apt to scratch plain metal jewelry. If stone jewelry is knocked together, moreover, the stones may chip, break, loosen, or even fall out.

If you use a jewelry box, then, do not jumble the jewelry. Keep it separate in bags or compartments. Most earring boxes are a good idea, however, since they usually have racks on which earrings can be clipped or screwed in pairs. Another type of jewelry that is easy to store is chains, which should be hung in order to keep the chains straight. If you do not have a rack similar to the ones used in jewelry departments, a nail on the back of a door or in a closet is a good substitute.

First of all, then, you want to protect the finish of costume jewelry. That protection does *not* mean coating it with lacquer or clear nail polish. The better costume jewelry is thickly enough elec-

troplated that the plate may take years to wear off, for one thing. For another, it is generally coated by the manufacturer to resist tarnish. Your applying any type of a coating or lacquer only presents you with the problem of what to do when the lacquer chips or starts to wear off. Removing it would ruin the plating and the finish of the jewelry. If you buy the better trademarked costume jewelry and find the plating does wear off in an unreasonably short length of time, you return the jewelry to the store where you bought it or to the manufacturer, if the store will not give you any satisfaction.

You can extend the life of the jewelry by using a minimum of care in wearing the jewelry, too. Use hair spray *before* you put on necklaces, earrings, or even pins, and try to avoid the jewelry's coming into contact with perfume, cologne, and cosmetics, as well. The ingredients in beauty products can sometimes cause jewelry—and that includes precious jewelry—to tarnish and leave black marks on your skin.

As far as costume jewelry rings go, you are better off to remove them before washing your hands and never to leave them on while you are doing dishes or working around the house. Much exposure to soap and water and household cleaners can cause even the best electroplating to wear off. Removing rings, furthermore, is a "must" where costume jewelry rings with stones are concerned. If the stones are only glued in, not much water is required to loosen them. Even hand-set stones, moreover, can be damaged or lost much more easily where costume jewelry is concerned than is the case with most precious jewelry. If a ring should get wet, take it off and dry it immediately with a soft cloth.

Avoiding water means avoiding salt water, above all. Never swim with any costume jewelry on. That precaution, incidentally, is also a good one to keep in mind with gold, which sometimes can be pitted by constant exposure to salt water or salt air.

You also want to clean costume jewelry as you would precious jewelry. All jewelry should be wiped periodically with a soft cloth. Any kind of soft cloth will do, but *never* use a treated cloth of any kind. Plain electroplated jewelry—without stones—should be washed with a mild soap and water solution, rinsed, and dried with a soft cloth to remove perspiration, oils, and any cosmetics that may be on them. The cleaning will prevent any buildup of the chemicals that can increase the possibility of tarnish or leave black marks on your skin. Chains, in particular, need cleaning because of the way

they slip around your neck. In this respect, you want to remember that only the better costume jewelry will take soap and water: the less you pay, the thinner the plating is, if it is plated at all and not just flashed or washed.

No matter how careful you are, though, even the best costume jewelry will not wear as long as karat-gold or sterling silver jewelry, although it can wear as long as gold- or silver-filled jewelry. With good care, however, you will get good wear and be able to enjoy the jewelry for many years. Some women, in fact, have had their favorite pieces of costume jewelry for twenty years and want to have them replated, which can be done.

What you are buying, in general, nevertheless, is fashion and a look, a flexibility you do not have with precious jewelry, especially for the amount of money involved. Remember, costume jewelry may be frankly fake, a look in itself, or it may have the subdued elegance of karat gold or sterling silver. Yet it is still an accessory and one that can be easily replaced as often as you want, which gives it a couple of added advantages: you never have to insure it against the possibility of loss, and you can throw it away if you get tired of it. Better yet, when you get tired of costume jewelry, put it away. Replace it, if you wish, but costume jewelry is an investment in fashion and a look that is well worth saving for the future.

8.
JEWELRY FOR MEN

When a man bought jewelry a few years ago, the jewelry was usually for a woman—unless it was a school, class, or fraternal ring; a wedding band; a watch; or a religious medal on a chain. Today, jewelry of all kinds is no longer the sole prerogative of women any more than fur coats are. Both are being bought by and for men as much as they are by and for women in the United States.

Ice hockey star Phil Esposito, for example, wears a fox jacket to match his wife's—and he also wears a heavy gold filigree cross, both on and off the ice, after having worn an Italian horn and a Star of David for good luck. Thomas Henderson, a linebacker in the equally rough-and-tumble sport of football, wore three gold chains to a pre-Super Bowl news conference. Bjorn Borg, a star in the more gentlemanly game of tennis, has been hit in the mouth more than once by his own necklace. Baseball batting champion Rod Carew wears a gold chain and a c'hai, the Hebrew symbol for life. Basketball star Earl "The Pearl" Monroe wears a gold chain with his nickname and—what else?—a black pearl, even though it is a target for opponents to grab in a game, and teammates, in practice.

Some athletes do not stop at gold. Baseball's George "Boomer" Scott wears a variety of necklaces, including several of large wood

beads and shells that he made for himself. Tennis's Eddie Dibbs wears a diamond-studded medallion.

Men are wearing bracelets, too, and more rings than ever before in recent history. And why shouldn't modern man wear jewelry? Historically, men have been the peacocks, not only wearing an array of precious gems and metals but also wearing furs, silks, and satins.

THE HISTORICAL TRADITION

Diamonds are called the King of Gems. They were the property of men and worn by them. The first woman known to wear diamonds was Agnes Sorel, mistress of Charles VII of France, in the fifteenth century, which could be called "modern" times as far as knowledge of jewelry goes.

Rubies and other red stones were potent charms against injury in battle, and wars were waged by men. The ancient Chaldeans dedicated the ruby to the god of war. The Black Prince's Ruby in the British crown, now known to be a spinel, was a gift to Prince Edward, son of Edward III, from Pedro the Cruel of Spain in 1367 and was worn by King Henry V at the Battle of Agincourt in 1415 to protect him.

Pins, clasps, and brooches were associated with men long before men wore tie tacks and tie clips. The pharaohs of ancient Egypt gave gold pins to soldiers who performed heroic feats of bravery, decorating them with the forerunner of today's medals. And where would the Greeks and Romans have been, with their draped clothing, without a means to fasten the cloth?

As late as the seventeenth century in Scotland, brooches were predominantly practical. Scottish dress was a large shirt dyed saffron, over which was worn a length of woolen cloth that was draped around the lower body and fastened at the shoulder with a pin or brooch. The lower drape evolved into the kilt, while the upper length became the plaid or shawl, with the brooch retained to fasten the plaid, leaving the arms free. The brooch was important in two ways: it incorporated the wearer's crest or the crest of the clan, making it an identification tag, and it was made of silver. The brooch was always worn into battle—not as a charm to protect the warrior but as insurance of a proper burial, with the person finding the body obligated to bury it in exchange for the silver ornament.

Although the Greeks dedicated the emerald to Venus, goddess of love, the Mogul kings of India treasured a 78-carat emerald as a charm to insure the special protection of god. Emeralds were also one of the four stones, according to legend, that were given to King Solomon by God to denote Solomon's power over creation. The others were a carbuncle or garnet, a lapis lazuli, and a topaz. And then, there is alexandrite, a form of chrysoberyl first discovered in 1831 in Russia and named after the heir apparent to the throne who became Czar Alexander II. So, the association between men and gems or jewelry is an ancient one that modern man is only emulating.

Exactly when jewelry went out of fashion for men in the United States is not easy to trace, although it was probably during the Victorian Age. Certainly, Diamond Jim Brady was noted for wearing diamonds as well as giving them lavishly to the women who caught his eye and fancy. Then, too, jewelry, particularly gold and gems, has always remained popular with men in Europe, where men have always worn diamond or other gemstone rings as well as chains with religious medallions.

Even so, for years, an American man's jewelry consisted mainly of cuff links, a tie clip or tack, dress studs, a watch, and perhaps a wedding band or a class, school, fraternal, or family crest ring. A religious medallion was permissible, but not a necklace. So was an identification bracelet or watch, but not a regular bracelet. Now, jewelry has lost its "sexuality." Women are wearing men's watches, and men are wearing chains and bracelets that could also be worn by women.

KINDS OF JEWELRY

What should matter to a man, as to a woman, is: "How do I look in the jewelry? How does it feel? Does it appeal to me emotionally? Can I afford it?" In short, men should apply the same criteria in buying jewelry, both costume and fine or precious jewelry, as women do, but from their own individual, masculine point of view.

Men may not have as wide a selection of jewelry as women do, but they do have a wider selection than they might imagine, especially nowadays. Until the early 1970s, men were more or less confined to the traditional masculine jewelry and accessories. Even though men who had served in the Armed Forces had worn identifi-

cation or "dog" tags, necklaces—aside from chains with religious medals—were considered effeminate. Again, an identification bracelet might be permissible, but not wearing a bracelet for the sake of the bracelet alone. Yet, it is a short jump, actually a step, to wearing a chain necklace for the chain alone and not the medal or dog tag and a chain bracelet without a name tag.

Jewelry, after all, is jewelry. Even the most practical jewelry. It is beautiful and handsome enough in itself, without needing a utilitarian excuse for wearing it. Thus, men now have a selection of chains and bracelets to choose from.

Rings, too, no longer need an excuse to be worn. The fraternal ring with the onyx and the diamond has moved over to make room for gold and platinum rings with diamonds, rubies, sapphires, or emeralds. Cartier's has also noticed a trend of men bringing in investment-quality diamond solitaires of 1 carat and larger for setting into rings for the men themselves to wear, rather than leaving the gems in safe-deposit boxes in bank vaults, unseen and unnoticed.

Watches have undergone a change, too. Watches are set with diamonds and other precious gems. The pocket watch adorned with a watch chain or waldemar is again a favorite, as it always has been with three-piece suits.

What is striking about these changes is that all of these kinds of jewelry are being made, sold, and bought in precious metals and gems. Unlike women's jewelry, where costume jewelry often leads the way, with men's jewelry it is precious jewelry that is the pacesetter. It is being bought, moreover, not only for the sake of personal adornment but also for its intrinsic value, the kind of intrinsic value that only jewelry—of all expensive purchases—can offer. Jewelry, in short, unlike a car or clothing, never wears out, a fact men appreciate. If a man gets tired of it, he can sell it, trade it in, or have it remodeled. If he gains or loses weight, he can still wear it, because it hasn't lost its usefulness and it doesn't need to be altered.

All of these facts have entered into making jewelry acceptable to men. Whatever the reason, however, men are buying more jewelry than ever for themselves and for other men—and women are buying more jewelry than ever for men, whether it is for the man who has everything else, the man who wants to be in style, the man who appreciates fine things, or for the man whom a woman loves and wants to give a lasting, personal gift.

At the same time, experts on men's clothing and how men should dress are divided about the role of jewelry. One expert advises no jewelry at all, even cuff links, since they are a sign of insecurity. A watch is permissible, as long as it has a leather band and a white face. This ultra-conservative view is opposed by another expert who advises cuff links as a finishing touch and says any jewelry is fine as long as it is not overdone with too many chains or bracelets. Obviously, the ultimate decision as to whether to wear jewelry or not is the man's, and only he can say whether it is right for him. If he likes it, if he is comfortable in it, if it is in good taste with the rest of his clothing, he has no reason not to wear whatever he wants. In fact, he then has every reason to wear jewelry.

And what about the man who prefers not to wear jewelry, except perhaps for a watch? He, too, can still enjoy the pleasure and luxury of owning precious jewelry—in the form of accessories. In this area, in fact, men have a far larger selection than women.

Any man, no matter how conservative, would enjoy karat-gold collar stays or blazer buttons. The buttons, for example, might cost the same as a good blazer, but they last forever, outlasting many a blazer, perhaps even increasing in value. A karat-gold or sterling silver belt buckle is elegant and hardly ostentatious. A long-standing favorite among men, according to Cartier's, is the belt buckle personalized with a man's initials or engraved with his signature.

Men, moreover, like anything personalized with their name or initials, from rings to blazer buttons, belt buckles, money clips, and leather items. In this respect, they are strikingly different from women. Women would prefer to have people know where they shop or what they buy than what their names and initials are. Gucci's *G* and Yves St. Laurent's *YSL* signatures are big with them. Men, on the other hand, want people to know who *they* are.

Accessories for men also include items to be carried and used. In this category are karat-gold or sterling silver money clips. But that is not all. There are also key rings and penknives—and moustache combs, toothpicks, and swizzle sticks. So, any man who thinks he has no need or use for fine jewelry—and any woman or man who wants to give a gift of fine jewelry to a man can think twice before discarding the idea of such a gift. There is far more in the way of fine jewelry and accessories for men than you think. All you have to do is look around.

Interestingly enough, there may be more for men in fine or

precious jewelry than in costume jewelry. The reason why is a practical one. Fine jewelry is made of karat gold or sterling silver, both with and without gems. An item that does not sell is never a total loss, as the metal can always be melted down and reused and the stones reset. The only loss is in the expense of the workmanship. Costume jewelry, which has no intrinsic value, is another matter. An item that doesn't sell is a total loss to the store, which means a store is less willing to take a chance on an item unless there is a proven demand and a manufacturer will not make an item unless a store—usually several stores—will buy it. Unlike women's jewelry, therefore, in which costume jewelers are the pacesetters, in men's jewelry it is more the fine jewelers who set the pace.

HOW TO BUY MEN'S JEWELRY

In buying men's jewelry, you want to look for the same quality marks and features as you would in women's jewelry. That precept includes both fine and costume jewelry.

Start out by looking around at different stores and shops to find the one with the biggest selection of the type of jewelry or accessories you want. Consider, too, the store's reputation: does it stand behind its merchandise? If it is a jewelry store, has the store been in business for at least a year and do the salesclerks and advertising strike the right note of ethical practices? If you are interested in gems, will the jeweler get you a Gemological Institute of America certificate of the quality of diamonds and of the authenticity of other stones if you want one? Once you are satisfied with the store, you are ready to take a closer look at the jewelry, beginning with the metals.

THE METALS

Although men's jewelry may be either precious or costume jewelry, most of the accessories mentioned above are available only in precious metals. Men's rings, too, usually are found only in the area of precious jewelry. For these reasons, first of all, you want to satisfy yourself with the fineness of the metal.

Gold, Silver, and Platinum

Gold, platinum, and silver in the United States and many other countries are required to be marked for precious metal content or quality, as explained in Chapter 2. Gold- and silver-filled jewelry must also be marked as to the weight of the precious metal layer in proportion to the base metal and the karat gold and silver fineness.

The majority of men's fine jewelry is karat gold, mainly because gold, and particularly yellow gold, has always been the most popular metal among men. At the same time, combinations of gold, such as yellow with white and pink gold, are becoming fashionable and taking the place of traditional gold wedding bands. As far as silver goes, it has always been popular for identification bracelets, and it is increasing in popularity, sometimes combined with gold, as the price of gold has risen.

The choice of metal, therefore, is strictly up to an individual— what does he like, and what looks best with any other jewelry he may wear, such as a watch? A man who wears a silver or silver-colored watch, for example, may find a silver bracelet is the best choice, while for a man with a gold watch the best choice might be a gold bracelet.

Costume Jewelry Metals

Costume jewelry may be either electroplated or washed or flashed. Washed or flashed means that the barest minimum of precious metal is deposited on a base metal. Sometimes, so little is deposited that rubbing the jewelry with your thumb will rub it off, indicating just how much wear you'll get from the jewelry. Washed or flashed jewelry is usually marked and should be to avoid being misleading. It is also very much lower in price than good electroplated jewelry.

Electroplate may be regular electroplate, meaning 7 millionths of an inch of gold or silver is deposited on the jewelry, or heavy gold electroplate, in which case 100 millionths of an inch is deposited on the base metal. The latter will wear longer. Federal Trade Commission regulations do not require electroplate to be marked as to thickness or karatage, and it rarely is. Since you may see an item marked "Heavy Gold Electroplate" or "Heavy Silver Electroplate," however, you should know what it is. Sometimes, too, you may see an

item marked "Rhodium Plated." Rhodium is an element of platinum that is a silvery color. It has the advantage of not tarnishing and, thus, is often used instead of silver, which will tarnish.

THE GEMS

The most popular gems for men's jewelry have traditionally been onyx, lapis lazuli, tigereyes, and carnelian. That does not mean that men cannot wear other gems, from the lesser priced turquoise to the most expensive diamonds, rubies, emeralds, and sapphires. The only gems that might be unsuitable are the fragile gems, since men are generally less careful with rings than women are—not that rings are the only men's jewelry in which gems are set. Cuff links, tie bars and tacks, shirt studs, and pendants may also contain gems.

The gems used in men's jewelry, particularly in the accessories, are relatively small. Cuff links and shirt studs, for example, depend more on the setting than the gem for their beauty. What this means—and what you should keep in mind—is that neither the gems nor the jewelry are an investment, except in beauty, any more than jewelry for women is an investment. The same qualification holds true for gems in rings. The exception is investment-quality diamonds, which are more likely to be bought by men than women, according to dealers.

WHAT TO LOOK FOR

What you look for, once you are satisfied with the quality markings of fine jewelry, depends on the particular piece of jewelry. In most instances, moreover, those features are the same in both fine and costume jewelry, except that the more you pay, the more you want to be satisfied that the jewelry meets certain standards for wear.

CUFF LINKS AND STUDS

Look carefully at how the cuff links and studs are made and especially how securely they fasten. The fastening, especially for cuff links, which are usually fastened after the shirt is on, should be simple enough for you to fasten yourself. In this respect, you want to be sure the cuff links and studs fit the holes for which they are made, that

they are not too large to go through or so small they can't do their job.

The fit may sound like a minor point to check, and you may think that cuff links are cuff links. Fit is important, however. Jean Shaffer, gold buyer at Cartier's, says it is a point she always checks because in fact many cuff links do not fit. So, follow her tip and check the fit of both cuff links and studs in the type of shirt in which they will be worn.

NECKLACES

If you are a man and think you might like to wear a necklace or chain, or a woman buying one for a man, you may want to start off with a costume jewelry chain. Keep in mind that chains are basically chains and they come in different lengths, since you may not find chains in the men's costume jewelry department. But you will find plenty of them in the women's costume jewelry department. For that reason, look at the men's chains in a fine jewelry store first and then look at chains in general. Men's chains are usually simpler in design, so concentrate on the link chains rather than those that have decorative loops between the links, are a twisted loop design, or are too fine.

You want to consider the length, too. The most popular length for men is 18 inches, which is just long enough to be seen under an open collar or sport shirt but too short to be worn under a collar. If a man wants a chain for under his collar or even to wear with a turtleneck, 24 inches or longer is a better length. Thus, consider how the chain will be worn, keeping in mind that men have far fewer clothing styles and necklines to choose from and that the chain should be appropriate to what he wears.

Chains with pendants are also popular. The pendant may be a religious medal, the kind men have worn for years, or it may be strictly decorative. The pendants are usually larger and heavier than those for women. They may be a nautical emblem, such as an anchor or twisted rope knot, or karat-gold "dog" tags with the same information stamped on them as was stamped on the original dog tags, or any other item a man may want. Chains can be bought separately and the pendant added later, once the man gets used to the chain. In either case, buying a pendant and chain or a chain for the possible addition of a pendant, you want to keep the weight of the pendant

in mind in buying the chain. A fine chain may be too fine or light to take a pendant, while a heavy link chain may not be appropriate for an additional ornament, which probably could not fit through the chain anyway.

Take a good look at the clasp before you buy. The clasp should be appropriate in size and weight to the size and weight of the chain. In buying precious jewelry, check for safety features on the clasp.

BRACELETS

Men's bracelets may be chain style or bangle or close-fitting. The choice and selection is generally as large as for necklaces. That does not mean you need to be any less careful in buying the bracelet.

First of all, check the clasps to make sure they are appropriate to the rest of the bracelet and have a secure fastening and safety features. Length or size is also important, because men generally have larger wrists and hands than women do. A man who cannot find a necklace in a man's jewelry department to suit him may find one in the woman's department. That option is less likely with bracelets. While a woman's bracelet is 6½ to 7 inches in length, the best length for a man is 8 to 8½ inches. So, be sure to try the bracelet on to make certain it is comfortable—and fits.

Another factor to consider with bracelets is the kind of metal. A man tends to wear a bracelet on the same wrist as his watch. If he wears a silver or silver-colored watch, a silver bracelet would look best. If he wears a gold or gold-colored watch, he is going to want a gold bracelet.

At the same time, although the look is attractive, a word of warning is necessary about wearing a watch and bracelet on the same wrist. Watchmakers warn that a bracelet knocking or hitting against a watch can damage the watch. So, if you wear an expensive watch, wear the bracelet on the other wrist or check with your watchmaker first for his opinion.

RINGS

Men's rings, regardless of whether they are plain metal or set with stones, are usually set flatter than women's rings. One reason is the look. Men prefer a larger, heavier ring. Another is more practical. A man puts his hands in his pockets far more than a woman does.

Men, in fact, always have pockets in which to put their hands, while women seldom do. For this reason, he wants a ring that will not catch on material, running the risk of losing a stone or tearing the material. The most popular setting, therefore, is a closed setting, while any open setting will be the low, belcher type.

Another factor to keep in mind is whether a man works with his hands. That does not mean whether he is a plumber or carpenter, but what he does in his spare time as well as his working time and if he will be wearing the ring all the time. Insurance statistics show that men tend to be less careful with rings and jewelry than women, meaning they are less apt to remove rings when working with their hands.

A plain gold ring, either a wedding band or a signet or coin ring, can take a lot of punishment and can usually be polished to remove any scratches. A ring with a stone or stones is another matter. A stone, including a diamond that is the hardest of all stones, can be scratched, chipped, or shattered with the right blow. So, consider how and how often a man will wear a ring. Some rings have a bezel setting—a narrow ring that fits around the edge of a stone or coin— which does give added protection to the stone or coin.

OTHER JEWELRY

Men are starting to wear earrings, too. Again, there is a historical precedent. Earrings in ancient Babylonia, long before the pharaohs of Egypt, denoted a man's rank. The Inca emperor wore large earplugs of the finest materials, with members of the lesser nobility permitted to wear only smaller, less fine earplugs. Earrings or earplugs are common among other cultures, too. What pirate or gypsy, for example, would be dressed without his earrings?

The earrings most popular among men are those for pierced ears. If you are considering them, be sure to examine them carefully, especially to make sure the posts are comfortable. In short, try them on. The best posts are 14-karat gold. If you wear the earrings all the time, be sure to take them off periodically and wash them in warm water with a mild soap and a drop of ammonia to keep them clean and avoid any chance of infection.

One further word about men and earrings: clip-back earrings can give any shirt a French-cuff look. Just snap them on to cover the buttons and you are all set.

The only other man's accessory that is worn is a belt buckle. In this case, you want to keep in mind the width of belt loops on trousers. First, the belt must go through the loops. Second, a large decorative silver and turquoise buckle may give just the right amount of sporty elan to casual wear or blue jeans, but is the size appropriate to the width of the belt with which it will be worn? Gold and silver buckles, on the other hand, are usually made and designed to fit standard size belts and belt loops. In any case, you want to be sure that the bar over or through which the leather must go is the right size for the width of the belt to be worn.

Accessories such as gold swizzle sticks, toothpicks, cigarette cases, and money clips are carried rather than worn. Swizzle sticks and toothpicks are light to carry, but you may want to take the weight of a money clip into consideration and in which pocket it will be carried. In cigarette cases, the length of the cigarettes a man smokes is important. Today, cigarettes come in a variety of lengths, some of which may be too long for a regular-sized case.

THE COMMON SENSE OF MEN'S JEWELRY

In short, there is little difference in buying men's jewelry from buying women's jewelry. You have to like it, be able to wear it or use it, and be able to afford it. You want to use the same care in selecting a jewelry store in buying karat gold, platinum, and sterling silver and gems, to make sure the store is reliable with a good reputation for standing behind what it sells. You want to find a store with good lighting, white or daylight and not blue or candlelight. You want to find a store, too, with as wide a selection as possible of the type of jewelry in which you are interested. And you want to be just as discriminating in looking for quality markings and features. You want to get what you are paying for and expect to pay for what you get, without wanting a "bargain." Above all, you do not want to be pressured into buying an expensive piece of jewelry that you do not like and will not wear.

Once you buy the jewelry, you want to give it good care, either cleaning it or having it cleaned regularly, the frequency depending on how often you wear it and how hard you are on it. And you want to be careful how you store it. Insurance is another factor. The more expensive the jewelry is, the more you may need or want insurance for it. Men's jewelry can be lost or stolen, too, of course.

Keep in mind that jewelry is made to be worn. The beauty of jewelry, aside from its intrinsic quality, is its versatility. The addition or changing of jewelry can change your look, just as it can change a woman's look. A bracelet, necklace, or a ring adds an instant touch of glamor to even the most casual clothes and confers status on the wearer.

9.
CARE, PROTECTION, AND REMODELING OF JEWELRY

If your jewelry has value to you, it is valuable enough for you to want to take care of it. Care means being careful you don't lose it as well as being careful how you store and clean it.

When you buy jewelry, any jewelry, from the most expensive fine jewelry to inexpensive costume jewelry, you buy it because it is beautiful. The gleam of the metal and the shine or luster and fire of the gems appeal to your aesthetic sense of beauty, based on what you can afford. The better the jewelry, the longer you want to wear it—perhaps even for the rest of your life—and the longer you want it to have that like-new glow, although some metals and finishes attain a warm patina with wear. What you don't want, however, is scratched or gouged settings and dull gems. Accidents can happen, but all too often the jewelry is damaged by carelessness or not taking the few moments necessary to tend to the jewelry.

In most cases, being careful is the only care jewelry needs. Some types of jewelry, nevertheless, need special care because the gems may be soft, absorbent, or fragile. For these reasons, some of the characteristics of gems from Chapter 4 are summed up in this chapter.

Keep in mind that the harder the gem and the higher it is on the Mohs scale of hardness, the more durable it generally is. At the same

time, a hard gem with high or distinct cleavage is apt to be fragile and may break or cleave if it is struck at the right angle. Hardness, therefore, is not synonymous with toughness. A tough gem may be soft enough to be more easily scratched but it is less apt to break or shatter. These characteristics have pertinence in wearing, cleaning, and storing jewelry—and in remodeling.

Metals have similar characteristics. The purer the silver and gold, the more easily it can be damaged. Also, you must consider the combination of metal in settings with a gem or gems. What may be perfectly good to clean a metal, such as sterling silver, may not be the best for the gems. You have to consider the jewelry as a whole, not as simply metal or gems.

These points are tied in with the third point: the care you take with your jewelry to protect it from loss, both when you are wearing it and when you put it away for safekeeping. All the care in cleaning and storing will not matter if you lose the jewelry. The care you should take in this sense involves the same precautions you would take to make sure you do not lose something you like and enjoy. That is common sense, and it is common sense whether or not the jewelry is insured—and whether or not it is valuable. The precautions you should take with any jewelry that you like and that means anything to you, in fact, are simple common sense.

PROTECTION OF JEWELRY

First of all, think about what you do when wearing jewelry. Rings are a good example of how common sense can prevent loss.

More rings are probably lost through carelessness than any other type of jewelry, because they are more apt to be taken off when being worn than pins or necklaces, bracelets or even earrings. So, Precaution Number One, if you wear rings, is to wear them at all times—or be as careful with them as you are with your money and credit cards.

Men and women, incidentally, tend to regard rings differently. An insurance company executive points out that men who wear rings tend to wear them all the time, even when doing manual labor. Women may wear more rings and wear them more often, but they tend to take the rings off when doing hard work with their hands. Men's rings, therefore, are more likely to be damaged, while women's rings are more likely to be lost.

Doing manual labor is not the basic reason why women lose rings. A woman who does a lot of typing may take a loose or heavy ring off when typing and leave it on her office desk. If she has to leave her desk for any reason, she may leave the ring there where anyone can see and take it. She may do it for years without anything happening until one day the wrong person goes by her desk, sees the jewelry, and takes advantage of her absence.

Another "good way" to lose rings is to take them off when washing your hands. Wide rings are often removed since water can be trapped between the ring and the finger. Rings with stones are often removed to avoid dulling them with a soap film. As a result, more than one person has walked off and left rings in a public washroom, inviting theft. Soap and water, however, will not hurt most rings or stones, although some stones—such as turquoise and opal—are soft enough to be damaged by dirt, soap powder, or even a rough towel. If you do take rings off for that or any other reason, you should avoid the temptation to put them on a washstand. Put the rings, instead, in a pocket or purse.

Even at home, be careful when washing your hands. Not all drains have strainers, and a ring can be easily knocked from a shelf or the back of the sink down the drain. It may end up in the trap where a plumber can reach it, although more than one ring has vanished without a trace. A shelf or cabinet over a toilet is even more unsafe, since a ring can accidentally fall into the bowl and be flushed down the drain before you realize the ring is not where you left it.

Rings with stones present another type of accidental or careless hazard—the loss of the stones alone. Prongs and settings can become worn or bent. As a result, a loosened stone may fall out in any number of ways, from making a bed to getting dressed, taking off gloves or a coat, or even in a restaurant where the prongs can catch on a napkin or tablecloth that gives just the final tug to loosen the setting enough for the stone to fall out. Having settings checked periodically by a jeweler takes only a few minutes and can prevent this kind of accidental loss. How often depends on how frequently you wear the jewelry. A ring worn every day should be checked once a year. A ring worn on only special occasions would need to be checked only when you are having it reappraised for insurance. Another good precaution that you can take yourself is to check the stone every time you wear the jewelry. Try to wiggle the stone—and

if it is the slightest bit loose take the jewelry to a jeweler's before you wear it again.

The same precautions hold true for settings of any kind of jewelry—necklaces, pins, and bracelets as well as rings. These items of jewelry also need checking for other reasons, too. Clasps can also be damaged or become worn and catch on clothing. Checking them means checking safety catches and clasps as well. They are put there for the purpose of safeguarding better and expensive jewelry, but they can serve that purpose only if they are in good working order—and are used. It is far better not to wear jewelry with a loose clasp or a broken safety catch until you can get it repaired than it is to take a chance on losing the jewelry. Wearing it "just one more time" could be the last time.

Being careful in wearing jewelry has another facet. You don't want to damage the jewelry any more than you want to lose it. Silver for the most part is softer than gold. As a result, silver is more apt to be scratched or gouged when you are working with your hands than gold. Although a jeweler may be able to restore the jewelry to its original finish, a little care can mean that the silver develops a lovely and soft patina without unsightly scarring that takes time and costs money to remove.

Another fact to keep in mind is that metals and gems, regardless of how soft or hard they are, can break. One jeweler recalls a customer's bringing in a gold ring that was in three pieces and irately demanding her money back. What had happened was that she had caught her finger in a door. The ring had protected her finger, which wasn't hurt at all, but the force and angle of the closing door had been enough to fracture the ring. If the ring had contained a gem, even one as hard as a diamond with its high cleavage properties, the diamond could also have been split had it been caught at the right place.

Most of these precautions sound pretty obvious. And they are as obvious as they are good common sense, but that doesn't mean that people follow them all the time, as insurance companies know all too well. A person may be in a hurry and not take the few extra seconds to fasten a safety catch or be "too busy" to have a setting checked. Yet, none of these precautions takes more than a few seconds, any more than it takes a few seconds to weave a pin a couple of times through the fabric as extra "insurance" to avoid losing it.

Carelessness in wearing jewelry isn't the only kind of careless-ness. Other types of carelessness, especially in the home, can have a bizarre twist. Insurance company files are filled with warnings of what not to do with jewelry.

There was the woman who didn't trust her maid and who hid her jewelry in a cereal box on the days the maid came to clean. One day, her husband came home early. He happened to see the cereal box on a counter in the kitchen and opened it. All he saw was cereal—and moldy cereal at that. He threw the box in the garbage. By the time that his wife went to get her jewelry after the maid had left, the garbage had been taken away, including the moldy cereal and the jewelry. The wife had never thought to tell her husband about her idiosyncrasy, and he hadn't thought to ask her what she was doing by keeping a moldy box of cereal.

In another case, a woman had cleaned her rings, putting them to dry on a tissue that she folded over. She left both the tissue and the rings on a shelf in the bathroom. Her husband went to the bathroom after she had gone to bed, saw what looked like a used tissue, and threw it away without looking inside. Again, the rings ended up in the garbage and garbage was gone before either thought to say anything to the other.

A third case turned out more fortunately. A family gave a garage sale at which clothing as well as furniture and other items were sold. A few days later, the wife noticed a diamond ring was missing and made a claim to the insurance company. The claim was never paid because she received a phone call. A man had bought a coat for his wife at the sale. Before giving it to her, he checked the pockets and found the ring—which he was honest enough to return.

Another precaution, therefore, is to be careful where you put or hide jewelry—and particularly if someone else is involved. One person's care can result in carelessness that leads to accidental loss.

Burglary and theft can't always be prevented, much less easily prevented. Even here, however, carelessness can contribute to the loss of jewelry. One important factor is how often you wear your good jewelry and where you keep it when you are not wearing it.

Keeping good, seldom-worn jewelry in the home, whether it is a house or apartment, is asking for trouble if there is a burglary. A jewelry box may be the first place a burglar will look. Hiding places are not much better. A place you think is a good idea may also be a good idea to the burglar. A home safe is a much better preventive

measure. The best measure, though, is to keep seldom-worn jewelry in a bank safe-deposit box. A safe-deposit box means a person has to plan ahead and take the time to get the jewelry out of the box and put it back, but that is better than having the jewelry stolen. Besides, if the jewelry isn't worn very often, the amount of time involved is minimal.

A safe-deposit box is a good idea, in addition, for a person who travels a lot. Any good jewelry that doesn't go along is secure and far safer than being left in an unoccupied home.

The jewelry one takes when traveling is another matter. Many women who travel a lot—and women are apt to take more jewelry with them than men—plan their jewelry to go with their wardrobe. They take only what they will wear all the time with all their clothing—or else take only inexpensive jewelry. In short, the best protection for valuable jewelry is to take only what you can wear.

At the same time, both men and women may need special jewelry for special occasions. A man may need studs and cuff links for a dress shirt, while a woman may need a necklace or earrings for evening wear that would be inappropriate for street wear. Such jewelry should never be put in a suitcase or carry-on bag. Suitcases have been known to be lost or opened. Jewelry can also be lost going through customs, regardless of the country. Although a carry-on or tote bag may be safer, it may not always be with the traveler at all times. A person may put the bag down to make a phone call or to buy a newspaper or magazine. The few seconds that the bag is out of the person's hands is all the time a thief needs to grab the bag and be gone before the victim realizes it is missing.

For these reasons, women should put extra jewelry in their purses, with which they are usually very careful. As far as men go, the best place is on their persons, since the extra jewelry is generally light and small enough to fit easily and comfortably in a pocket.

Traveling creates another hazard for jewelry that is not worn all the time: the danger of having it stolen from hotel or motel rooms, even if it is not left out in the open. Leaving it in full view may be an open invitation, but jewelry hidden in a drawer or suitcase is not safe either. The best place is a hotel safe, which is usually covered by insurance. Regardless of these precautions, the best precaution is to take only jewelry you will wear all the time and put the rest in a bank safe-deposit box.

Being robbed of jewelry when you are wearing it is less avoida-

ble. Still, a thief may be interested in only what he can see. Thus, an expensive necklace or gold chains or pearls may be safer worn inside a dress on the street or riding public transportation. One woman who was wearing several heavy gold chains was riding a New York subway. Just as the doors were closing at a stop, a man grabbed the chains, breaking them, and dashed out of the train. The robbery took only a few seconds, and the woman luckily suffered only a bruised neck.

All of these precautions pertain to any jewelry a person likes, regardless of value, although the more valuable or precious the jewelry is, the more they make good common sense. Still, all the precautions in the world won't prevent jewelry's being stolen or accidentally lost during a single moment of carelessness. For these reasons, insurance (see Chapter 10) can give you peace of mind. If anything does happen, that jewelry will be replaced or you will be paid for the loss.

The key word is loss. Insurance does not pay for jewelry damaged through your own carelessness. A damaged setting or a shattered gem does not come under the heading of theft or mysterious disappearance. So, regardless of whether you have insurance or not and how much insurance you have, you want to be careful—especially in wearing rings when working with your hands.

Chemicals, even ordinary household chemicals, can damage metals and some gems. Chlorine bleach, for example, will not hurt a diamond but it could discolor the setting. Ammonia is safe for precious metals and is even a preferred method of cleaning them, but it will erode copper. Harsh cleaning soaps and cleansers may also damage some metals and gems. That includes costume jewelry, too. Gold- or silver-filled or gold or silver electroplate can have only a thin layer of precious metal that, when removed, will expose the base metal.

You should also take rings off when cooking. Using a knife or can opener may seem safe, but rings can slip around on fingers so that the gems are on the palm side where pressure on the wrong place could break or shatter a fragile or soft stone. A good idea is a ring container that you hang on the wall near the work area, not over the sink. That way, you will be reminded to put your rings in it, safe from damage while you're working and from being accidentally swept into the sink and down the drain or into the garbage.

The wall near a workbench is another good place to put such

a container. Hammering, sawing, and using other tools can damage rings all too easily.

These precautions mean that, despite the warning to keep rings on to avoid losing them, there are times when you should take them off. There are times, as well, when you want to take them off for other reasons, such as to change to other rings or to clean them.

STORING AND CLEANING JEWELRY

When you take jewelry off—all jewelry and not only rings—what do you do with it? First, for the reasons stated above, you should have a good and a safe place for it. Second, that place should keep the jewelry safe not only from loss but also from damage.

The worst place you can put it is in a jewelry box already filled with other jewelry all jumbled together, where it can become scratched or more seriously hurt. The best place you can put it is in individual leather or cloth cases or bags that will protect each piece from being damaged by other pieces of jewelry. If you look at Appendix III, which gives the hardness and cleavage properties of gems, you will quickly see why this care is also common sense.

The table lists the various gems by hardness, from the hardest to the softest. Diamonds will scratch every gem below them on the Mohs scale. The other gems will scratch any gems below them and will be scratched by all gems above them. Note the cleavage properties, too. Gems with good or high cleavage can split or cleave if hit in the "right" place. That may not happen often—and you probably couldn't do it if you tried unless you used a hammer—but everyone has had some kind of freak accident that could not happen and did. So, if you do not have separate boxes from the jeweler for each piece of jewelry, at least put each piece in an individual case of some kind and do not drop it casually into a jewelry box.

In most cases, a plastic bag—the same kind you use for sandwiches—is a good substitute for leather or cloth. Plastic, however, should never be used with pearls, opals, and ivory, which need air to retain their beauty. Plastic, nevertheless, does have an advantage for other jewelry in that you can easily see the piece of jewelry that's "in the bag." This method, incidentally, is also good for costume jewelry, which can be scratched as easily, if not more so, than precious jewelry.

Cleaning is also important in retaining and restoring the beauty

and luster of jewelry with and without gems. Even gold can discolor from soaps and perspiration. Silver can be especially prone to tarnish, although almost all American sterling silver jewelry is coated with rhodium, an element of platinum, to prevent tarnishing. Any other silver that is worn all the time rarely needs polishing either, since wear retards tarnish. It still may need cleaning, though.

In fact, any metal may need cleaning now and then to remove dirt, soil, or soap film, as may gems. There are, in general, four methods of cleaning jewelry. Although all are safe for cleaning precious metal and diamonds, all are *not* interchangeable and safe for all kinds of jewelry. These are the methods most commonly suggested and used, but be sure to read further for the exceptions and for the precautions you should take with specific metals and gems.

Detergent Bath. Mix a mild detergent and warm water in a small bowl or cup. Immerse the jewelry, brushing the pieces with an eyebrow brush. Rinse the jewelry under warm running water, being sure to put the jewelry into a tea strainer or cheesecloth for safety's sake. Pat dry with a lintless cloth. *Do not use for soft gems or for any jewelry that is strung, such as ivory or pearls.* See below for special care.

Cold Water Soak. In a cup or bowl, combine half cold water and half household ammonia. Put the jewelry in and soak for 30 minutes. Do not leave it overnight or for a long period of time. After 30 minutes, remove the jewelry and gently clean the front and back of the setting, if necessary, with an eyebrow brush before swishing the jewelry in the solution again and draining it dry on tissue. *Do not use for soft gems or for any jewelry that is strung, such as ivory or pearls.* See below for special care.

Quick Dip. Commercial jewelry cleaners generally employ the quick-dip method. Since cleaners vary, you should read instructions carefully and follow them to the letter. *Do not use the cleaners on any jewelry not specifically mentioned unless you check with a jeweler first.*

Ultrasonic Cleaners. You will find several of these small machines on the market. In general, the principle is that of using high-frequency turbulence to clean jewelry soaking in a metal cup of water and detergent. Again, be sure to read and follow the directions with the utmost care and do not use the machine on any jewelry not specifically mentioned. Not all jewelers, moreover, feel these ma-

chines are safe even for diamonds. Before buying one, therefore, be sure to check with your jeweler and get his advice.

These, then, are the common methods—*in general.* Specific metals (and gems) require specific care. The methods described below are safe for the specific metals and won't harm most gems. Keep in mind, though, that some gems need special care. Those gems are listed by themselves later in the chapter, and you should refer to that list before cleaning any jewelry with any kind of stones. Whenever you have any doubt about cleaning jewelry, be sure to take it to your jeweler, who knows what to do and has special equipment and cleaners.

COPPER

Copper will tarnish like silver in the presence of moisture and sulfur. In most cases, however, a lacquer is baked on to prevent the jewelry from tarnishing. To clean copper, use any commercial cleaner that specifies it is safe for copper. *Do not use ammonia, which can erode copper.*

GOLD

The lower the number of karats, the more gold will discolor due to the higher percentage of base metals in the alloy. Mild soap, water, and ammonia will remove the discoloration with ease.

One theory goes that you can prevent gold from leaving a black mark on the skin by spraying the gold with a hair spray. All you are actually doing is adding a substance that can add to the tarnish. Keeping gold clean is the best way to avoid skin discoloration. *In any case, do not use hair spray on any gold with gems.*

Gold-Filled. Remember, the character of gold-filled jewelry is the same as the karat gold that makes up 1/20 of the total weight, except that the jewelry will not last as long as the same jewelry in solid karat gold. Gold-filled jewelry can be cleaned the same way as karat gold, with mild soap, water, and a drop of ammonia.

Rolled Gold Plate. Rolled gold plate may contain less gold than rolled gold, but it should be cleaned the same way as gold-filled and karat-gold jewelry.

Gold Electroplate. Although the layer of gold deposited by electroplating may be only 7 to 100 millionths of an inch thick, good

gold electroplate can wear as well as rolled gold. It should be wiped clean regularly with a damp, soft cloth, and a mild soap and water solution may be used to remove any makeup. *Do not use a treated cloth to clean gold electroplate.*

Gold-Washed or Gold-Flashed. Jewelry finished in this manner contains very little gold. The surface layer, in fact, is so thin that it may be negligible and wear off after a few times of being worn. Any cleaning, and particularly any rubbing, may remove the finish entirely.

SILVER

Any commercial silver cleaner or silver cloth will touch up and clean silver jewelry. Soap, water, and a drop of ammonia will also clean silver that is very lightly tarnished or may just need cleaning to remove makeup and perspiration.

Silver-Filled. Clean silver-filled jewelry in the same way as sterling. The older the jewelry, however, the more permanent the patina will be. Such a patina cannot be removed.

Silver Electroplate (Plate). Silver plate, unlike gold, can last for years and can be cleaned in the same way as sterling. It can be replated, if necessary, although replating is more common in silver tableware than in jewelry.

COMBINATION METALS

Metals, including precious metals, are sometimes combined with other metals and with enamel. When this is the case, be very careful in cleaning the metal that you don't clean off the inlay or enamel. The same caution holds true for vermeil, which is sterling silver with a karat-gold electroplate. If you must rub, rub very gently with a soft cloth.

GEMS

Some gems, as mentioned above, need special care. That care includes both cleaning and storing the gems. Be particularly careful with:

Amber. Amber is the softest of all gems and will be scratched by all other gems. Be careful in wearing it and always store it by itself.

It darkens gradually with age and exposure to light and should be kept in a cloth or leather bag or case.

Never use a rough cloth or a cloth that may have dirt, dust, or grit on it to clean amber because of its softness. *Never* use acid to clean amber or wear amber when working with acids since acid will decompose amber. Alcohol and other solvents do not normally affect amber, however, unless it is exposed to them for a long period of time. For this reason, be careful not to leave amber in any cleaning solution, except very briefly. Hair spray and perfume can also affect amber.

Coral. Coral is relatively tough. Be careful with twig coral in both storing and wearing, since the thinner the twigs the more easily the coral can break. Remember, coral isn't a mineral and its luster may be spoiled by preparations used to clean other jewelry.

Diamonds. Diamonds should be kept apart from other gems to avoid scratching the other gems. This rule holds true for both storage and cleaning. One expert suggests boiling diamonds for 10 minutes in soap, water, and ammonia to clean them.

Ivory. Wash ivory carefully in soapy water, drying it with a damp cloth. *Never* soak ivory in soap and water, however, since soaking can cause it to crack or break. If you are cleaning ivory beads, *do not* get the string wet because the string will stay wet and can affect the beads. *Do not* use commercial jewelry cleaner or acid.

Ivory darkens with age. It can be bleached by sunlight or peroxide. If peroxide is used, do not soak the ivory in it—and avoid wetting any string with which ivory beads are strung with the peroxide.

Keep in mind that ivory is permeable and relatively soft, factors tending to make it contract or shrink in cold and expand in heat. The combination of temperatures, along with soaking and drying out, can lead to the cracking of the ivory. Wiping it carefully with a soft, damp cloth, therefore, is probably the best method of cleaning ivory.

Jet. Jet, although tough, is soft and should never be kept with other jewelry that can scratch it. Scratching diminishes its polish and lessens its value to collectors.

Lapis Lazuli. Despite its softness, it wears well and is popular for men's jewelry and especially men's rings. Even though it may scratch, the scratches aren't difficult for a good jeweler to polish out.

Malachite. Malachite is soft and is not tough like jet. It breaks easily and should be worn with care. It also scratches easily, losing

its polish. Be careful wearing it next to your skin, which can turn malachite dark or black.

Moonstone. Moonstone's softness means that it needs care. Moonstones should be kept by themselves and be cleaned carefully with only a very soft cloth and soap and water.

Opals. All kinds of opals are fragile and require care, the most care of any other gem. The polished stones are usually thin and may crack or craze (see Chapter 4). One cause may be extremes in temperature. For this reason, never wear opals in extremely cold weather, in direct sunlight, in hot dishwater, or when handling frozen foods. Cold weather may also cause opals to shrink, which means they can fall out of the setting. Because of their softness, they are easily scratched and may absorb dirt or grit, another reason for avoiding dishwater and being careful in cleaning them.

Opals contain water, sometimes as much as 10 percent. Thus, they may dry out. For this reason, some experts suggest leaving them in water, in a mixture of water and glycerine, or in mineral oil to keep them from drying out and losing their fire, whenever they are not being worn. Use only a mild soap solution and a soft cloth to clean them. *Never* put opals in plastic bags, commercial jewelry cleaner, or acid.

Pearls. Both Oriental and cultured pearls are genuine pearls and need a certain amount of special care. Cosmetics (including hair spray), dust, dirt, and particularly perspiration can affect pearls. They should be wiped carefully only with a soft cloth after wearing and kept in a satin-lined box, never in a plastic bag. Because of their softness, care should be taken not to scratch them. Pearls need to be worn and allowed to breathe. *Do not* use commercial jewelry cleaner or acid to clean them.

Peridot. Peridot scratches easily and tends to lose its polish. It should be stored and worn carefully but no special cleaning is necessary.

Topaz. Topaz should be kept in the dark—literally. The gems tend to fade or pale in light, and some yellow-brown topazes on display in museums have turned clear after several years. Remember, too, it cleaves easily. It does not require special cleaning methods.

Turquoise. Since turquoise is very porous, it will absorb all sorts of impurities, especially if it is exposed to dirt and grease, such as in working in the yard or in washing dishes.

Turquoise tends to change color with age. It may lighten,

darken, or streak. According to an old wives' tale, burying turquoise in dirt will restore the color, but the advice does not say for how long or what amount of dirt might be absorbed. You are probably better off learning to appreciate the change in color.

Never expose turquoise to ammonia, which will spoil the surface by pitting or spotting. Jewelry cleaner and acid will also injure or destroy turquoise.

To sum up, one of the best methods of cleaning jewelry is simply to use mild soap, water, and a drop of ammonia, even though ammonia should not be used with certain gems. Commercial jewelry cleaners are also available at fine jewelers, and these are safe, too, for most—but *not* all—jewelry. Be sure to read the directions on any commercial cleaner carefully and to follow them.

When in doubt about cleaning any jewelry, ask your jeweler what *he* would suggest. Remember, a watchmaker is not a jeweler. A watchmaker may be an expert at cleaning watches but he does not know jewelry and gems. For expert advice and help, you need a jeweler who knows metals and gems, because in some cases you may be better off bringing the jewelry into the jeweler's for cleaning.

REMODELING JEWELRY

Taking care of fine jewelry preserves the luster of the metal and the beauty of the gems. It also preserves the value of the jewelry— and that can be important, should the time come when you tire of it.

Many women and men may have contemporary jewelry they rarely wear for one reason or another, not the least being that the style has changed. Little can be done about costume jewelry, including gold-filled jewelry. Regardless of what you paid for it, the metals and the gems are not fine enough to be reworked and their value is not such that the jewelry has a resale value. Fine jewelry is another matter.

If the jewelry is made of precious metals, especially karat gold or platinum with or without gems, you have two choices:

*One is simply to sell the jewelry to a jeweler who buys as well as sells jewelry, and put the money toward a new piece of jewelry. Although appraisals cost money (see Chapter 10), the jeweler who buys the jewelry absorbs the cost in the price he offers you. The price you get will be the price the jeweler must pay for an equivalent piece

at wholesale. It will not be the insurance appraisal value. Depending on the price you paid and what you are offered, which can depend on the length of time you have had the jewelry and how much costs have increased, you may decide to keep the jewelry.

*The other choice is to have the jewelry remodeled, the settings changed, the gems reset, new gems added, and so on.

Which solution is best for you can depend on the jewelry itself, both the value of the metal and gems and their condition. These factors then have to be weighed against the cost of remodeling as opposed to what you will get in selling the jewelry and what a new piece of jewelry will cost.

Any metal that is scratched can be remelted, which is usually necessary for a new setting. Scratched or not, moreover, it retains an intrinsic value, that of the market value of the metal. If gems are chipped, however, they may not be able to be reset and they would have little or no resale value. If the gems are only scratched, it may be possible to repolish them. These factors, nevertheless, make a good argument for taking care of jewelry in order to preserve its value, both for the present and the future.

You have several considerations to take into account in having jewelry remodeled. First is the metal itself. The more precious and fine the metal, the more worthwhile remodeling may be, considering the cost of the metal when you bought the jewelry and the cost of it today. Although silver can be remodeled, the cost may not make it worthwhile or practical to remodel. Second, there are the gems, especially their size and quality, not to mention the kind of gem and what you want done. Do you want a new ring made from an old ring, a ring made from a pin, new earrings from old ones, or perhaps earrings made from a pin?

Although you want to have some idea of what you would like, what can be done depends on the jewelry. For this reason, take the jewelry to a jeweler who does remodeling and discuss what you have in mind. He may make suggestions himself, or give your ideas to a designer with whom he works to come up with one or more designs. In some cases, as Ralph Destino points out, what you want may not be possible. That does not mean remodeling is impossible, but it does mean the designer will make other suggestions. In any case, the final decision is yours.

When gems are involved, the type, quality, and condition of the gems are major factors. The remodeling of inexpensive gems such

as garnets or quartz may be too costly to make the new jewelry practical. Remodeling is generally practical only for the more expensive or precious gems. Even then, a gem such as precious opal may be too fragile to take the handling necessary in remodeling.

Other factors arise when you want to add new gems. That means adding gems of the same quality, cut, and color. Remember, the sparkle of gems depends on these characteristics. The size of the gems enters into the picture, too. Here is where the expertise of the jeweler is important. Where you want to combine a single brilliant-cut diamond with a similar diamond or diamonds, it may be preferable to add baguettes because of the difficulty of matching the old diamond. For the same reason, adding colored gems may be an alternative.

Although the preliminary work of the design should cost nothing at a reliable jeweler's, you should expect that cost to be included in the final cost of the work. What you should see and get is a design or designs along with an estimate of what the cost will be, for new or other metal, for gems, and for workmanship. The last can be considerable, since only highly skilled jewelers can make jewelry themselves. In any case, if you decide not to have the jewelry remodeled, because the design is not what you want or the cost is too high, the design is a service offered by a jeweler who wants your future business.

You can always go to another jeweler, who may be able to do what you want and at the price you want. If you are still not satisfied, you can keep trying jewelers until you find one who says he can do what you want. Shopping around in this way, however, raises problems. A reliable jeweler who knows metals and gems should know what can and cannot be done and knows the cost of materials. The cost of gems and metals is international. A jeweler cannot offer you a "bargain" unless the gems are inferior in quality. That cost should be pretty much the same at all jewelers. Again, the cost of fine workmanship should be similar; there are no bargains in quality workmanship. In short, a fine jeweler is an expert who knows gems and metals and knows what can and cannot be done at what price, while you are an amateur. It is better to pay a higher price and be satisfied than it is to pay a lower price for a piece of jewelry you may never wear.

Under no circumstances should you be obligated to accept a design that does not appeal to you. Jewelry, after all, is personal and

has an emotional appeal. If a jeweler says what you want cannot be done, however, ask him why and listen to his advice and suggestions before shopping around. That does not mean you should be pressured or feel you are being forced into buying what you do not want or do not like. Any time that you are pressured or pushed into making an immediate decision is the time you should find another jeweler.

For these reasons, in having jewelry remodeled:

*If you have a reliable jeweler, ask his advice about what you want done. If you do not know a jeweler who does this kind of work, ask your friends about any jewelry they have had remodeled and whether they were satisfied. You can always check the jeweler's reputation with consumer bureaus, Better Business Bureaus, and Chambers of Commerce, too.

*Be sure you like the design. As with buying new jewelry, your initial reaction should be an emotional one.

*Be sure you understand the cost. Get an estimate that includes all the expenses involved in the remodeling, from the cost of the design to the cost of new gems and metal and the cost of workmanship. Expect to pay for labor and skills as well as material.

*If the cost of what you want or like is more than you feel you can afford, you can keep the piece of jewelry as it is or you can find out about selling it and putting the money toward a new piece of jewelry.

*Be sure to find out how long the remodeling will take. It may take time, especially should new gems be necessary, since matching your gem or gems to new ones may take a while. Although the length of time should not be a factor in your making a decision, you should be aware of it and not expect to get the jewelry in a few days or weeks.

Remodeling has another side to it. In general, what you will probably want remodeled is contemporary jewelry. Old jewelry, jewelry that may possibly be antique, is another matter. Even the simplest remodeling or change of stones may destroy or lessen the value.

Antique jewelry is a collector's item, and jewelers who deal in contemporary jewelry—expert as they may be—are not always expert in antiques. You want to keep in mind that some antique jewelry can be exquisite with a value not always related to the value of the metal or the gems.

When imitation rubies were first manufactured in the nineteenth

century, they were often used by fine jewelers. So was rolled gold. Those jewelers were also not above using glass to imitate gems. When such jewelry is inherited, there may be an assumption that the metal is karat gold and the gems are genuine. Do not be shocked if a jeweler in contemporary jewelry tells you the item has no value. Granted, he may be right, but there is also the possibility the jeweler simply is not knowledgeable about period jewelry. Before you throw it out, have its value checked by a jeweler or antiques gallery that deals in antique jewelry.

Remodeling, therefore, is often possible with fine jewelry. Sometimes it may be practical and reasonable in cost. Other times, it may be impractical and too costly. Still other times, it may be a mistake, as is the case with antique jewelry. At all times, you will have to rely on the advice of the jeweler—and that means making sure the jeweler you talk to is reliable and has a good reputation.

10.
WHAT IS JEWELRY WORTH?

How much is your jewelry worth—not your inexpensive costume jewelry but your better and fine jewelry? You may think you know or you have an idea of its value, but before you answer that question, you want to consider several factors.

First of all, there is the value of the jewelry when it was bought, its purchase price, in other words. Depending on how long ago or how recently that was, there is the value of what it would cost to replace it today, which could be many times more than the purchase price. Then, there is the question of how much jewelry is worth if you inherited it and must pay taxes on it. Should you decide to sell jewelry, the value may be still different from its replacement and tax values. And jewelry even has another kind of value, which has nothing to do with monetary value of any sort, because it is a senti-mental value and may be beyond pricing.

In short, although fine jewelry has value, the actual monetary value can be relative. In fact, no one can put a definitive value on jewelry because it has different kinds of value. That is why you need expert help to establish what the value is or might be, with the exception of sentimental value that only you can know.

The reasons why you should know or want to know what your jewelry is worth, aside from curiosity, can vary. An important reason,

however, is whether you should insure the jewelry and for how much. Good jewelry is expensive, as you know if you bought jewelry recently or have looked in stores or seen it advertised. You know prices seem to be going up all the time. Yet, you may not have connected those higher prices to jewelry you already own.

Consider these facts. Between 1973 and 1978, jewelry prices rose at least 100 percent, if not more—a minimum of 20 percent a year. Prices for gold increased even more in those same five years, approximately 500 percent. To put those increases in perspective, that means even a simple gold ring bought for $50 more than five years ago is worth several hundred dollars now. For this reason, unless the jewelry was bought recently, you may not know what it is worth on the market today if you were to buy it or have to replace it now. What you paid for the jewelry, in other words, may have little to do with its present worth.

Jewelry that has been in the family for a long time is another question mark. It may be worth far more than sentimental value, regardless of how "old-fashioned" you may think it is. The problem is: do you know whether it is merely old and worth little more than the value of the settings and stones, or it has much greater value as a piece of antique jewelry? Even inexpensive jewelry from the right period and of the right kind can have value as "collectibles," since some of the least expensive jewelry of former times, such as Victorian jet and rock crystal jewelry, is eagerly sought today.

In addition, you may have misconceptions about gems. Diamonds are one example. Color is often given a high premium in the public's mind because of the emphasis in advertising on white diamonds. But color is only one quality to be taken into account. An appraiser recalls being asked to appraise two diamonds. One was a white diamond that the owner thought was valuable and the other a yellow diamond that "probably was not worth much." The opposite was true: the white diamond had several flaws, while the yellow diamond was flawless and of a good color and worth much more.

Another example is smoky topaz. Smoky quartz is similar in appearance and less expensive. Is the jewelry smoky topaz or smoky quartz? Only an expert can tell. In short, when it comes to actual value, you are not a good judge.

Now, ask yourself again how much your jewelry is worth. Chances are that this estimate is higher than your original one—and it could be even higher if you look around and compare your jewelry

to what similar items cost in stores today. That means you cannot afford to lose it, because you may not be able to replace it unless you have insurance.

When you think of losing jewelry and of insurance, the tendency is to think in terms of theft, either robbery or burglary. It is true that statistics show a burglary occurs every 20 to 25 seconds—but burglary and robbery account for only approximately 40 percent of all jewelry losses, according to insurance statistics. What, then, happens to the other 60 percent? The answer to that question may be surprising: it is lost by owners themselves through carelessness and by accident.

Carelessness and accidents are other reasons for appreciating the worth of jewelry, since the more you appreciate the value, the better care you may take with it. At the same time, appreciating the value and knowing the value can be two different things, and the only way you can know the real value is by having jewelry appraised.

Appraisals cost money. Still, they are worth it if they help you to take better care of your jewelry, and they are necessary if you want to insure jewelry. Insurance is for everyone—and not only the wealthy who have a fortune in gems. Even a few pieces of good jewelry represent a considerable investment and one you may not be able to replace without making a financial sacrifice in other ways. Thus, you should know more about the value of jewelry, which means knowing what appraisals are, when they are a good idea and necessary, and how to go about having your jewelry appraised.

HAVING JEWELRY APPRAISED

The basic purpose of an appraisal is to determine—in the appraiser's opinion—the replacement or the market value of your jewelry. Even so, much more is involved than merely putting a price tag on the various items. An appraiser must take into consideration such factors as the authenticity of the setting and gems and their quality, design, and condition. Also involved is the reason for the appraisal, since appraisals can and do legitimately vary. This leeway can be important to you, and you should know more about the different kinds of appraisals.

INSURANCE APPRAISALS

An insurance appraisal determines the jewelry's replacement value. The key word is *replacement.* Insurance is indemnification in that it provides for the jewelry to be replaced by new jewelry as nearly identical to the original as possible *or,* if that is impossible, for you to be paid the amount of money for which the jewelry is insured. Replacement is the first concern, however. That means a complete and detailed description of the jewelry being appraised is as important as setting a price on the item. The value, moreover, must take into account the cost of labor as well as the current market prices for precious metals and gems.

ESTATE APPRAISALS

The same factors have to be considered for estate appraisals for tax purposes as for insurance appraisals, with one exception: replacement is not the issue. At stake, in this case, is what the jewelry would fetch—its *market value*—from a willing buyer. Thus, the estate appraisal would be lower than an insurance appraisal, where replacement costs of labor and materials are included. This does not mean that you will always be able to sell the jewelry at that price, because the appraisal is based on the premise of a willing buyer. Tax laws generally take into account only the willing buyer premise, while a forced sale may mean you will get less. At the same time, as long as the appraiser knows the appraisal is for tax purposes, he can legitimately give you a lower appraisal than he would for insurance purposes—and a lower amount on which to pay taxes.

The variation does *not* mean that anyone is being deliberately cheated, as long as the appraiser is reputable. A good appraiser knows that a too low or too high appraisal will be questioned, in which case the Internal Revenue Service or the insurance company will ask for another appraisal. In addition, his reputation will be hurt.

OTHER APPRAISALS

Aside from the above usual reasons, there are other times when you may want an appraisal. One time is when you buy jewelry in another country. Although prices of gems and gold are pretty much the same wherever you buy them, the cost of labor can vary tremen-

dously. It is a good idea, therefore, to have the jewelry appraised when you get home to find out its market and replacement value here. Still another, and perhaps more important reason is to make sure the jewelry is actually what you think it is and bought it as, especially if you paid a "bargain price." Some countries have few regulations on the marking of precious metals, much less differentiating between quality and inferior gems or even between genuine and substitute gems. Fraud in jewelry, unfortunately, is international, and today some synthetics are so realistic that even dealers can be taken in. If you have been victimized, there is little you can do about it, unless you have bought the jewelry from a reputable firm that will stand behind the jewelry and may even have an outlet or store in this country.

Another time, you may want an appraisal for the purpose of selling the jewelry. In this case, another factor enters in: the wholesale versus the retail market value. Perhaps you have a gold and diamond pin. An appraiser may value it at $4,000 for estate and tax purposes, while the same appraiser might value it at $5,000 for insurance purposes. Both valuations reflect a fair market or replacement value. But that does not mean you can get either price should you want to sell the pin. In this case, the appraiser may evaluate it at $2,500, because $2,500 would be the wholesale price, the price at which a jeweler could get an equivalent pin at wholesale and then sell it at retail for the full market value. The jeweler has to allow for markup and profit, regardless of whether he buys the jewelry from an individual or a dealer.

If you want to sell jewelry, however, you have another option that may mean you can get the full market value. Auction galleries such as Sotheby Parke Bernet, Christie's, and others around the country will take jewelry on consignment. You can set a floor price, under which you won't sell the jewelry, and the gallery will sell the jewelry for you for a commission. Selling jewelry this way takes time. Most galleries plan sales several months in advance, with the result that you will not get your money for four or five months—if the piece is sold. Jewelers who buy jewelry, on the other hand, will give you the money at the time they buy the jewelry. The difference is between an immediate sale for less money than you may want and a later possible sale for your asking price.

If your jewelry has already been appraised for estate or insurance purposes, therefore, do not expect the jewelry to be worth

either amount of money should you decide to sell it. Some jewelry, moreover, may have little or no resale value on the market, other than for the intrinsic value of the metal and gems. It may simply not be in a style or design in demand. On the other hand, some jewelry may have a resale value far beyond the intrinsic value because of the design or style. An example is antique jewelry, where the judgment and knowledge of the appraiser and buyer can be especially important in determining the value.

Judgment, in fact, is an important element in any appraisal. Appraisals between or among appraisers can vary, just as an individual appraiser's valuation can vary, depending on the reason behind it. There is no "book price" for jewelry as there is for cars, because jewelry is individual and may even be unique, with the value relying on the appraiser's opinion of the quality and design. These variables do not mean that you should want to "shop" for jewelry appraisals as you would shop for a car. For one thing, shopping for appraisals costs money. Appraisers generally charge either a fixed flat fee or a percentage of the appraised value, usually 1 to 1½ percent. Thus, you want to be as sure as possible that the appraiser is reputable and reliable.

FINDING AN APPRAISER

Do not expect a neighborhood watchmaker or a store that specializes in watches to be able to appraise jewelry. They may be experts in watches, but for jewelry you need an expert in jewelry and stones. How, then, do you find such an appraiser?

The best place to have jewelry appraised is where it was purchased, if possible, for several reasons, according to the Retail Jewelers of America, Inc. First of all, if you are a regular customer, you obviously have confidence in the jeweler—and confidence is important in getting an appraisal. Second, the jeweler knows the jewelry and has the data necessary to do the appraisal.

Going back to the original jeweler, nevertheless, is not always possible: you may have moved, the jewelry may be part of an estate, it may have been bought elsewhere, or it may be antique and your jeweler is familiar only with contemporary jewelry. Then, too, you may simply want a second opinion. In any and all of these cases, you want to select a well-established jeweler who has been in business a long time and has a good reputation in the community. Since there

will be a fee, find out what it is—but don't try to save money on an appraisal. You are buying an expert opinion based on special education and training and experience, backed up by expensive technical equipment.

For these reasons, you should know about two organizations whose members must meet certain standards that qualify them to appraise jewelry. They are:

* *The American Gem Society,* which is responsible for the registration of members and for the setting of ethical standards. More than 1,100 jewelers are registered with it, all of whom have had several years of on-the-job training and have taken courses from the Gemological Institute of America on either diamonds or colored stones. AGS publishes a roster of retail firms that have either a registered jeweler or certified gemologist or both on their staffs. It is available from the American Gem Society, 2960 Wilshire Boulevard, Los Angeles CA 90010.

* *The Appraisers Association of America.* The association includes experts in jewelry, art, antiques, and other items and also sets certain standards for its members. It puts out an annual directory of members, available for a small fee from the association at 541 Lexington Avenue, New York NY 10017. Included are the members' specialties.

Members of both groups generally have certificates or symbols displayed indicating to which group they belong. If you don't see one, ask about membership and to see the certificate. That membership is a form of security for you, since both groups monitor their members and are receptive to any complaints. If gems are involved, an appraiser should be a qualified or certified gemologist or have one available.

If you have antique jewelry—or think you have—a jeweler experienced in modern jewelry, even though he may be a gemologist, may not be the best judge of the jewelry's value. Technically, antique jewelry, like any other antique, must be 100 years old or older, and that is the rule that U.S. Customs follows as far as letting antique jewelry come into the United States duty free.

Among collectors, nevertheless, there are exceptions to the 100-year-old rule, just as there are exceptions to any rule. Some jewelry 50 years old or less has recently become highly prized. Experts point out that Art Deco jewelry from the 1920s and 1930s now has antique status among collectors. That does not mean that

all jewelry from that period has a value above its intrinsic value. Bar pins of filigree and set with gems were also popular, but these have little market value in comparison to the enamel, precious metal, and geometric forms of Art Deco. To determine the value of old or antique jewelry, therefore, you need an expert in that kind of jewelry.

To find such an expert, you can look through the Yellow Pages of the telephone directory for jewelers and galleries that specialize in antique jewelry or estate appraisals. The directories of the Appraisers Association of America and the American Gem Society may also be a help. Whomever you choose, should you have old jewelry, be sure to have the appraiser check not only what looks like precious metal and gems but also what may look like "junk" to you. Black beads may turn out to be Victorian jet and clear beads to be rock crystal, both of which are collectibles in the antique market.

Other jewelers, of course, may have gemological training and be qualified to appraise jewelry. Friends who have had jewelry appraised may be able to make suggestions. In any case, what you want to guard against is an unethical appraiser. As both the Retail Jewelers of America and the American Gem Society point out, a certificate is not always a mark of ethics. For this reason, if you do not know the jeweler yourself, you may want to check with the local Chamber of Commerce, Better Business Bureau, or consumer protection agencies that should be able to tell you about the jeweler's standing and whether he has a record of complaints.

"Unfortunately," as the Retail Jewelers of America points out, "an unethical appraiser may intentionally give an incorrect price on your jewelry in a deliberate attempt to put your jeweler in an unfavorable light in the hope of casting doubts on your purchasing decision. (It may not be pure coincidence if he also shows you something 'similar' for less money.)"

Despite these warnings and qualifications, you can find a reliable appraiser. Knowing what and whom to avoid, in fact, can be a help when you are talking to jewelers about having jewelry appraised—and you do want to talk to them *before* leaving any jewelry with them. To summarize:

1. Look around to find out which jewelers carry merchandise similar to what you want appraised. If the jewelry is modern or contemporary and contains stones, you want to be sure the jeweler

specializes in or carries similar stones. If the jewelry is old and may possibly be antique, you want a jeweler who carries enough antique merchandise to be able to recognize the value of what you have. Remember, genuine antique jewelry has a value greater than the value of the metal and stones. So you need someone who can appreciate its design and quality.

2. Look for certificates indicating gemological training. These will usually be displayed, but be sure to ask to see them.

3. Look for gem testing equipment and instruments. Again, be sure to see them for yourself.

4. In connection with 2 and 3, ask about having gems sent to a gem laboratory for identification and quality analysis, should it be necessary, for example, if the appraiser's identification of the gem and/or its quality is not what you have been told previously. These laboratories do not appraise gems in the sense of setting a value on them, but they do provide protection against fraud. The most prominent laboratories are those of the Gemological Institute of America at 1660 Stewart Street, Santa Monica CA 90404, and at 580 Fifth Avenue, New York NY 10036.

5. Ask to see copies of appraisals that the jeweler has done in the past. Have the terminology explained to you. The appraisals should meet the qualifications in the next section.

6. Ask about the fee. Be sure to understand whether you are paying a flat fee or a percentage of the value.

7. Make an appointment to bring the jewelry into the shop, unless the jewelry is a single item. Sometimes, especially in the case of estate jewelry where a large amount is involved, an appraiser may go with you to the bank or wherever the jewelry is stored for safekeeping. If the jewelry must be left with the appraiser, be sure you are given a receipt with a full description of the jewelry.

THE APPRAISAL

Whenever you get an appraisal and for whatever reason, the appraisal should be specific and complete. That is what you are paying for. The description "a platinum ring with a white diamond" could fit a multitude of rings and is not an appraisal that will be accepted by anyone. The guidelines for an insurance appraisal are probably the best guidelines for what any appraisal should include since—regardless of the initial reason for the appraisal—you may

decide to insure the jewelry. These guidelines include the following nine considerations:

1. Major stones should be listed, giving the number, identifications, shape, dimensions in millimeters, weight, and quality.

2. Smaller stones (less than .20 carat) may be grouped with estimated total weight and identification, although number and size should be listed.

3. The quality grade should include remarks about color, clarity, and cutting and should identify the system used, such as Gemology Institute of America (GIA), American Gem Society (AGS), etc.

4. The metal stamping and type of workmanship should be noted, such as 14-karat yellow gold casting.

5. A written description of the item that would assist in its identification if it is lost or stolen. A photograph is also a good idea and may substitute for the description.

6. An estimate of what the appraiser thinks is a fair replacement cost for the item, taking into consideration today's market prices for materials, labor, design, etc. Remember, for tax or sale purposes the cost estimate may be different.

7. Any damage to the stones or mounting should be noted.

8. The type of equipment used to make the appraisal should be listed.

9. Appraisal forms should be dated and signed with copies for the individual and for insurance or tax purposes.

All the above information should be included insofar as possible. For example, diamonds and other gems may be identified by size and weight in carats alone, while pearls will be identified by millimeters.

Some appraisers automatically go over an appraisal with a customer, explaining terms and giving the reason for the valuation. The one you choose may even offer to show you any flaws under the loupe. If he does, you may not be able to see them. It takes a trained eye to use a loupe and some imperfections may be so minute you will not be able to see them even when they are pointed out. By the same token, you may see them strictly because of the power of suggestion. For these reasons, you have to rely on the appraiser, which is why it is so important to choose one you can trust.

In any case, remember you are paying for the appraisal and are entitled to an explanation of what is or is not included and any terms you don't understand. Terms you want to know about and have explained, in particular, are those concerned with the quality grading of diamonds. The most common systems used for color and clarity are given in Appendix II. Whatever system is used, however, be sure to ask about any terms that are not clear, if an explanation is not forthcoming.

If you are not satisfied with the appraisal, you can check with someone else; complain to the group to which the appraiser belongs, to Better Business Bureaus, or consumer protection agencies; and you can even send the gem yourself to a GIA laboratory. The latter may and should be the case when you have a complete bill of sale for an item and it identifies the jewelry differently from the appraisal. It is also the reason why you should insist on a GIA certificate at the time you buy a gem.

At the same time, you have to remember that an appraisal is subjective. As one jeweler says, "Identifying a stone has always been my word against someone else's." A new process may change that, making the identification of diamonds—especially of 1 carat and above—absolutely certain and invaluable if the diamond is lost or stolen. The process, called Gemprint, was developed by the Weizmann Institute of Science in Israel and is becoming widely used in the United States.

A Gemprint is as reliable for diamonds as fingerprints are for people, according to experts. It is a print of the pattern of the gem that combines photography with a laser beam and computers. The resulting distinctive picture of the reflections of light within the diamond is so accurate that experts say that the chance of finding two diamonds with the same print is even less than that of finding two people with the same fingerprints. The Gemprint will identify stones even if they have been chipped or slightly damaged, but it will not identify recut stones because the pattern would not be the same as that of the original stone. Yet, a Gemprint can be an invaluable tool if it is taken of a gem before or at the time of sale. The cost is minimal, and it is positive proof in identifying a gem. An appraiser would have to take it into consideration in evaluating a diamond. Gemprints would also be invaluable in recovering stolen jewelry, and theft is what most people think of when they think of insuring their jewelry.

INSURING JEWELRY

The value of your jewelry, whether or not it has already been appraised, is probably the determining factor in deciding your need for jewelry insurance. Another is the possibility of burglary. A third factor, and perhaps more important, is how careful you are in wearing and storing your jewelry. Remember, only about 40 percent of lost jewelry is stolen.

Whether or not you need insurance is your decision. In the meantime, you need to know the various types of coverage and what they mean to you. To begin with, insurance companies define "fine jewelry" as any item of precious or semiprecious metal and/or stones worn for personal adornment. On the other hand, "costume jewelry" includes two types: it may be made of lesser-quality metal and/or stones, such as a sterling silver charm bracelet, or it may be fake or paste. In general, what would be insured would be fine jewelry because of the high cost of buying—and replacing—it. That means you want to take a good look at insurance you may already have, to see whether any jewelry is covered and to what extent.

Many people already have some type of homeowners' policy that covers all possessions, including jewelry to some extent. A similar type of insurance which is available in areas with high crime rates, but which covers only theft, is Federal Crime Insurance. Both have advantages and disadvantages as far as jewelry coverage goes.

HOMEOWNERS' POLICIES AND FEDERAL CRIME INSURANCE

Homeowners' policies are limited policies. That means their coverage is limited only to the perils spelled out in the policy. If you are covered for fire and theft, for example, the insurance will pay only for losses due to fire and theft and not for losses due to any other cause, such as wind or water damage or mysterious disappearance. Wind and water losses may not be important where jewelry is concerned, but mysterious disappearance is the major cause of jewelry losses. Thus, you are not paid when jewelry is lost through carelessness on your part.

More important, under homeowners' policies a theft loss is limited in payment to not more than $500 in the case of jewelry—and that could be even less because homeowners' policies are deductible. In other words, the first $50, $500, or $1,000 of the loss,

depending on the terms of your policy, must be deducted and absorbed by you. If only that amount is stolen, the insurance does not reimburse you. If your deductible is $500 and $1,000 worth of jewelry is stolen, you will receive only $500. What may be even more disadvantageous is that the payment for jewelry losses may be limited to a certain amount, usually $500. Thus, if $1,500 worth of jewelry is stolen, you still may receive only $500 because of the $500 deductible and limited amount of payment.

Two major disadvantages, therefore, are that these policies are limited and deductible. They do not cover what is called the "first dollar" of the loss. Insurance with a lower deductible and even first-dollar coverage may be available, but at a much higher premium or even a prohibitive one. Even so, it would still be a limited policy.

Still another disadvantage of a homeowners' policy as far as jewelry is concerned is the problem of fixing the value of the jewelry that is covered under the terms of the policy. Appraisals are not required, which means neither you nor the insurance agent may be able to fix a realistic value on the jewelry. In addition, you must prove that the jewelry actually existed.

None of these disadvantages means that you should not have a homeowners' policy. These policies are invaluable in their own way. What you want to keep in mind, however, is that they do have limitations and especially where fine jewelry is involved. Since the policies vary, moreover, you should read yours carefully to see exactly what it covers, both in terms of type of loss and conditions of payment. Theft is not included in some homeowners' policies. In recent years, the high cost of premiums for policies including theft provisions has forced many people in metropolitan areas to drop the provision, or it may not be offered in those areas at all.

The difficulty of getting homeowners' policies with theft provisions in high-crime areas (which many large cities are) and its high cost are the reasons for the federal government's sponsoring Federal Crime Insurance. Administered by the Department of Housing and Urban Development through the Federal Insurance Administration, its premiums are minimal, even low, but like homeowners' policies it has disadvantages as far as jewelry is concerned.

First, it is available only in states where crime insurance is not fully affordable at reasonable rates. Second, it is available only in amounts up to $10,000. Third, it is deductible, with a deductible of $50 or 5 percent of the loss—whichever is greater. Fourth, it covers

only theft and theft must be proven, such as by a report to the police.

At the same time, the two types of policies cover both burglary and robbery. The difference is that burglary is the stealing of property from within a house, which has been forcibly entered, while robbery is the stealing of personal property from the victim by violence or threat of violence, both inside and outside the home. Thus, you are covered for thefts on the street or elsewhere outside the home, as well as inside the home.

Both policies, therefore, are invaluable in their own ways for most household possessions. The point to keep in mind, however, is whether either protects you from the financial loss involved when *jewelry* is lost. You have to consider that loss from the point of view of the value of the jewelry today, not from its original cost. Remember, few other purchases have increased in value so much and so quickly as jewelry. For that reason, insurance that covers your jewelry specifically can be a very good idea.

SPECIFIC JEWELRY INSURANCE

Jewelry insurance is sometimes called a "floater" policy, but the correct name is actually *inland marine insurance*. Both inland marine and floater refer to the fact that jewelry is mobile or "floats" from place to place, so to speak. Interestingly enough, inland marine insurance is an outgrowth of marine insurance that covers ships and cargoes at sea, hence the "marine" terminology.

The concept of today's insurance, in fact, is supposed to have evolved out of the transportation of goods. One theory credits the Babylonians of five thousand years ago with developing the practice. Merchants would send salesmen to distant lands to sell and buy merchandise, with the salesman's being paid out of the profits from the trip. Naturally, the merchant needed security or insurance that the salesman would return and would not abscond with the goods and the profits. As a result, the salesman put up his wife or children as insurance, and the merchant took the wife or children if the salesman failed to return.

Some salesmen may have been just as glad to be rid of an unwanted wife, but others were not that happy about it. Then, too, the hazards of travel at the time were numerous, and a salesman could easily lose the goods through no fault of his own. An arrangement was worked out in this case that the merchant would free the

salesman from all debt. Before long, the provision was applied to all forms of shipping, spreading with civilization to the Greeks and Romans, who developed the marine concept even further. A ship-owner who needed money to finance a trip would borrow the money, using his ship as collateral. At the end of a voyage, he would pay back the loan plus a premium from the profits.

Another theory credits the Chinese of five to six thousand years ago with developing marine insurance because of the hazards of the Yangtze River, the main route of commerce. Marine insurance, in other words, is a universal concept and has a venerable history.

Inland marine is simply an extension of marine insurance, with the idea further extended to include anything mobile, not only ships and their cargoes. Today, inland marine insurance covers such a wide variety of items as archery or golf sets, furs, musical instruments, and jewelry. Jewelry is probably one of the easiest types of inland marine insurance to get.

It has numerous advantages over other insurance policies. Some of these advantages may come as a surprise, such as the fact that inland marine policies are for everyone, those with only a few pieces of fine jewelry and those with a safe-deposit box full of diamonds and emeralds:

1. Inland marine jewelry insurance is easily obtainable, unlike homeowners' policies with theft provisions.

2. Inland marine premiums are reasonable, running generally from $1.00 to $1.50 for every $100 of coverage.

3. Inland marine is *all-risk* insurance. Instead of stating the few cases it does cover, the policy states what it does *not* cover, with all risks covered except the few stated. And the few risks that are not covered basically do not pertain to jewelry. For example, the policy of one major insurance company reads: "We Cover: All risks of loss of or damage to your jewelry except as otherwise provided by this policy." The risks not covered are: "Loss or damage caused by wear and tear, gradual deterioration, insect, vermin or inherent vice." In short, what is not covered is obviously not a usual hazard with jewelry. The all-risk provision, moreover, includes mysterious disappearance as well as burglary and theft, making it one of the most important advantages of inland marine insurance. If you take your rings off to wash your hands in a washroom, walk away, and the rings are stolen, insurance covers the loss. If you hide your jewelry in a cereal box because you don't trust workmen who are making repairs

and your husband throws out the box, you are covered. If you lose a stone from a piece of jewelry, you are covered for replacing the stone and repairing the ring to its former condition.

4. Inland marine insurance is first-dollar coverage: there is *no* deductible clause. If you lose $1,000 worth of jewelry, the insurance covers $1,000.

INLAND MARINE RATES

Shopping around is not necessary for jewelry insurance. It is what is called a "controlled class of business." Rates are *not* set arbitrarily by insurance companies based on what they think the premiums should be or on how good or bad a risk people are. They *are* based on statistics and other data that provide a complete profile of the factors insurance companies need to know and consider to set rates fair to them and to their customers. The statistics and data are collected and computed by the Insurance Service Offices, an independent organization that serves as a clearinghouse for all information on jewelry losses.

The rate-setting process works this way: the Insurance Service Offices compiles statistics bearing on insurance companies' profits and losses. If 100 percent of the money taken in as premiums is being paid out for jewelry losses, the premiums are too low. The companies cannot make even a minimal profit for their stockholders, much less cover operating expenses. On the other hand, if the profits are too high, with the profits far above operating expenses and what is being paid out for jewelry losses, then the premiums are too high. The rationale is that companies should be able to make a reasonable profit, not such a high profit that the premiums are unreasonable.

A factor that enters into losses is where they occur. "Where" means basically which state, because rates are established by state. For this reason, losses are broken down by state and sometimes by areas or cities, or both, within a state. The purpose is to assure that everyone pays a reasonable premium, that those who live in places with low crime rates don't carry the burden for those who live in high-crime areas.

One point to keep in mind in talking about losses is that the term includes all lost jewelry for which insurance companies must pay the owners, whether that jewelry is lost through accident or carelessness or is stolen. To a certain extent, therefore, individuals influence the

rates they pay. The more careless a person is and the more accidental losses there are, the higher *all* premiums are—not just those in high-crime areas. As one insurance company executive pointed out, "A very few big losses can affect everybody, making everybody pay for a few people."

Crime and profits and losses, then, are major determinants in setting premium rates. Once an insurance company has the data for the past year, it develops its premium rates for the coming year. Even after it has developed its rates, it cannot charge them—yet. First, the company must go to the insurance department of the state or states where it operates—another reason why statistics are broken down by state. The state insurance department has the final say, which is what makes inland marine insurance a controlled class of business.

The individual state insurance department decides whether the premiums are commensurate with the risk—are fair to both the person wanting insurance and to the company. If it decides that the premiums are too high, that the company will make an unjustifiable profit, it asks the insurance company to justify its rates. Even then, the rates may be rejected, and the company must come up with a lower rate schedule. On the other hand, if the state insurance department decides that the premiums are in line with prospective losses, the rates are accepted and published.

Once a rate is published, that rate holds for all companies operating within the state on the basis that all companies in that state will have the same loss experience. The only variation within a state will be geographic. The state insurance department will permit a higher rate for everyone living in a high-crime area—and most major metropolitan areas are considered that—than for those living in low-crime areas.

At the same time, state insurance departments recognize that some people may pose exceptional risks. A person who wears a great deal of expensive jewelry all the time or one who wears a single, very expensive item, like a $75,000 ring, would be an exceptional risk. A person who travels a great deal might be an exceptional risk. So might a person who takes poor security measures to protect expensive jewelry. In other words, an exceptional risk need not be a person with a large amount of very expensive jewelry.

Such people, however, cannot arbitrarily be charged a higher premium than the average person. To begin with, most insurance

companies first explain to a person the reason why they consider that person presents an above average loss exposure and so must ask for a higher premium. If the person refuses to accept the higher rate and decides to try another insurance company, that's that. If the person agrees to the higher premium, then the insurance company must go to the state insurance department and apply for permission to charge the higher premium. The state insurance department reviews the justification and then makes its decision. If it decides the person is *not* an exceptional risk, the company can charge only the regular premium.

In other words, you are protected from a capricious decision on the part of an insurance company on how high a risk you represent. In addition, if you are rejected by a company, laws in many states today require a company to tell you the reason why. At least one major inland marine company has a full disclosure policy, regardless of state laws, and others are following suit.

Sex discrimination is becoming less and less a factor in inland marine jewelry insurance. At one time—and still sometimes today—men were considered a bigger risk than women. The reason was that men were harder on jewelry because of the type of work that they did and were less apt to be careful with it. Women were considered better risks because they did less manual work and were apt to be more sentimental and careful about jewelry. Those stereotypes are beginning to disappear, thanks partially to sex discrimination laws in other economic areas and to the fact that more men are wearing jewelry. As men wear more jewelry, the loss experience is becoming similar to that of women. In addition, as an insurance executive points out, women are now working at the same jobs as men, with the result that women's jewelry is more apt to be damaged, too. In short, jewelry is jewelry, and jewelry wearers are jewelry wearers, not women and men.

Sex, nevertheless, may be one reason to shop around for jewelry insurance if you are a man. Some companies still charge men a higher premium, and not all states have laws prohibiting the discrimination. The point to keep in mind, however, is that a man can find a company that does not discriminate.

INLAND MARINE POLICY PROVISIONS

Understanding how premium rates are determined is the basis for understanding some of the questions you may be asked in applying for an inland marine policy or a "floater." The company has the right to determine whether you are an average risk or present a high enough risk that you could affect the rates for other policyholders. The state insurance department may need the information, too, to make its own decision about the kind of risk you represent.

For these reasons, you will be asked where you live and the type of building; the kind of safeguards you have or take, including fire protection, burglar alarms, watch dogs, or safes; about domestic employees; where valuables are kept; about travel, and previous loss and insurance history. You will also have to itemize the jewelry and, in most cases, have it appraised.

There are two exceptions to the appraisal rule. Jewelry to be insured at less than a certain value, usually $1,000, may not require an appraisal as long as you can furnish the purchase price, date, and where it was purchased—as well as proof that the item or items exist. The purpose of knowing where the jewelry was bought is to permit the insurance company to go to the jeweler to have it replaced, should the item be lost or stolen.

The other time you may not need to have jewelry appraised is when you bought the jewelry recently *and* have a bill of sale that gives the same information as an appraisal would. Otherwise, you will have to have the jewelry appraised.

Insurance companies cannot and do not recommend individual appraisers, although they may sometimes suggest you select one who is a member of the American Gem Society or Appraisers Association of America. In any case, appraisals are usually not questioned as long as the appraisal is complete and the value seems reasonable. That means the jewelry must be fully described in words or there must be photographs of the jewelry. Photographs are a good idea and serve a dual purpose: they help the police to identify the jewelry should it be stolen and they help the insurance company to duplicate the jewelry should it be lost or stolen and not recovered.

The purpose for the appraisal brings up the question of what happens when you have to make a claim for any reason. First of all, be sure to read and understand the policy before you take it out. To the relief of most of us, policies are beginning to be written in "plain

English," with a minimum of whereins, whereinafters, and where-fores. If your policy is not in plain English, and even if it is, be sure to have any provisions or conditions you don't fully understand explained to you. Policies generally read that the company will pay whichever of the following that is the least:

1. For a substantially identical replacement.
2. For the cost of that replacement.
3. The applicable amount of the insurance.

What these provisions mean is that the company will *first* try to replace the lost jewelry with jewelry as identical as possible to the original. That is why the appraisal must contain a complete written description of the items or photographs, with photographs being especially important in duplicating jewelry. Since the company has recourse to wholesale jewelers to whom you might not be able to go, it may be able to replace the jewelry—both at less money than the same jewelry would cost retail and at less money than the ap-praised value. For example, if an item is insured at $10,000 and it can be replaced for $8,500, you have a choice of accepting the replacement or being paid $8,500. If the item cannot be replaced for $10,000 or any amount of money, you will receive the amount shown in the policy.

One other provision you should understand is that insurance pays only for what is lost. If a stone is lost out of a setting, it pays for replacing the stone and repairing the setting—not for the loss of the entire piece of jewelry or for a new piece of jewelry. As far as the insurance company is concerned, reasonably enough, you still have the setting and the original valuation can be restored with the replacement of the stone and the repairing of the setting.

Paying only for what is lost has another meaning as far as pairs go, whether it is pairs of earrings or cuff links, bracelets or pins, or any other item of jewelry that might be in pairs. If you have a pair of earrings appraised at $5,000 and you lose one, insurance pays only for the one you lost, or $2,500. With this in mind, you should be aware that you can get special or optional coverage to cover pairs at a slightly higher rate. The extra money could well be worth it, if you wear earrings a lot. Under this coverage, when one earring is lost and it cannot be replaced, you give the insurance company the earring you still have. The company then pays you the value of the set.

In considering whether you need or should have jewelry insurance, therefore, consider the value of the jewelry, the type of jewelry (such as pairs), and the care you take with your jewelry. Value also means the cost of replacing the jewelry at today's prices. For that reason, once you have jewelry insured you want to have it reappraised periodically, a good time being when you renew the policy. The reappraisal does more than update the cost of your jewelry today; it also means that the jewelry is being checked to make sure settings are secure and clasps and catches in good working order. The condition of the jewelry, after all, is part of an appraisal.

Although a reappraisal value is generally higher than the original appraisal value, it is rarely questioned unless it is out of line with rises in prices. As an insurance company executive said, "If the value of a diamond ring was $5,000 in 1961 and was reappraised for $15,000 in 1978, we would not question it. If it was $5,000 in 1973 and $25,000 in 1978, we probably would question it. One of the appraisals is unrealistic. It could have been either the original or the reappraisal, and we would have to know the realistic valuation before we insured the jewelry." In any case, that ring bought for $5,000 in 1961 could not be replaced today for that amount. Yet, unless it were reappraised and the policy changed to show the present value, all the policyholder could get would be $5,000.

None of these qualifications means that insurance is not a good idea. It is, because the insurance means you can replace the jewelry or be paid for it without a financial loss. What can't be replaced, however, is the sentimental value—and that can sometimes be far greater than monetary value. An even better idea, for this reason, is to be careful with jewelry, which may even mean lower insurance premiums since each person's losses can affect everyone.

GLOSSARY

The purpose of this glossary is to give a brief definition of terms and words you will find used throughout this book. As a result, it includes the majority of those terms and words with two exceptions: excluded are the gems, since any listing would be identical to the alphabetical listing in Chapter 4, and, for the same reason, the types of jewelry listed in Chapter 2. For any questions concerning gems or jewelry, therefore, see those chapters.

a/a/a. See Appraisers Association of America.

AGS. See American Gem Society.

A jour. An open setting in which a gem is set in prongs or claws, with the stone visible from all directions.

Alloy. A combination of two or more metals, with the metals combined in molten form.

Alluvial gold. Gold found in the form of nuggets, dust, or foil in or near rivers and streams. Also called "placer gold."

Altered gem. A natural gem that has been treated in some way, usually heated or irradiated, to change the color to a more desirable hue.

Aluminum. A base metal. No quality markings are required.

American Gem Society. A society of member jewelers whose goals are to promote ethical business practices and further jewelers' education in gems. Abbreviated AGS.

Appraisal. An opinion by an expert as to a gem or a piece of jewelry's quality, authenticity, and value.

Appraisers Association of America. An association of appraisers of fine arts, including jewelry and gems. Abbreviated a/a/a.

Assembled gem. A gem that is partly natural and partly some other material. See "Doublet" and "Triplet."

Asterism. A chatoyant gem with three intersecting lines of needle-like inclusions that form a star.

Baguette. A simple emerald cut that may be rectangular or tapered at one end.

Balas (ballas) ruby. A spinel, not a ruby.

Baroque. A rough or irregularly shaped gem.

Base metal. Metals with little resistance to corrosion, such as iron, copper, and nickel. They are the opposite of precious metals.

Basse-taille. A design embossed on metal with the valleys between the raised design being filled with enamel and ground level after firing or baking.

Belcher. An à jour setting that is relatively flat.

Boule. A synthetic gem crystal.

Brilliance. The internal reflection or refraction of white light in a gem.

Brilliant cut. A gem cut in a round shape with 58 facets at an angle to the top, or table. The top third is the crown, while the bottom two-thirds is the pavilion, with the culet at the very bottom. The edge separating the crown and the pavilion is the girdle.

Brittleness. How easily or suddenly a metal breaks when drawn into a wire. Gems may also be brittle; see "Fragility" and "Cleavage."

Cabochon. A flat-bottom round or oval cut gem, usually with a dome. Cabochons are polished, not faceted.

Cameo. A carved gem or shell with the carving raised in low relief against the background. Cameo is the opposite of intaglio.

Carat. The basic measurement of the weight of gems. A carat is 200 milligrams or .007 ounce and has 100 points. In England, karat, the measurement of weight for gold, is spelled "carat."

Casting. A form of mass production of jewelry in which a mold is used. Molten metal is poured into the mold to create a piece of jewelry, rather than the jewelry being made piece by piece by hand.

Cat's-eye. Needle-like inclusions in a chatoyant gem that are lined up to reflect light in a single line or slit like a cat's eye.

Champlevé. A design etched or engraved in metal and filled in with enamel.

Chasing. The metal is worked from the top, with the metal being pushed aside, not removed, to form a design.

Chatoyancy. A satiny sheen found in certain gems due to numerous fibrous inclusions.

Clarity. A term used to denote the presence or absence of flaws or inclusions in gems.

Cleavage. The facility with which a gem cuts or cleaves along its planes or grain.

Cloisonné. Wire is twisted into a design and mounted on a metal backing. The cells (cloisonné) of the design are filled with enamel.

Closed setting. A setting in which a stone is set in a cavity in the metal with the rim fashioned to hold the stone in place. Only the top of the gem is visible.

Coin silver. Silver that is 90 percent or .900 pure silver.

Color. See "Hue," "Tint," and "Intensity."

Composite gem. See "Assembled gem."

Copper. A base metal. No quality markings are required.

Costume jewelry. Jewelry with little or no intrinsic (resale) value, made of nonprecious metals with or without inexpensive gems or synthetic or imitation stones.

Created gem. See "Synthetic gem."

Crown. See "Brilliant cut."

Culet. See "Brilliant cut."

Cut. The way in which a gem is cut in facets or polished.

Damascene. Metal is grooved in a design into which iron and steel traditionally is hammered, although today gold, silver, copper, and/or bronze may be used.

Diamond finish. Similar to "Florentine," except that both sets of parallel lines are engraved with equal pressure and the sets of lines are farther apart to create the diamond pattern.

Dichroic. A characteristic of transparent gems in which the gem shows two distinct colors.

Doublet. A gem in which a genuine crown or top is affixed to an artificial bottom. Also called a composite or assembled gem.

Ductility. The capability of a metal to be drawn into wire.

Elasticity. The capability of a metal to return to its original form after being worked on.

Electroplate. A process in which a base metal or alloy is placed in a bath with a solution containing precious metal, which is deposited on the base metal or alloy when an electric current is passed through the solution.

Embossing. The metal is worked from the back or inside to form a raised design. Also called repoussé.

Emerald cut. A gem cut, usually rectangular in shape, with 58 facets and with a flat table facet accounting for as much as 50 percent of the top surface matched by a flat culet of equal size. The facets are parallel to the table, not at an angle, as in the brilliant cut.

Encrusté. The same as basse-taille, except the enamel is not ground level but is left rough or encrusted.

Engraving. A design or pattern is drawn onto metal with a sharp implement that removes the metal.

Etching. The same as engraving, except that acid is used to remove the metal.

Filigree. Metal is drawn into a fine wire, which is twisted and soldered into a design or pattern.

Fine (Fineness). The amount of precious metal used in proportion to base metal. The greater the amount of precious metal, the finer the alloy is.

Fine jewelry. Precious jewelry of precious metals, with or without precious gems.

Fire. See "Dispersion."

Flaws. See "Inclusions."

Floater. See "Inland marine insurance."

Florentine. A finish in which parallel lines in one direction are engraved with heavier pressure than the parallel lines cross-hatching them at a 90-degree angle.

Fragility (Frangibility). The ease with which a gem can be chipped or shattered. See "Cleavage."

Frosted finish. See "Matte."

Fusibility. The capability that permits one metal to be combined with another metal in an alloy and that permits two metals to be bonded or welded together.

Gemological Institute of America (GIA). A scientific and educational institute with complete laboratory facilities and services for testing gems as to authenticity and quality but not price.

Gold. A precious metal. In the United States, any item marked "gold" must be 24-karat gold. See "Karat."

Gold electroplate. See "Electroplate."

Gold-filled. A process in which an outer layer of karat gold is fused to a base metal or alloy. The jewelry thus has the characteristics of the karat gold used but will not wear as long as solid karat gold, since wear depends on the thickness of the gold layer.

Gold-flashed/washed. Jewelry with less than the minimum standard of electroplated gold.

Gold overlay. The same as gold-filled.

Gold plate. The same as gold-filled. It is not electroplate.

Gypsy mounting. A setting in which the stone is set flush with the mounting.

Hallmark. Originally a mark designating an article's precious metal content. Today, it may also be the manufacturer's stamp or trademark.

Hardness. The quality of a gem that decides how easily one gem scratches or is scratched by other gems. See "Mohs scale."

Heart cut. A pear cut with a notch in the round end.

Hue. The actual color of a gem, such as blue, green, red, etc.

Ideal cut. A brilliant cut that is perfectly cut, in which the pavilion is neither too shallow nor too deep.

Imitation gem. A gem of any material, such as plastic or glass, that closely resembles a natural gem.

Inclusions. Imperfections within a gem caused when the stone was crystallized by nature. They may be bubbles, uncrystallized minerals, hairline cracks, etc.

Inland marine insurance. The type of insurance that covers portable items, including jewelry, furs, and musical instruments.

Intaglio. An engraved gem in which the engraving is below the surface, as for a seal. Intaglio is the opposite of cameo.

Intensity. How vivid or dull a color or hue is.

Irradiated gem. A gem treated with gamma rays to alter the color.

Karat. The measurement of the fineness of gold, with 24 karats or .9999 signifying pure gold.

Limoges. A picture or portrait is painted on wet enamel and fired to set the enamel.

Lost-wax casting. A form of casting in which the mold is solid with hollows inside into which molten metal is forced. The mold must be destroyed to remove the cast item.

Loupe. A jeweler's lens that fits in the eye to act as a single-lens microscope.

Marquise. A brilliant cut oval with pointed ends.

Matte. A soft, nonshiny finish.

Mohs scale. The scale of hardness of minerals based on the numbers 1 through 10.

Momme. A Japanese weight of measurement for cultured pearls, equal to 18.75 carats or 3.75 grams.

Noble metal. See "Precious metal."

Niello. Silver, usually .625 pure, with a blue-black inlay.

Native gold. Gold found in veins or rocks deep inside the earth. It must be mined and smelted.

Opalescence. A translucence with an iridescent play of colors and light. The name comes from the particular qualities of the gem opal.

Opaque. A gem that is impervious to light.

Open setting. See "A jour."

Oval cut. A brilliant cut that is elongated, not round.

Pavé. A setting in which small faceted gems are set in prongs over a closed backing for a paved effect. Pavé gems are brilliant cut with only 17 or 18 facets because of the small size.

Pavilion. See "Brilliant cut."

Pear cut. A brilliant-cut oval, round at one end and pointed at the other.

Pearl grain. A unit of weight for natural pearls, with 75 grains to the momme and 4 grains to the carat.

Pewter. An alloy of lead and tin, two base metals.

Piqué. Used with tortoise shell. A design is cut in the shell in shallow channels that are filled with stilver.

Placer gold. See "Alluvial gold."

Platinum. A precious or noble metal, the rarest and most expensive of precious metals and also the hardest.

Pleochroic. A characteristic of transparent gems, in which the gem shows more than one color.

Plique-à-jour. A filigree design is made, with enamel used to fill the cells for a stained-glass effect.

Point. One-hundredth or .001 of a carat.

Precious gem. A gem that is rare in comparison to other gems and is expensive.

Precious metal. A metal that resists corrosion and oxidation. Also called noble metal.

Reconstructed gem. A gem made of fragments of a genuine gem that have been heated to form a solid mass that can be cut.

Repoussé. See "Embossing."

Rhodium. An element of platinum often used by itself and to coat sterling silver as a tarnish preventive.

Rolled gold/R.G. plate. The same as gold-filled.

Scintillation. The reflection of light externally on the facets of a gem, as opposed to the inner reflection or dispersion.

Sheffield. See "Silver-filled."

Siam silver. Blue-black silver with a design incised in the background.

Silver. A precious metal. See "Sterling," "Coin silver," and other "silver" words.

Silver electroplate or plate. A process in which an item of base metal or an alloy is placed in a bath of silver and other materials and an electric current is passed through, depositing silver on the item.

Silver-filled. A process in which a layer of silver is bonded to supporting base metal. Also called Sheffield or silver overlay.

Silver overlay. See "Silver-filled."

Star. See "Asterism."

Step brilliant cut. A brilliant cut with 12 more facets in the crown and 8 more in the pavilion, for a total of 70 facets.

Step cut. See "Emerald cut."

Sterling. Silver that is 92.5 percent or .925 pure silver.

Substitute gem. Any stone, synthetic or natural, that looks like another gem and is used in place of that gem.

Synthetic gem. A man-made gem identical in chemistry and structure to the natural gem. Also called simulated or created gem.

Table. See "Brilliant" and "Emerald" cuts.

Tiffany setting. A very high à jour setting, giving maximum visibility to the gem.

Tigereye. A chatoyant gem with alternating bands of yellow and brown.

Tint. How light or dark a color or hue is.

Toledo. Metal is grooved into a design into which gold and silver is hammered.

Toughness. A term used to describe the characteristic of gems that are firm or strong in texture and that have no cleavage and are not fragile.

Translucent. A gem with minute inclusions that let some, but not all, light through the gem.

Transparent. A clear gem that lets as much light as possible through the gem.

Trichroic. A characteristic of transparent gems in which the gems show three colors, depending on the angle of the light.

Triplet. A three-layered stone in which the top and bottom layers may be genuine and the middle artificial, or the top and bottom artificial and the middle genuine.

Tumbling. A mass-production method of polishing gems into cabochons or baroque stones in large barrels, literally by tumbling them.

Vermeil. Sterling silver on which karat gold is electroplated, either in a design or as a finish.

Waldemar. A man's watch chain or fob.

Wash. A light coating of precious metal on another precious metal (e.g., vermeil), a base metal, or an alloy.

APPENDIX I
SUBSTITUTE GEMS
AND WHAT
THEY ARE

All precious gems and some nonprecious gems have substitutes. The substitutes are not always easy to detect and, in some cases, may require laboratory analysis. Some substitutes are sold under names that are misleading in the sense they lead you to think a gem is genuine, with the seller making no actual claims. The name of a precious gem may be combined with a modifying word; a word may be coined in such a way that it seems to be the name of a type of gem; or an unfamiliar word may be used, leading you to think the gem is something special.

The terms below are some of the most common ones used to make you think you are buying a gem other than what the gem actually is. There are others, however, far too many to make any listing complete. For that reason, your best protection is to listen carefully to what a gem is called, keeping in mind that no modifying or explanatory word is needed with the most precious gems. Those gems stand alone. For that reason, any time you hear any word other than "precious" or "genuine" used with a gem, or any unfamiliar term, you have cause to be suspicious. Remember, though, some of the substitutes are lovely in their own right—as long as you know what they are.

ADELAIDE RUBY Garnet
AMBEROID Pressed amber
AMBRE ANTIQUE Plastic
AMERICAN JADE Another stone, not jade
AUSTRALIAN JADE Chrysoprase

BALAS (BALLAS) RUBY Spinel
BOHEMIAN RUBY Rose Quartz
BOHEMIAN TOPAZ Uusually citrine, a quartz
BRAZILIAN RUBY Red tourmaline
CALIFORNITE Sold as jade
CAPE EMERALD Any green stone
CAPE RUBY Garnet
CARBUNCLE Garnet
CITRINE TOPAZ Citrine, a quartz
DRAVITE Brown tourmaline
EVENING EMERALD Any green stone
FRENCH IVORY Plastic
GERMAN LAPIS (LAZULI) Dyed chalcedony
HYACINTH Zircon
INDIA JADE Aventurine
INDICOLITE Blue tourmaline
JACINTH Zircon
JARGOON Zircon
JASPER JADE Jasper
LITHIUM EMERALD Any green stone, including hiddenite
MADEIRA TOPAZ Inferior amethyst, heat-treated
MAJORCA PEARLS Imitation pearls
MEXICAN JADE Dyed onyx
MORION Black quartz
MORNING EMERALD Any green stone
OCCIDENTAL TOPAZ Citrine, a quartz
ORIENTAL AMETHYST Violet-ruby sapphire
ORIENTAL AQUAMARINE Light blue sapphire
ORIENTAL CHRYSOLITE Yellow-green sapphire
ORIENTAL EMERALD Green sapphire
ORIENTAL HYACINTH Yellowish red or brownish red sapphire
ORIENTAL RUBY Any red stone
ORIENTAL TOPAZ Yellow sapphire
PALMYRA TOPAZ Inferior amethyst, heat-treated
QUARTZ TOPAZ Citrine, a quartz
SAPPHIRE QUARTZ Quartz, not sapphire
SIBERITE Red tourmaline
SMOKY TOPAZ Usually quartz
SOUDE EMERALD Doublets of clear quartz glued with green cement
RUBELITE Red tourmaline
RUBY SPINEL Spinel, not ruby
WATER SAPPHIRE Cordierite

APPENDIX II
DIAMOND
GRADING SYSTEMS

1. GIA CLARITY GRADING SYSTEM

Although diamond grading systems for clarity can vary among countries and even among stores in one country, the Gemological Institute of America (GIA) system is being used more and more widely all over. Except where noted below, the inclusions or imperfections cannot be seen with the naked eye but would be seen under 10-power magnification, that is, with the gem enlarged to 10 times the size it is seen with the naked eye:

TERM	DEFINITION
F.1	Flawless, with no visible inclusions
V.V.S.1	Very, very slightly included, with inclusions difficult to see
V.V.S.2	Same as above, with inclusions more easily seen
V.S.1	Very slightly included
V.S.2	Same as above, with inclusions more easily seen
S.I.1	Slightly included, with inclusions easily seen under magnification but not with the naked eye
S.I.2	Same as above, with inclusions seen more easily under magnification
I.1, I.2, I.3	Included, with inclusions increasingly easy to see with the naked eye

2. COLOR GRADING SYSTEMS

Color grading varies much more widely than clarity grading. The old system dates back to the discovery of diamonds in South Africa, with the names referring to the places where diamonds were found. It is still being used by some stores and in some countries, although diamonds may be found anywhere. The two other systems are the ones most commonly used in the United States. As you can see, the GIA system defines color more narrowly and precisely than either the old system or the American Gem Society (AGS) system. Top color, the stones most nearly white or transparent, would be stones graded River, D through H, or O and I.

SYSTEM	COLORLESS OR TRANSPARENT (WHITE)			TO	PALE YELLOW
Old	River	Wesselton	Crystal	Capes	etc.
GIA	D E F	G H I J K L M N O		P	etc.
AGS	O I	II III IV V		VI	etc.

APPENDIX III
TABLE OF HARDNESS
AND
CLEAVAGE PROPERTIES

The table below lists gems according to their hardness and gives their cleavage properties. The harder a gem is, the less easily it will be scratched, although you still have to be careful. It can scratch other gems, and there is its cleavage. Cleavage is the term used for how easily a gem splits along its planes. A gem with high cleavage will split or chip more easily than a gem with low cleavage, regardless of how hard the first gem is. These properties are important because they help determine how careful you should be with gems, in wearing them, in storing them, and in cleaning them.

GEM	MOHS SCALE	CLEAVAGE
Diamond	10	High
Corundum (Ruby, Sapphire)	9	Low
Chrysoberyl (Alexandrite, Cat's-eye)	8½	Low
Beryl (Aquamarine, Emerald, Heliodor, Goshenite, Morganite)	8	Low
Spinel	8	None, but brittle
Topaz	8	High

GEM	MOHS SCALE	CLEAVAGE
Tourmaline	7-7½	Low
Quartz (Amethyst, Cairngorm, Citrine, Milky Quartz, Rock Crystal, Rose Quartz, Smoky Quartz; Agate, Aventurine, Bloodstone, Carnelian, Cat's-eye, Chrysoprase, Jasper, Onyx, Sardonyx, Tigereye)	7	Not Distinct
Spodumene (Hiddenite, Kunzite)	7	High
Garnet (Almandine, Pyrope, Demantoid, Rhodolite)	6½-7½	Not Distinct
Zircon	6½-7	Not Distinct, but brittle
Jade (Jadeite, Nephrite)	6½-7	None
Peridot (Olivine)	6½	Not Distinct
Feldspar (Moonstone, Sunstone)	6-6½	Good
Tanzanite	6	Low
Turquoise	6	None
Lapis Lazuli	5½-6	None
Opal	5½-6½	None, but brittle
Obsidian	5-5½	None, but brittle
Coral	3¾	Not Applicable
Malachite	3½-4	None
Pearl	3½	Not Applicable
Amber	2-2½	None
Jet	2½-4	None

APPENDIX IV
BIRTHSTONES AND
STONES OF
THE ZODIAC

Gems have been worn as charms or amulets since earliest times, with certain gems supposed to be particularly powerful in insuring a wide variety of good luck. The assigning of a stone to the 12 months of the year or the 12 signs of the zodiac is an extension of this superstition. The idea originally was for a person to wear each stone in turn, which could be expensive. In the eighteenth century, the idea of wearing only the stone of the month in which you were born took hold. The next problem was which stone was the stone for that month, since lists tended to vary. Finally the National Association of Jewelers drew up the list below that has been accepted in the United States since 1912.

The stones for the signs of the zodiac have never been similarly resolved. The list below is the one that is suggested by several experts.

1. BIRTHSTONES

MONTH	STONE	SIGNIFICANCE
January	*Garnet*	Friendship, power, constancy
February	*Amethyst*	Sincerity. (This was the favorite gem of St. Valentine, who wore one engraved with a cupid.)

March	*Aquamarine* *Bloodstone*	Courage
April	*Diamond*	Innocence
May	*Emerald*	Love and success
June	*Pearl, Alexandrite* *Moonstone*	Health and longevity
July	*Ruby* *Star Ruby*	Contentment and peace
August	*Peridot* *Sardonyx*	Married happiness
September	*Sapphire* *Star Sapphire*	Clear thinking
October	*Opal* *Tourmaline*	Hope
November	*Topaz, especially* *golden topaz*	Fidelity, long life, intelligence, and beauty
December	*Turquoise* *Zircon*	Prosperity

2. ZODIACAL STONES

SIGN OF THE ZODIAC	GEM
Aquarius *(January 20–February 18)*	Garnet
Pisces *(February 19–March 20)*	Amethyst
Aries *(March 21–April 19)*	Bloodstone
Taurus *(April 20–May 20)*	Sapphire
Gemini *(May 21–June 21)*	Agate
Cancer *(June 22–July 22)*	Emerald
Leo *(July 23–August 22)*	Onyx
Virgo *(August 23–September 22)*	Carnelian

Libra *(September 23–October 23)*	Chrysolite
Scorpio *(October 24–November 21)*	Aquamarine
Sagittarius *(November 22–December 21)*	Topaz
Capricorn *(December 22–January 19)*	Ruby

INDEX

ABOUT THE AUTHOR

Edythe Cudlipp is a graduate of Mount Holyoke College. Following gradua-
tion, she was a continuity writer for Radio Station WJTN in her native town
of Jamestown, N.Y., and later moved to Buffalo to write and produce for
television. A vacation in Europe led to a job with the government as an editor
of military publications with the United States Army, Europe, in Heidelberg,
Germany. On her return, she worked briefly in public relations in Washing-
ton, D.C. After moving to New York City, where she still lives, she was a
magazine editor before becoming a full-time free-lance writer. She is the
author of several books, and her articles have appeared in such magazines
as *Harper's Bazaar, Playboy, Working Woman,* and others. She has also
written several romance novels under other names. Her major hobby is
traveling.